MICHAEL LUCERO

Sculpture 1976–1995

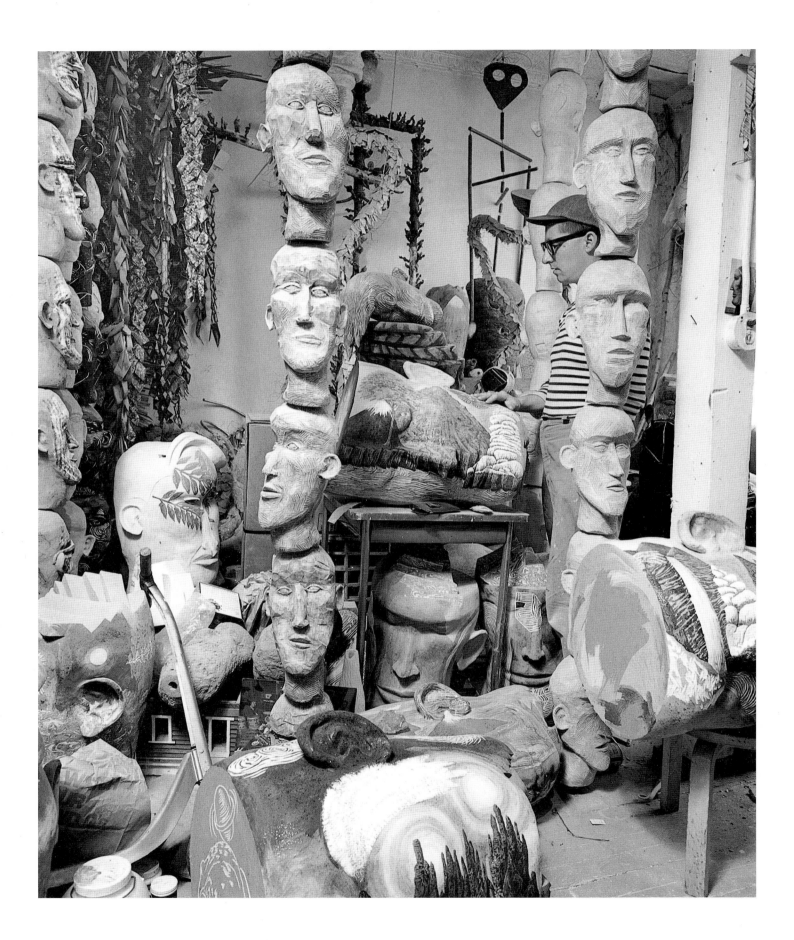

MICHAEL LUCERO

Sculpture 1976–1995

MARK RICHARD LEACH, *Curator*

and

DR. BARBARA J. BLOEMINK, *Co-Curator*

with an essay by **LUCY R. LIPPARD**

HUDSON HILLS PRESS, NEW YORK

in association with

THE MINT MUSEUM OF ART, CHARLOTTE, NORTH CAROLINA

Published in the United States by
Hudson Hills Press, Inc.,
Suite 1308,
230 Fifth Avenue,
New York, NY 10001-7704.

Distributed in the United States, its territories and possessions,
Canada, Mexico, and Central and South America by National
Book Network.
Distributed in the United Kingdom, Eire, and Europe by Art
Books International Ltd.
Exclusive representation in Asia, Australia, and New Zealand by
EM International.

Editor and Publisher: Paul Anbinder

Copy Editor: Renée A. Ramirez

Proofreader: Lydia Edwards

Indexer: Karla J. Knight

Designer: Abby Goldstein

Composition: Angela Taormina

Manufactured in Japan by Toppan Printing Company

Frontispiece: Peter Bellamy, *Michael Lucero,* Chelsea 1987, from
the book *The Artist Project: Portraits of the Real Art World/New
York Artists 1981–1990.* Photo © Peter Bellamy, 1987.

Cover illustration: *Anthropomorphic Infant Form with Tutu in
Stroller (New World Series),* 1993. Collection of Donna Schneier

Published on the occasion of the exhibition
MICHAEL LUCERO: *Sculpture 1976–1995*
presented at the Mint Museum of Art.

EXHIBITION ITINERARY

MINT MUSEUM OF ART, Charlotte, North Carolina
March 16 through June 9, 1996

AMERICAN CRAFT MUSEUM, New York
October 31, 1996, through February 16, 1997

KEMPER MUSEUM OF CONTEMPORARY ART AND DESIGN,
Kansas City, Missouri
March 30 through July 6, 1997

RENWICK GALLERY OF THE NATIONAL MUSEUM OF AMERICAN ART,
SMITHSONIAN INSTITUTION, Washington, D.C.
September 19, 1997, through January 4, 1998

CARNEGIE MUSEUM OF ART, Pittsburgh
February 28 through May 24, 1998

MICHAEL LUCERO: *Sculpture 1976–1995* and its national
tour are sponsored by Philip Morris Companies Inc. Major
support for the exhibition has also been provided by the
Rockefeller Foundation, New York; the Andy Warhol
Foundation for the Visual Arts; and the National Endowment
for the Arts, a Federal agency.

LIBRARY OF CONGRESS CATALOGUING-IN-PUBLICATION DATA
Leach, Mark Richard.
 Michael Lucero : sculpture 1976–1995 / Mark Richard
Leach and Barbara J. Bloemink ; with an essay by Lucy R.
Lippard. – 1st ed.
 p. cm.
 Catalogue of a traveling exhibition first held at the Mint
Museum of Art, Charlotte, North Carolina, Mar. 16–June 9,
1996 and at four others through May 1998.
 Includes biographical references and index.
ISBN 1-55595-127-9 (pbk. : alk. paper).
 1. Lucero, Michael, 1953– –Exhibitions. I. Bloemink,
Barbara J. II. Lippard, Lucy R. III. Mint Museum of
Art. IV. Title.
NB237.L82A4 1996
730'.92–dc20 95-43867
 CIP

CONTENTS

COLORPLATES

LENDERS TO THE EXHIBITION

Allene LaPides Gallery

Alvin H. Baum, Jr.

Stanley Baumblatt

Becky and Jack Benaroya

Dawn F. Bennett and
 Martin J. Davidson

Elaine and Werner Danheisser

David Beitzel Gallery

Alan Dinsfriend

Richard Ekstract

First Bank System, Inc.

Caren and Walter Forbes

Hirshhorn Museum and Sculpture
 Garden, Smithsonian Institution

Stephen and Pamela Hootkin

Daniel Jacobs and Derek Mason

Shonny and Hal Joseph

Janet and Robert Kardon

Michael Lucero

Mint Museum of Art

Sandra and Gilbert Oken

Francine and Benson Pilloff

Arlene B. Richman

Betsy and Andrew Rosenfield

Linda Leonard Schlenger and
 Donald Schlenger

Donna Schneier

Patricia Shaw

Gae and Mel Shulman

Mimi and Vinton Sommerville

Dorothy and Fred Weiss

Arthur J. Williams

Beverly and Hadley Wine

Hope and Jay Yampol

MICHAEL LUCERO: *Sculpture 1976–1995*

For the past twenty years, Michael Lucero has explored art and craft traditions and images from a variety of cultures, and with growing freedom and accomplishment he has combined them to create his own distinctive work. This exhibition is his first major survey, and it reveals the consistent sense of direction behind the artist's varied interests and influences, while capturing the evolution of a career in the middle of its course.

At Philip Morris, we have supported the arts for nearly forty years. We are especially interested in the kind of energetic, innovative work featured in this exhibition, because it shows us the world—and the worlds of art and culture—from a fresh perspective. We congratulate the Mint Museum of Art for initiating this exhibition, which is bound to be just as exciting and successful in New York, Kansas City, Washington, and Pittsburgh as it will be in Charlotte.

Michael Lucero's work is bold, astonishing, powerful—and fun. We hope you enjoy it.

STEPHANIE FRENCH
Vice President, Corporate Contributions and
Cultural Programs
Philip Morris Companies Inc.

FOREWORD

The partnership between the Mint Museum of Art and artist Michael Lucero that has resulted in the current exhibition is fascinating. As the exhibition concept has developed between the artist and curator Mark Leach, the traditional lines between artist and museum have become blurred. Lucero is both artist and educator; Leach is at once curator and artist.

The Mint has long been recognized for its multidimensional collections of ceramics—pre-Columbian, American, British and European—and, more recently, for its multicultural program of exhibitions of young artists whose work reflects contemporary issues. Like most art museums, the Mint is concerned with providing a meaningful context for the works in its collection—using those works of art as windows into the times and societies that created them.

Michael Lucero's work is multidimensional in its synthesis of diverse forms and influences. As he deals with issues of appropriation and assimilation, the artist becomes educator, posing through his art the questions a museum educator might ask visitors: What is the difference between two forms? What effect does surface decoration have on functionality?

His sources are multicultural as well, ranging from pre-Columbian, Native American, European, and Afro-Carolinian to the vernacular and to popular media. In fact, this exhibition is not presented in the traditional way, limited to a space dedicated to temporary exhibitions. Instead, it spills throughout the museum with the artist appropriating works from the permanent collection and insinuating Lucero's works amidst the installations of works from other cultures.

As it is in the museum, the concept of context is a constant in Lucero's work. When he assimilates a form from its original context into a new, Lucero-generated context, he asks us whether the original is not still present as part of an aggregate. To answer his questions we may well have to leave the exhibition and visit the permanent collection in order to compare, for instance, the original pre-Columbian object with Lucero's adaptation of it.

A fascinating aspect of the exhibition is that as it moves from Charlotte to Washington to New York to Kansas City to Pittsburgh, its own context will change. Associations that exist in one museum will not be present in the next. Again, the lines between artist and museum have blurred. Is the exhibition the work of art in itself or is it a collection of works of art? That is a typical Lucero question.

BRUCE H. EVANS
President and Chief Executive Officer
Mint Museum of Art

ACKNOWLEDGMENTS

Foremost among those who merit the museum's deepest appreciation and thanks for their important contributions to this exhibition and publication is Michael Lucero. Through the artist's compelling vision, the dynamic conditions of global culture and its history come alive in hybrid objects whose shapes and surfaces resonate with human meaning. Without his extraordinary commitment to his art, this exhibition would not be possible.

Michael Lucero's sculptures pose difficult questions and offer few easy answers. From the outset, the artist's rich, complex vision has called for a different curatorial approach. Eighteen months into the exhibition's development, I concluded that my curatorial goals for the project required the addition of a perspective different from my own, and yet one that was complementary. At that point I invited Dr. Barbara J. Bloemink to work with me as co-curator to develop further the exhibition's curatorial aims. It is my pleasure to thank Dr. Bloemink for her considerable contribution. Her expertise in contemporary Latin American art and her thorough knowledge of twentieth-century American and European cultural history as well as her creative approach to curatorial method have deepened the exhibition's innovative orientation, thus placing the artist's oeuvre in the context of global cultural history. I am equally indebted to art historian and critic Lucy R. Lippard. Her intelligent analysis of the artist's sculpture presents a rich socio-cultural reading that enables us to appreciate more fully Michael Lucero's unique and important contribution to contemporary American art.

It is an honor to thank those public and private institutions as well as the many individuals and organizations who so generously lent their enthusiastic, unstinting support to the production of *Michael Lucero: Sculpture 1976–1995*. My initial thanks go to the four museums, and the key individuals within them, whose unflagging support has enabled the exhibition to go forward and has ensured that it will be seen by the widest possible audience. At the American Craft Museum, Janet Kardon, director, Kate Carmel, chief curator, and Ursula Ilse-Neuman, project curator; at the Kemper Museum of Contemporary Art & Design, Dr. Barbara J. Bloemink, director, Michelle Bolton, exhibition coordinator, and Pauline McCreary, museum secretary; at the Smithsonian Institution's National Museum of American Art, Dr. Elizabeth Broun, director, and Michael W. Monroe, curator-in-charge of its Renwick Gallery; and at the Carnegie Museum of Art, Phillip M. Johnston, director, Sarah Nichols, curator of decorative arts, and Vicky Clark, associate curator of contemporary art. It has been my great pleasure to work with Paul Anbinder, president of Hudson Hills Press. Early in the exhibition's development, Mr. Anbinder's accessibility, genuine interest, and trust were crucial to the project's success and, later, to the book's realization. The beautifully designed catalogue that accompanies *Michael Lucero* is the product of Hudson Hills Press's thoroughly professional staff and Paul Anbinder's commitment to record and share important cultural developments with the field and the public. One of the greatest debts owed is to the many wonderful and passionate collectors of Michael Lucero's sculpture, who so generously lent their treasured possessions for exhibition and publication.

Financial underwriting, so crucial to the development of this ambitious project, was generously made available by numerous foundations, private individuals, and corporations. We are deeply grateful to Philip Morris Companies Inc. for its generous support of the exhibition and the national tour. Within the company, we thank Stephanie French, vice president, Corporate Contributions and Cultural Programs, and Karen Brosius, manager, Cultural Programs, who enthusiastically supported our original proposal and a subsequent request for support to

use the Internet and World Wide Web to make information on the exhibition and its contents available to a global audience. On behalf of the Mint Museum of Art, I want especially to thank the Rockefeller Foundation, whose early support and generous grant lent important credibility to the project. In particular, Dr. Bloemink and I wish to thank Dr. Tomas Ybarra-Frausto, associate director, Arts and Humanities, for his assistance in planning the Mint's grant application and for his enthusiasm and encouragement for the exhibition overall. Generous additional support has been provided by the National Endowment for the Arts, a Federal agency; and the Andy Warhol Foundation for the Visual Arts. We also thank USAir, the official airline of the Mint Museum of Art.

A core group of the artist's most dedicated supporters have contributed financially or offered other support in assisting in the exhibition's development. I particularly wish to thank Pamela and Stephen Hootkin for their generous contribution and for the privilege of their hospitality during my frequent research trips. Others played crucial roles in defraying exhibition costs through their generous donations. For their enthusiastic support of the exhibition and the Mint Museum of Art, I thank Caren and Walter Forbes; Mr. Jerome Shaw; Patricia Shaw; Donna Schneier; and Dorothy and Fred Weiss.

This project and accompanying publication have resulted from the cooperation and assistance of many individuals. The Mint Museum of Art thanks the following galleries and their professional personnel for generously supplying pertinent information on the artist, his work, and its whereabouts: David Beitzel and Caroline Prymas of David Beitzel Gallery, New York; Linda Farris and Michelle Burgess of Linda Farris Gallery, Seattle, Washington; Fay Gold of Fay Gold Gallery, Atlanta, Georgia; Jeff Guido of Habatat/Shaw Gallery, Pontiac, Michigan; Tom Boone and David Jones of Indigo Galleries, Boca Raton, Florida; Allene LaPides and David Chickey of Allene LaPides Gallery, Santa Fe, New Mexico; and Dorothy Weiss of Dorothy Weiss Gallery, San Francisco, California.

At the Mint Museum of Art, the dedicated and enthusiastic support of the entire staff merits my warmest and heartfelt thanks. To Bruce H. Evans, president and chief executive officer, and his management team, consisting of James R. Hackney, Jr., director of development and marketing, Charles L. Mo, director of collections and exhibitions, Cheryl A. Palmer, director of education, and Michael Smith, director of administration and personnel,

I owe an enormous debt of gratitude, for it has been their good counsel, enthusiasm, and untiring commitment to the exhibition that have ensured its success. In the Collections and Exhibitions Division, I thank assistant curator Kathy L. Kay, who ably coordinated foundation applications and worked closely with me on virtually every aspect of the exhibition's production. E. Michael Whittington, curator of non-Western art, and James C. Jordan, III, curator of decorative arts, generously gave of their time and expertise to the interpretation of the exhibition's collections-based education component. I am grateful to Kurt Warnke, head of design and installation, Mitch Francis, cabinetmaker, William Lipscomb, preparator, and Emily Blanchard, graphic designer, for their sensitive and thoughtfully conceived exhibition installation. Special thanks are due to registrar Martha Tonissen Mayberry, who has been an invaluable colleague and participant in the exhibition from the beginning. She has ably assisted in the development of accurate budgets as well as attending to the planning and coordination of the consolidation, packing, transportation, and safe handling of the exhibition. I thank assistant curator Anne E. Forcinito for the hours that she devoted to the transcribing, cataloguing, and photography assignments associated with the exhibition. Special thanks are due to museum interns Mary Beth Crawford, Lynn Daubenspeck, and Julia Norwood, who labored tirelessly on the myriad exhibition-related details, including those involving the book's development.

The exhibition's public programs are rich and varied, each designed to illuminate the unique and complex character of Michael Lucero's creative genius. With gratitude I acknowledge the joint efforts of Robert West, curator of film and video, Susan S. Perry, docent and tour coordinator, Jill Shuford, school programs coordinator, Sara Wolf, librarian, and Janet Austin, education department assistant, for their respective roles in developing a lively and provocative public program to complement the exhibition during its run in Charlotte.

In the museum's Development and Marketing Department, I am indebted to personnel who gave generously of themselves to orchestrate and facilitate the fundraising as well as the marketing and promotion programs for *Michael Lucero*. Polly B. McKeithen, development officer, and Andrew King, development assistant, expertly coordinated and compiled curatorial narratives and budgets into successful federal and private grant applications. Phil Busher, public relations coordinator, and

John West, marketing assistant, prepared a dynamic advertising campaign for the exhibition and its national tour.

Externally, the Mint's *Michael Lucero*–related programming has been greatly enhanced by the formation of two important community partnerships. I wish to thank Tom Stanley, director of the Winthrop University Galleries in Rock Hill, South Carolina, for agreeing to develop a Catawba Indian artist residency in the Winthrop University Art Department and a related exhibition in the University Galleries during the spring 1996 semester. The exchange programs planned between the Mint and the university will include artist-accompanied field study trips to the Mint's and Winthrop University's exhibitions. I also wish to thank Jeannee Von Essen, NBC News Channel Director of Foreign Development, for her enthusiastic support of the exhibition. Through *Canal de Noticias NBC*, a Spanish newscast transmitted to nineteen countries in Latin America from the NBC News Channel studios located in Charlotte, North Carolina, on-camera interviews and exhibition footage that elaborate on the significance of the artist's sculpture as seen in *Michael Lucero: Sculpture 1976–1995* will reach an international audience.

Finally I would like to thank my wife Laura and our children Andrew and Aryn for their patience, good humor, and continued support throughout the exhibition's development. They have been a source of inspiration and comfort, and they have provided needed perspective during critical periods in the project's development.

MARK RICHARD LEACH
Curator of Twentieth Century Art

PREFACE

*Multiculturalism, when not deteriorating into fruitless spasms of cultural separatism,
has begun to provide a groundwork for considering culture as a mutable and
ever-negotiable set of interrelationships.[1]*

Michael Lucero's holistic vision ignores hierarchies and boundaries. His sculpture expands traditional Western ideas about art and its origins as well as the creative process and the artistic product by unifying utilitarian form with cultural artifact. However, the abrupt change that periodically occurs between the movement of one culture's usable property to another culture's museum, as signified in many of the pieces presented here, poignantly illustrates colonial value systems. The cultural, political, economic, and social subtexts that create such activity are compelling and integral factors to inquiries such as the one at hand. The work presented in *Michael Lucero: Sculpture 1976–1995* reflects an odyssey at once introspective and personal, filtered through the public discourse of global culture. Though born in the United States of America, Michael Lucero inherited a complicated and, until recently, an unspoken, ancestral past. Not long ago, the artist became aware that his ancestors were practicing Sephardic Jews. The spiritual apartheid previously practiced against Sephardic people in Spain and elsewhere precipitated a coerced migration to Latin America and, subsequently, to New Mexico where Lucero's extended family was among the one hundred original families to settle the New Mexico territory. In both locations, colonial activity forced religious worship underground. References to these historical circumstances and others as well can be seen throughout Lucero's sculpture.

The artist's mature vision, recognizable as early as the mid-1970s, developed against a cultural backdrop characterized by abundant discourse, including feminism, identity construction, appropriation, and art commerce, as well as the reemergence of narrative and figuration. These subjects, among others, are reflected in 1980s exhibitions of global culture, including *ART/Artifact,*

Magiciens de la terre, The Decade Show, and *Africa Explores: 20th Century African Art.* These exhibitions also indicated that traditional hierarchies and formerly inviolate art-historical narratives were subject to scrutiny and revision. Concurrently, craft exhibitions, including *Craft Today: The Poetry of the Physical, The Eloquent Object: The Evolution of American Art in Craft Media since 1945,* and *Clay Revisions: Plate, Cup, and Vase* have challenged the status of crafts by demonstrating that utilitarian forms can be transmuted, in and through the creative process, into works of art. As the above exhibitions suggest, there is great interest in works that combine the previously separated idioms of craft and fine art because the fusion of the two, or adaptations of one to another, offer many artists an alternative approach to creative problems and modes of production. Nowhere is this more evident than in Michael Lucero's sculpture.

The forty-seven pieces selected to represent approximately two decades, including the mid-1980s *Earth Images* installation, explore the artist's unique synthesis of iconographic pluralism, ceramic tradition, and sculptural innovation. Seen here, Lucero's work is distinguished by its integration of forms and surface imagery from diverse cultures, including pre-Columbian, Native American, European, Afro-Carolinian, and the vernacular and popular media. In and through his sculpture, Michael Lucero's creative experimentation promotes our understanding of changing global, social, and cultural circumstances.

The curatorial initiatives contained in *Michael Lucero: Sculpture 1976–1995* support alternative concepts of originality and change, as seen in nearly two decades of the artist's glazed ceramic, bronze, and mixed media sculptures. Taken as a whole, Lucero's artworks contain three core elements: an ecumenical borrowing from the history

of art of various cultures, a persistent metaphorical and physical movement between interior and exterior structures and spaces, and a faithfulness to the ceramic medium. The artist's creative reworking of multicultural forms and his exploration of such dialectical ideas as beauty and the grotesque, culture and nature, the sacred and the profane, ritual and accidental, and purity and contamination offer an authentic model of cultural pluralism. Unlike traditional views that explain cultures as isolated, separate entities, Lucero's creative vision interprets civilization as an aggregate, formed over time by exposure, improvisation, and adaptation.

In the initial stages of development, the curator sought an appropriate means of working and presenting the artist's work that would echo the many tenets of Lucero's oeuvre, including the rich appropriation of diverse ideas and cultures. Out of this vision, Mark Richard Leach conceived the idea of working collaboratively with Dr. Barbara J. Bloemink in the selection of the exhibition and building in the interpretive elements that support the curatorial thesis. Dr. Tomas Ybarra-Frausto, associate director, Arts and Humanities at the Rockefeller Foundation, was highly instrumental in focusing the curators' intentions toward developing an interpretive introductory area of the exhibition that would posit the main themes while allowing the integrity of the artist's work to stand on its own. Over a three-year period, trips to Santa Fe, New York City, and Seattle, to interview the artist and to talk about the development of and different influences on his work, contributed to the evolution of the checklist. Each work of art, ceramic, bronze, and mixed media, was examined with the artist to explore its myriad contextual, thematic, and sculptural meanings.

Through constant and challenging dialogue, extraneous curatorial ideas and superfluous gimmicks were pared away, leaving an integrated, in-depth exploration of the mature artist's work as well as a visually interesting introductory area that would stimulate questions about Lucero's work without offering any single explanation or interpretation. The final result is a rich mix of approaches and ideas that would not have been possible had only one person contributed to the project's planning and development. Instead the exhibition, like Lucero's work, represents an amalgamation of concepts, imagery, and

perspectives reflecting the complexity of art and society at the end of this century.

To underscore these ideas and facilitate access to major themes, the exhibition includes several educational/interpretive elements. In the introduction to the formal exhibition, works of art selected from diverse cultures and periods are placed in comparative relationships to reflect primary concepts explored by the artist in his work. The accompanying text and identifying labels illuminate those associations visually suggested between the juxtaposed objects. Prominent questions raised by the artist's sculpture include: "How is meaning altered when a form, concept, or motif is appropriated into different contexts and cultures?" "Should the medium (clay) determine whether an object is considered an artifact or art?" and "How does surface decoration complement and subvert the object's overall form?"

A second facet of the interpretive program of *Michael Lucero* will be to use the artist's work to reinforce notions of cross-cultural fertilization within the Mint Museum of Art's permanent collections. A small photographic reproduction of a related Lucero work will be affixed to text panels of permanent collection works selected by the artist from the museum's many departments. This indexing technique will link parallel histories and cultures to the artist's oeuvre, further expanding access to Lucero's own work. Finally, the exhibition includes a study carrel featuring texts covering postmodern theory, museology, ethnology, and anthropology.

As an accumulation of ideas and critically directed cultural explorations, Michael Lucero's sculptural oeuvre is simultaneously an homage to the greater whole and the sum of its parts, to the lesser-known and omnipresent histories of humanity, and to the fluid, changing circumstances of global existence. Lucero unites the disjunctive worlds of differing cultural forms and images in a Siamese twin–like tension of independent and competing desires. Among the insights gained from intensive study of the artist's work is the idea of the artwork as a reprise of familiar themes—a traditionally non-Western concept of creativity. According to African scholar and curator Susan Vogel,[2] such aesthetic concepts are often based on a continuum, reflecting communities of artists drawing on preexisting forms. Where repetition in European art is often directed toward perfection, in much non-European-

based work, the reprise is an end in itself, designed not to improve on a basic theme but to develop or play off it. Never solely an imitator, never literally duplicating earlier forms, Michael Lucero in his sculptures always engages this variation and adaptation of existing aesthetics. Technically, visually, and conceptually, the artist's work offers immediate access to alternate notions of originality and cultural relativity. There is no one reading or *answer* to his works. Their visual and formal diversity acts as a metaphor for contemporary life and collective existence in which there is not one predominant culture but many voices existing simultaneously.

MARK RICHARD LEACH

Curator

DR. BARBARA J. BLOEMINK

Co-Curator

NOTES

1. Eleanor Heartney, "Recontextualizing African Altars," *Art in America*, December 1994, p. 60.

2. We are particularly indebted to Vogel's discussion of alternative concepts of creativity in *Africa Explores: 20th Century African Art.* For additional commentary, see Susan Vogel, "Repetition or Reprise," in *Africa Explores: 20th Century African Art* (New York and Munich: The Center for African Art and Prestel, 1991): pp. 17–20.

That was the world and it still is!

A CONVERSATION WITH MICHAEL LUCERO

MARK RICHARD LEACH

The visual and iconographic complexity of your sculptures as well as the different cultures to which your work simultaneously refers suggest that your life experiences have been quite extensive. Looking back over the years, are there memories or experiences from your childhood that you think have influenced and continue to influence your work?

MICHAEL LUCERO

Travel has certainly played a role because, through it, I was exposed to so many interesting things. Driving from California to Las Vegas, New Mexico, to visit my maternal grandparents is particularly memorable. Trading posts along the original Route 66, now Interstate 40, really captured my attention because

I'd see signs that would say "Stop to see Indian weavers," and "Stop to see Indian jewelers." These advertisements caught my imagination.

My parents would stop at these places so I could explore them. There I discovered large Indian figures made of wire and burlap cloth *(fig. 1)*. Over time, one pair in particular started to decay and I remember having seen hanging threads blowing in the wind. I found them haunting. Though I knew they weren't real, they scared me, but I loved them, too. They were almost like folk art. They were big, flattened silhouettes, but they had volume to them.

In the trading post, my parents would remind me that Indians wove

these beautiful rugs and made this beautiful pottery and jewelry. Everything was *made* by somebody. It was at this point that I realized people made these things and they were intended to be beautiful and they were also intended, for the most part, to be functional. Whether it would be or not, the original idea of a saddle blanket or an Indian blanket, in my impression, was that it be used. We had a small Indian rug, but it was never a big focal point.

I never considered applying my love of useful things to my artistic pursuits, though, until I entered college. There I discovered that ceramics and all crafts really interested me. It wasn't that I was thinking about Indian pottery particularly, but I think I had a natural affinity to it. It wasn't a conscious thing, like one day I realized, "Oh, yeah, I'm interested."

MRL

When you visited Santa Fe, you would spend time with your maternal grandparents. Was

Fig. 1 The artist's sister Gloria (right) and brother Claudio (left) pose for a photograph in front of a trading post along Route 66 in Arizona, circa June 1957. As a child, Lucero held the figures seen in the background in high regard, having, as he states, "... loved them and feared them." He further credits the primal and imposing qualities of the tableau with inspiring his treatment of the hanging figures of the mid- to late seventies.

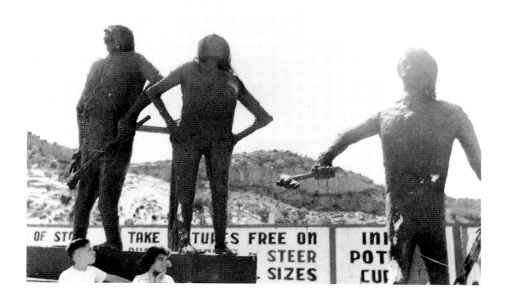

NOTE

A series of tape-recorded interviews with Michael Lucero took place in August 1992 in Santa Fe, New Mexico; April 1993 in New York City; September 1993 in Santa Fe, New Mexico; April 1994 in New York City; July 1994 in New York City; November 1994 in New York City; and February 1995 in Charlotte, North Carolina. The contents of the original transcripts have been combined and edited to follow a chronology of the artist's life and the development of his work over the previous nineteen years.

ML

Years ago, my mother's father and mother owned a general store. Their home seemed kind of old and had a different feeling, which I attribute to its New Mexico location. It was made from adobe in the Pueblo style, though inside I recall furnishings similar to those owned by my parents in California. There wasn't a *viga* (beam), or log, to be seen in my grandmother's house. My mom told me that when she was a little girl, the houses in which she lived were all fashioned that way. Occupants would tack a white muslin tarp to the ceiling for a cleaner look. This would conceal the *vigas*. To leave them exposed was considered old-fashioned, not modern or clean.

My grandmother's mother was also alive. She lived way out in the country in a compound of homes owned by relatives of my mother. Grandma Lita was married to a Frenchman. Her husband had imported Victorian furniture, a velvet settee, for example, to furnish their home. Of course, the kids could never go in those rooms. They were to be looked at, never to be used. This arrangement expressed a different, confusing set of values about usable items to me.

One summer, their home was destroyed by fire. We rummaged through the debris for family possessions. Buried in the cellar among the clutter was a large piece of Indian pottery that, in style, resembled Acoma pottery *(fig. 2)*. It reminded me of a pitcher with its handle and spout. Its orange, black, and white patterns were wonderful, quite beautiful. We brought it home to California. I was in second grade

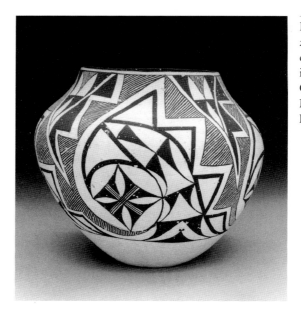

Fig. 2 Hilda Antonio. Acoma, 20th century. *Black-on-White Olla*, c. 1978. Earthenware, 10⅛ × 11½ inches. Mint Museum of Art, Charlotte, North Carolina. Museum Purchase. H79.72.14. Photo: David Ramsey.

and I took it to school for show-and-tell. I thought it was the most amazing pot I had ever seen. It was truly beautiful! I think about it now—it was perfectly innocent.

I never imagined that such experiences would affect my creative thinking later in life. Nevertheless, I assumed that I wasn't alone in my appreciation for such things. I thought everyone had seen American Indian artworks.

MRL

The desert surrounding Santa Fe and Las Vegas, New Mexico, is, for many reasons, a fascinating place. From your descriptions, it sounds like you felt at home in that environment. There's a physical and psychological sense of freedom that one experiences in spaces whose scale is so grand, isn't there?

ML

Yes! My grandmother lived on the edge of an arroyo. A creek flowed through the ravine adjacent to her home. It was my favorite place. I used to play down there for hours. I collected many living things. I really loved the animals, particularly the reptiles and amphibians.

Desert anthills are the most amazing things! My mother once

told me that when she was a little girl, she and her sisters and brothers would go for walks to look for Indian beads that they later would string. We believed that the Indians, who lived there previously, traded beads with other tribes who may have passed through the area. My mother recalls having found turquoise beads and other types as well. One story she would tell me explained how ants would bring bead after bead, like pieces of sand, to make their mounds. I, too, remember gathering Indian beads or rocks or whatever excited me.

I also remember trips to Carlsbad Caverns. On one such occasion, my parents let me get a souvenir from the gift shop. I chose a book about reptiles and amphibians. I memorized pictures of every frog and their American habitats. I read the book over and over.

MRL

So many of the activities you describe have an element of intense, focused play at their center. Has that carried over in your work?

ML

Perhaps it's a bit less than serious, but I love the fact that I can still

appreciate and play with my work to the point of illustrating a frog or a moth on one of my pieces, things like that that I always loved. Once somebody asked me, "When are you going to stop playing with bugs and frogs and start making real art?" Well, when I made the *Earth Images*, I thought this was my chance to show that art can be fun and compelling too!

MRL

When you went off to college, did your artistic personality find a home in the structured undergraduate culture of academia?

ML

The women faculty members with whom I studied, and who hailed from the Bay Area, were discussing Judy Chicago and feminism. Feminist thinking, in particular, was new to me. My painting professor, Louise Stanley, for example, talked about how she liked the idea of making a painting on the kitchen table. I thought that sounded interesting. What really struck me was the idea of making smaller work. I thought, why can't I join in this conversation? I don't need fancy equipment—metal grinders, welders, etc. Smaller scale doesn't mean less significant. In fact, it has the potential to mean just the opposite because it invites a closer physical relationship. So I began making small clay sculptures. I was just adapting the feminist arguments to suit my own creative impulses.

Ironically, everything I did as a child was handmade in a funky kind of way. It was smaller, on a more human scale, and manageable. During this period, I never thought in monumental or traditional terms, nor was I motivated by typical "male" sculpture. In fact, that scared

me. It wasn't something I felt completely at ease with, in part because I never had any real introduction to it other than the basic rudiments taught in school. On the other hand, my father wasn't a welder. Rather, he was a tinkerer who made such small, usable objects as wooden boxes and cast cement planters for our backyard.

Along with my male friends who studied sculpture, I was inspired by William Wiley's assemblage, which we perceived as a counterculture statement in terms of scale and in a material sense. So, I felt I didn't have to weld steel, carve wood, or chisel stone to make sculpture. Suddenly, I thought there were infinite alternatives and I could make something that was as justified or as legitimate as anything traditionally understood as sculpture. Though clay was still not truly accepted, on the West Coast you could move out the potter's wheel, bring in a lump of clay, and start making things by hand. All of a sudden, hey, you've got some sculpture going! That was a given. The trick was to personalize it!

MRL

Were you exposed to or aware of the larger figurative movement in California while you were an undergraduate student, and did this genre inspire you to work figuratively?

ML

That's a tough one. The figurative genre just seemed natural. There are so many differences between the West Coast and the East Coast. The same applies from Los Angeles to San Francisco. Los Angeles in the mid–1970s seemed to align itself with New York, whereas artists in the Bay Area seemed to say, "Hey we're different, forget it, there's no

chance." California's colors, foliage, and its weather are so conducive to an outdoor life-style. Whenever I visit, I'm overwhelmed by the flower gardens people live with every day. It's no wonder the setting influences people. I look at my own work and say, "God, do I have to use that red? Do I have to use yellow? What is it about the colors that makes me want to keep doing it?" You look at Mexico and you see all the color used and people celebrating life and they celebrate the fact that it's a pretty or beautiful color. In America, we do tend to honor things differently.

MRL

Your undergraduate sculptures were innovative, particularly in the solutions you found to the marriage of form and image. How did this come about?

ML

Well, for me it was a natural thing. I was in the painting department, but I also studied printmaking, metalworking, and, of course, ceramics. In my pottery class, I had difficulties learning to throw. So I built all these forms and painted images on the pots. My professor said, "Look, you're a sculptor, forget about pottery. Just concentrate on handbuilding." So I did. This was so exciting because at Humboldt, the ceramics department was in principle a sculpture department. They had very few wheels there and it was during that time that the clay revolution had already begun. One memorable occasion that was particularly inspiring to me was the collaboration between artists Richard Shaw and Robert Hudson *(fig. 3)*, seen later in an exhibition mounted by the San Francisco Museum of Modern Art. I

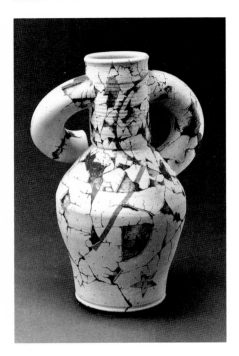

Fig. 3 Robert Hudson. American, b. 1938. *Untitled No. 21*, 1973. Painted porcelain, 16 × 5½ × 11 inches. Collection of Daniel Jacobs and Derek Mason. Photo: Malcolm Varon.

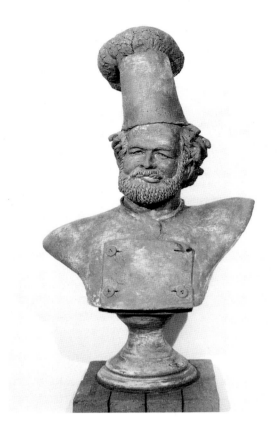

Fig. 4 Robert Arneson. American, 1930–1992. *Overcooked*, 1973. Hand-built terra-cotta, 52 × 30 × 20¾ inches. Crocker Art Museum, Sacramento, California. Gift of the Crocker Art Gallery Association with matching funds from the National Endowment for the Arts. 1973.25. © 1973, Robert Arneson. Photo: courtesy Frumkin/Adams Gallery, New York.

remember being overwhelmed by the variety of slip-cast forms that were collaged together to make incredible images. I think they were based on the vessel or the teapot form, yet they were absolutely sculptural. . . . I was just amazed. Even though I never wanted to make teapots, it made me want to use clay all the more. You could get these incredible colors! You could fire them in the kiln and if you didn't like the results, or if you wanted to embellish upon them, all you had to do was add more glaze and refire them. . . . There were infinite possibilities.

The painting department was academic. Even so, they had interesting people and it was funkier and looser. I remember thinking I could paint my ideas on a flat surface, but that was limiting. So I said to myself, "Why not paint on clay?" I could take this material and make a shape and work it with color. It seemed very natural to me.

MRL

As a painter smitten with clay, did you encounter any resistance from your peers?

ML

Most of my friends were painters and so-called sculptors. They would say, "Oh ML, come on back to the painting department. The ceramics department is its own entity." Even so, I caught the bug! I felt that committing myself to clay was appropriate and that the boundaries were really broken down with such artists as Robert Arneson *(fig. 4),* Shaw, and Hudson. I felt that I could contribute somehow.

MRL

Following the completion of your undergraduate degree, you then moved to Seattle, where you worked under Howard Kottler, *Patty Warashina, and Robert Sperry in the M.F.A. program at the University of Washington. How did graduate study affect your work?*

ML

There I began using scale as a serious component in my work. I also wanted to explore, or to work against, ceramic conventions. For example, where the figure is concerned, most often the form is displayed on a pedestal. I suspended my pieces from the ceiling *(fig. 5).* There they hung free in space, as if weightless. These figures were comprised of many little shards assembled over a period of time. I was searching for a way to dissect the figure and to reassemble it so that it would be viewed differently. The shard enabled me to view the figure anew. That's a particularly vivid memory that I have from graduate school . . . working this or that

figure out by using the shard as a vehicle for discussing the metaphor or the idea pertinent to the piece.

MRL

In 1978 you received your M.F.A. degree from the University of Washington. You then moved to New York City. Did you discover affinities between your own creative interests and artworks being produced there at the time?

ML

I did get excited by some of the painters. Susan Rothenberg and Neil Jenney, both of whom were included in the Whitney's *New Image Painting* exhibition, were really interesting to me because the spirit of their work, as with works by other painters included in the exhibition, was in keeping with sculptural work I had previously done. Their images were primal and basic. I responded

to that. Aside from the work of sculptors like George Segal, who limited figural compositions to monochromatic color schemes and who focused on a psychological theme or dimension, it seemed like a new approach to me.

MRL

In New York you really hit your stride. There you focused intently on the shard concept and the series seems to have reached a critical mass, resulting in dramatic and innovative figures rich with metaphor and formal innovation. Can you speak more specifically about this formative series?

ML

I was never a potter, so I never acquired the facility for making vessels on a wheel. These pieces, the vessels and shards, were all hand-built and were intended to be read metaphorically. Of course the shard

is an archaeological remnant and something I wanted to speak about. In fact, I deliberately played the vessel and fragment against one another to refer to history, decay, accumulation, meaning, and so on. I didn't want to use clay indiscriminately, but rather through its use allude to symbolic meanings of the material, the history of the material. I thought clay–vessel, clay–bones. I wanted to refer to the ancient and to speak of it in contemporary terms.

I have always been infatuated with different ceramic forms, American Indian and Greek pottery, for example. I referred to these forms in such pieces as *Untitled (In Honor of the S.W.) (colorplate 3)* and *Untitled (Lizard Slayer) (colorplate 4).*

MRL

These pieces, and others subsequently, entailed a very labor-intensive process.

Fig. 5 Michael Lucero. Installation, January 1980. Wood, wire, and paint; all figures approximately 12 feet high. Wake Forest University, Winston-Salem, North Carolina. Photo: courtesy of the artist.

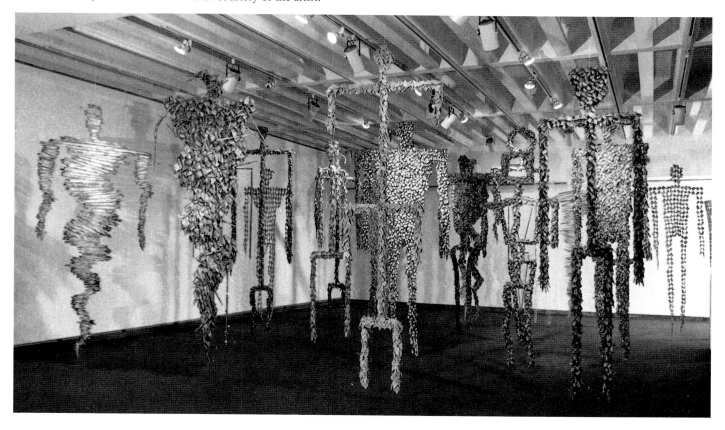

What led you to such a detailed and time-consuming procedure, given your love of expediency?

ML

At Humboldt we were taught that you could embroider and still call it sculpture. I thought wow . . . this is exciting. I was fortunate to be there. This whole process demystified the heroism typical of much of the art of the day and gave equal credibility to the crafts or their alternatives . . . small scale could be just as powerful as large scale.

I really identified with the process entailed in embroidery and quilting. I remember visiting my parents during my first semester in graduate school. I saw my fifth-grade teacher, who was particularly inspirational to and supportive of me. We talked about a project I had worked on in his class. It was a processional staff to be used in a May Day parade. I purchased a big dowel and with pieces of chicken wire and crepe paper, I made elaborate flowers and tied them to the staff. When I returned to school, I decided that was how I loved to work. So I took my clay and made little parts and tied it to this big chicken wire form. . . . I had finally broken away from my previous mode of making one-piece ceramic sculptures. That rejuvenated my mind. I recognized that I am compulsive, I am obsessive. I decided not to deny it, but to use it to my advantage. That's how I regrouped. It helped me to reinvent the making of the form in a real interesting way. I thought, now I can personalize it. I came to the conclusion that piecework was not just for women—I decided I could do it, too!

MRL

This series offered you many formal opportunities and rich thematic ground to work. It began in Seattle and in New York, after several years, drew to a close. Can you describe how the transition between the shard figures and totems happened?

ML

Yes. I worked on the hanging figures for two to three years. By that point, I was getting tired. I went through this rhythm of making the head and making the shard. While they were in the kiln, I prepared the armature for the accumulation of all the parts on my studio floor. I had this rhythm thing down. It worked beautifully and I loved it.

I wouldn't worry about the form until I made all the parts. At that point it became exciting for me because I would take this new shape and I would hang it up and I would tie shards on it for days. Nevertheless, by 1982 or 1983, I began to feel that I had made enough figures in this way. I had then decided I wanted to remove the literal figure from my work and had recalled from anatomy class the axiom of seven heads equal the figure's height *(fig. 6)*. I decided to stack them and this is where the totem entered my vocabulary. Another stunning thing for me was that I made the seven heads simultaneously. They all came together at the same time and then I stacked them on rods.

MRL

In the subsequent Dreamers *series you chose a single head as the primary shape. Formally,*

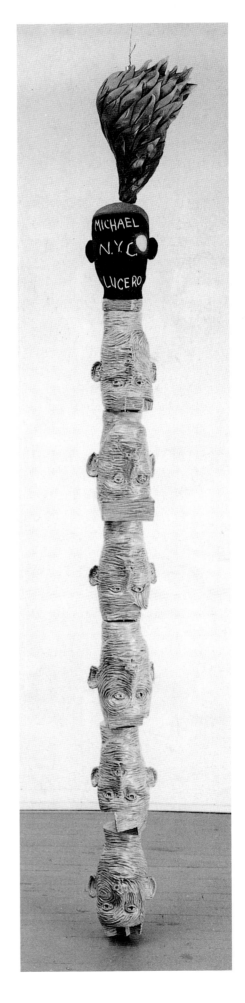

Fig. 6 Michael Lucero. *Totem (Self-Portrait)*, 1983. Hand-built white earthenware with glazes, 108 × 16 × 12 inches. Collection of the artist. Photo: D. James Dee.

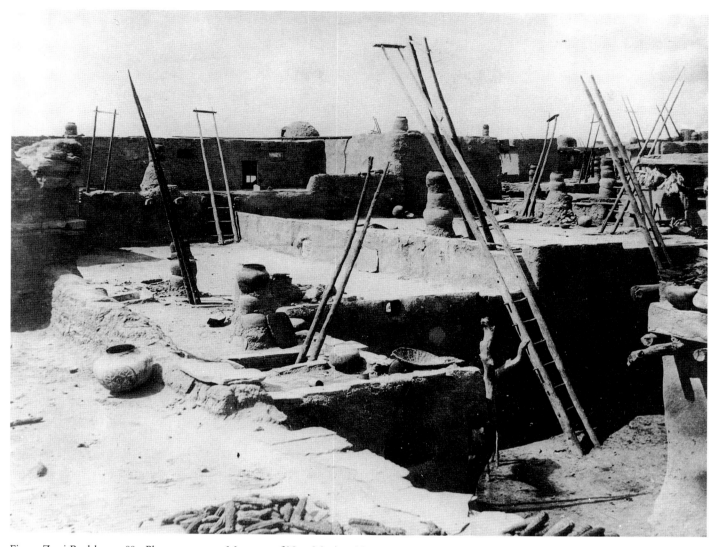

Fig. 7 Zuni Pueblo, c. 1885. Photo: courtesy Museum of New Mexico, Neg. no. 5031.

this series marks a departure from your previous work. In addition, your pictorial treatment of the surfaces is considerably more complex. It's as if your earlier obsession for material accumulation had been adapted to a pictorial scheme. How did this series develop?

ML

I realized I could push the pictorial surface way back and bring it forward again. I also wanted to refer to earlier landscape and architectural forms that I have always admired. Pueblo architecture, in particular *(fig. 7),* inspired the heads' stepped architectonic features. This is how the *Dreamers* began *(colorplates 7–14).* Though I worked concurrently on

the individual heads and the totems, I had a desire to get away from the big figures, and the *Dreamers* fulfilled that objective. I felt that I didn't need to make another twelve-foot piece or make giant art. The individual heads were intimate and, even though considerably smaller than the previous work, I liked the way they alluded to a big figure because the head was larger than life.

MRL

During this period you went abroad to Italy. Did your travels in any way affect the development of this series?

ML

For one thing, I selected colors more metaphorically. For instance, blue represented water and the earthy colors represented the earth. I didn't want the colors to be indiscriminately decorative. I used very earthy colors and the *Dreamers* surface images were all basically frescoes. They were applied to wet clays. While in Italy, I saw the frescoes of Fra Angelico and Giotto. Some of the colors I was getting at the time were strange, though, pinks and blues, for example, and I tried to change them. I noticed that the same colors were present in the Italian frescoes . . . that blew my

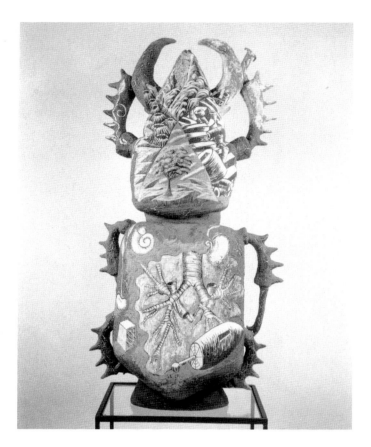

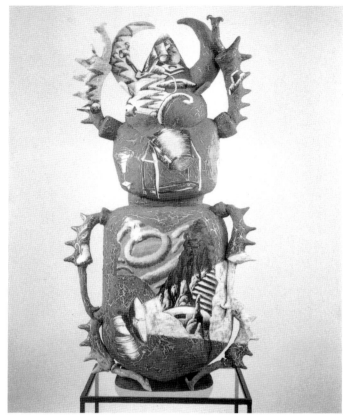

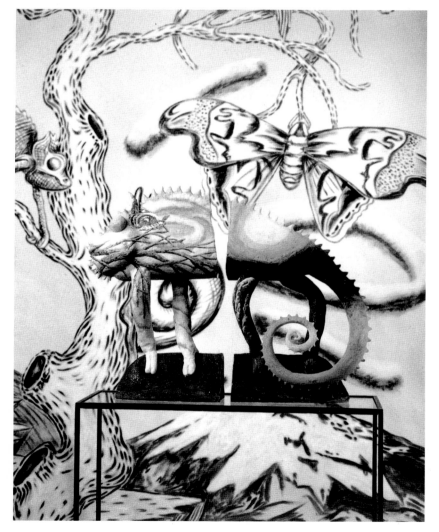

Fig. 8 Michael Lucero. *Mud-Loving Beetle*, 1986 (recto). Hand-built white earthenware with glazes, steel stand, and glass, 46 × 22 × 12 inches. Mint Museum of Art, Charlotte, North Carolina. Gift of the artist in honor of Mark Richard Leach. Photo: Ellen Page Wilson.

Fig. 9 *Mud-Loving Beetle*, 1986 (verso).

Fig. 10 Michael Lucero. *Earth Images* (detail with *Cameleon*). Installation at Hokin/Kaufman Gallery, Chicago, 1986. Photo: courtesy of the artist.

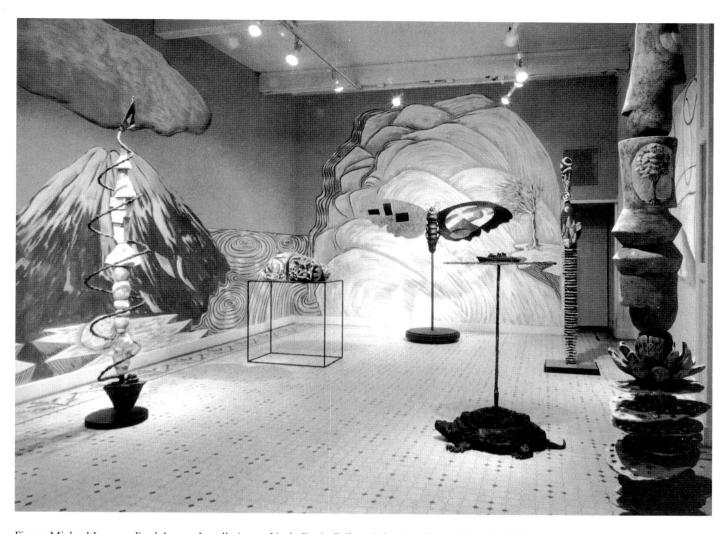

Fig. 11 Michael Lucero. *Earth Images*. Installation at Linda Farris Gallery, July 1987. Photo: Eduardo Calderón.

mind. Nevertheless, I developed a way to create variations by adding gray or blue.

I would build a head in one day. The next morning I would color it . . . manipulate the very ordinary shape of a head and distort it.

MRL

You speak frequently of the metaphorical possibilities of clay. The Earth Images, *the series that followed the* Dreamers, *is a particularly compelling example of material as metaphor. I'm struck by the tension you manage to evoke by combining concepts of beauty and ugliness, nature and culture.*

ML

In the *Earth Images (figs. 8, 9, and 10),* I wanted each form to be special and individual, not modular as the *Dreamers* were. Certainly the forms were slightly varied and I painted different images using various colors, but in the *Earth Images* I wanted to show variety—vertical, horizontal, large and small. In addition, though, I had to deal with the challenge of scale. My kilns were small, and not up to handling the size I had in mind. That's when I decided to work in sections. I considered disguising the division between forms and then I thought, oh hell, I'll just glaze them separately and combine them in a way that underscores the individual and related nature of the forms. The diptych format has a long history in painting. I approached those sculp-

tures much as I would a painting, in terms of a divided, but related, vision.

I also decided to illustrate the relationship of these creatures to nature. I accomplished this by creating a primordial environment consisting of scenes rendered in charcoal directly onto the gallery walls and drawn on canvases that I executed in my studio *(fig. 11).*

MRL

The diptych enriches the narrative these pieces contain. It also allows you to play interior against exterior, primitive against civilized, ritual against accidental, etc., and the stories become highly charged as a result.

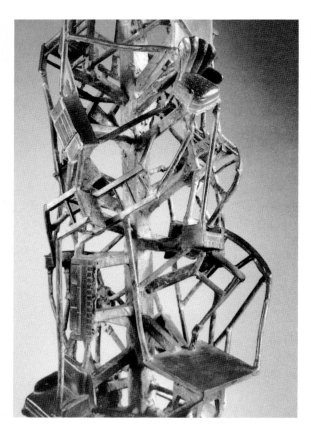

Fig. 12 Michael Lucero.
Fossil Fuel, 1988 (detail).
Bronze, 105 × 11 × 20 inches.
Collection of the artist.
Courtesy Allene LaPides Gallery.
Photo: Ellen Page Wilson

ML

That's the magic of working! It's that sometimes your handicaps turn out to be really great assets. I do believe that when I allow things to go, I will get there and the discovery process along the way can be very informative.

MRL

In 1986 you made a decidedly abrupt departure from working in clay, choosing instead to concentrate on making bronze sculpture. What precipitated this move?

ML

I think that I felt that I had been working in clay for so long and still I wasn't being taken seriously. I decided to make the jump to bronze and to use it metaphorically. I wanted to try another material and not use it as if I were using clay. I saw so many artists who used clay to fashion sculptural forms that were then cast in bronze. Often the metal emulated the characteristics of

clay . . . but the clay never got the credit! I thought it was unfortunate that the clay was treated as simply a vehicle instead of as a subject with metaphorical potential. I decided to try to make sense of the method of the flowing of the hot metal, to expose the vents and gates, and to exploit the process in a holistic and metaphorical sense.

MRL

In this series you used found objects as grist for your sculptural ensembles. Among others, I remember seeing miniature toys of the type that one might find in a doll house, seemingly caught in a cultural web of vents and gates (fig. 12). Did you do waxes of these things, or how did you work these objects into the forms?

ML

I used objects that were plastic and wood, that were burnable, not clay. This way I could do direct castings and didn't have to deal with molds. I saw such artists as Nancy Graves

who used a similar approach with organic plant material. I wanted to speak to the process and to the ideas I had in mind. I was after a kind of fossilizing quality where these images were concerned, but that were current to my culture. I also wanted a direct relationship to my environment. I didn't want to filter it, as in hand-making the objects, but rather to arrange them to achieve the statement I had in mind.

I worked with bronze for a couple of years. I got interesting results, but I also was beginning to see the limitations of the material. I missed the intrinsic qualities of the clay, the immediacy that I had enjoyed so much and the color range to which I had access.

MRL

There was a transitional period in which you reconnected with the totem motif, using not the heads of a few years ago, but, among other things, the human heart. In this series, you continued the nature-culture dialectic and added to it by introducing symbols whose origins include, but are not limited to, Western iconography. How did this series challenge you, and did you feel that it broke new ground?

ML

The heart totems also used the organ as a sculptural module. At first, I proceeded as I had with the head totems, stacking the forms seven high. I would glaze them in earthen tones, but would also incorporate life-form images such as moths. *Dry Land Totem (colorplate 29)* illustrates this direction nicely. Then, during a summer teaching session at Humboldt, I increased the scale as I had with the *Dreamers*. I made six large forms that summer and their surfaces were covered with

various image types, colors, and the like. Yes, I think the heart idea began with the bronzes and the idea of vents/veins and gates. That did open new territory for me and I really dug in! I bought a biological specimen of the heart to study and subsequently a facsimile of it terminates the totem *Spirit*.

MRL

Pre-Columbian iconography first appeared in the large heart forms. As the next half-decade of your work illustrates, pre-Columbian imagery and forms are used by you to various ends. How was the connection essential in the Big Heart *series?*

ML

I chose to integrate pre-Columbian images with the heart to allude metaphorically to human sacrifice and an earlier Latin American people and culture. To link their religious rites to the heart symbol seemed natural to me. On *Big Heart (Deer) (colorplates 32 and 33),* which is where I painted the first Maya image, I had first painted a picture of redwood trees. I was grappling for an image that had equal or greater resonance. After all, the redwoods have been there for centuries.

MRL

You did another totem series a year or so later. The Mint's Cohasset, *included in this group, has a different feel and complexity. How did they develop?*

ML

Yes! I was in California teaching for a semester at Chico State University. I wanted to explore ideas relating to the agricultural fabric of the area. I wanted to consider the earth, the implements used in its cultivation, for example wheels and plows. So I had bases fabricated for totemic

pieces, and the totem series focused on the idea of working through the earth, the material, and the metaphor of the clay. The vertical format was a natural vehicle to accomplish my objectives. The houses, the ready-made hobby shop sort of motifs that I found at the ceramic supply house, add a rural feeling to the work. Combine these elements with the names of streets in Chico and you get this play between the rural and the suburban.

MRL

You recently discovered that your ancestral past is linked to the Sephardic strain of Judaism. I think this is particularly crucial information as it indicates the migratory trajectory of your ancestors and thus links you to a heritage in which racism, oppression, and genocide were experienced. What are your thoughts on this and how do you see it impacting your work?

ML

The history of my ancestral family— it's such an old history of the Americas. Nevertheless, I do know that my parents were raised Catholics, but that a recent family tree made by a cousin shows that my earlier ancestors were Sephardic Jews. Some people don't want to deal with it. It's too heavy and pits Catholics against an earlier mode of worship. It's too much energy to think about it. However, my mom told me there was always talk about it, that it was always sort of in jest, but the Jewish religion is being recovered now in the Southwest. There have been several texts written recently that have brought this history to light. These people were ancient Jews. The Sephardics were thrown out of Spain during the Inquisition, boated to Latin America, and hid there. They were

even ostracized and killed in Mexico. They were continually running. As you now know, the northern New Mexican landscape has, for many years, been populated with Jewish people that immigrated from Mexico and have been practicing as Catholics for hundreds of years in order to survive. . . . I feel somehow connected. That's why it's so odd, the images that I'm working on. They do speak about all that. Again, it just seems natural. Maybe it's my own way of going through that [my ancestors'] history intuitively.

I was raised a Catholic and I never really questioned it too much, but the interesting thing is that I'm not a really devout Catholic now. I believe in God, I do believe in that aspect of religion, but I don't like the Church and I don't believe in or stand for all things the Catholic Church does.

Several years ago I went to Spain. One day I went from Madrid to Toledo to see the churches and the cathedral. It was an enormous monstrosity. During the tour, the tour guide said to me, "Mister, please remove your hat," because men never wear hats in Catholic churches. I said, "OK, fine." When he returned to the front of the group, I put my hat back on. He returned and again said, "You must remove your hat." I said, "No, I'm not removing my hat." He told me if I didn't, I'd have to leave the church. So I left! I was so insistent about wearing that baseball cap during this period. Subsequently, the same group went to the synagogue. Toledo had the biggest contingent of Jews in all of northern Spain. They didn't ask me to remove the hat. Now that I think of it, my baseball hat looked

yarmulke-like. It's an interesting contrast between the Catholics and the Jews, don't you think?

MRL

Your use of ceramic history is very sophisticated, as is your acknowledgment of other artistic movements and trends through the formal and stylistic references you overlay onto your sculptures. I get the feeling that you now recognize the great power of these visual languages and their ability to communicate your message.

ML

I felt I could take this material and use it in a symbolic way, with a respect for it and an understanding of the material and its history, and make something new out of it in my time and my place. I never saw anybody who took the earth and the idea of the earth and then made a fired ceramic thing that, in my opinion, enabled clay to operate as a metaphor. Like the hearts—I wanted to make a heart, an earth heart, a clay heart. And then the trees that I painted on it were so perfect and beautiful, what else could I paint that I love as much as these big damn redwood trees? So I severed that heart, I dissected it, and added the pre-Columbian image. I had never used that image and I thought, "Aha, here it is—it just appeared before me. So now I can take it and make it three-dimensional in the *Pre-Columbus* series." I felt the courage to go back into history and pull it out again. The idea of appropriation, which was quite fashionable in the art of the eighties, gave me license to borrow more directly.

I should also credit living in New York and seeing trends come and go and witnessing the prominent use and borrowing of our historical past as an inspiration to my work. Why

should I spend time in my studio trying to invent a shape or restructure a material to become a new form? To me, that wasn't an interesting or motivating factor to start working. What interested me was that maybe I could take one of these forms and apply it through the use of the glazes, which is another sort of celebration of the fact that it is ceramic, not bronze or wood. It's clay and it's glazed and it's fired. It's cooked and it's gone through the whole ritual of being made. That is exciting to me.

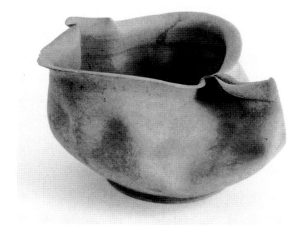

Fig. 13 George Ohr. American, 1857–1918. *Bowl*, c. 1902–7. Earthenware, 4¾ inches high. Collection of Cheryl Laemmle and Michael Lucero. Photo: Jerry Stuart.

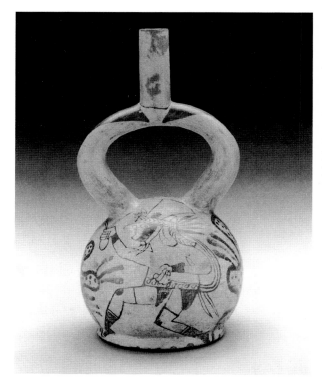

Fig. 14 Moche, North Coast Peru. *Stirrup Spout Bottle with Running Figures*, A.D. 200–600 (Moche IV). Fine line bichrome pottery, 10⅝ × 5½ inches. Mint Museum of Art, Charlotte, North Carolina. Gift of the Charlotte Debutante Club. 68.2.13. Photo: David Ramsey.

MRL

For some time, you've collected American ceramist George Ohr's work (fig. 13). Beginning in the Pre-Columbus *series and continuing through your present* Reclamation *series, you've used stylistic quotations—wavy, undulating vessel rims and handles—of his forms in your own work. What do you find so compelling about Ohr?*

ML

I admire his work for so many reasons! He was a great colorist. He experimented with glazes tirelessly. He dripped, he poured it on, he

layered those colors, and they were all more beautiful than the next, but I also loved the pure form of his pieces. Years later, there's something that's so revealing about his fingerprints and his process. I'm awed by the fact that he saw something different, full of energy, grace, and dynamism in the awkward and asymmetrical. He must have felt, "I don't need to dip them into the glaze now," but maybe it took him all of his sixty-one years or so to get to that point. That's why I admire his work so much.

MRL

Your inventiveness in the Pre-Columbus *and, subsequently, the* New World *series provokes wonderment, a state of mind essential to engaging viewers in the darker, under-lying subtexts of colonialism, racism, and genocide. What were your objectives when you first started out with the* Pre-Columbus *series, and did you anticipate that there would be a more holistic relationship between* Pre-Columbus *and* New World?

ML

When I started doing the *Pre-Columbus* pieces, I thought I didn't have to go back in and fuss over all the little images here and there, but when I saw them as forms I just couldn't resist. While doing a bit of research, I made a wonderful discovery. As I examined different collections of pre-Columbian art, I found out that the Maya also painted illusionistically; with slips and glazes the Indians used to depict arms on their forms *(fig. 14)*.

For example, on a vessel whose primary motif was a head, they would use a coil or bulge in the clay to suggest an arm. Then they would use different slips or glazes to fashion designs that made the arms with fingers over the bulging area of the form specific. So, in fact, they too were mixing two- and three-dimensional elements even then. Unfortunately, many of the pieces that we see, with the exception of a few that have been preserved, have suffered from environmental degradation, causing much of the surface painting to chip or flake. It was mind-blowing to me because I had the same inclination to do what was already done, sort of unknowingly. I thought maybe I really do have a connection to these pieces, more

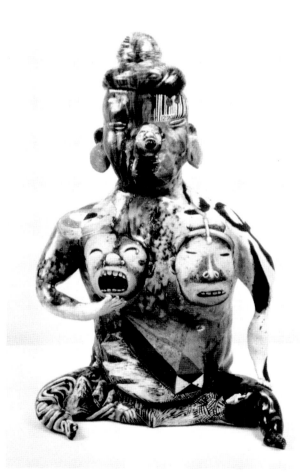

Fig. 15 Michael Lucero. *Seated Lady (Pre-Columbus)*, 1991. Hand-built white earthenware with glazes, 19 × 15 × 10 inches. Collection of Shonny and Hal Joseph. Photo: Ellen Page Wilson.

Fig. 16 Michael Lucero. *Anthropomorphic Female Form with Wig (New World Series)*, 1992. Wheel-thrown and hand-built white earthenware with glazes and wig, 23½ × 16½ × 10 inches. Collection of Hadley Wine. Photo: James Hart.

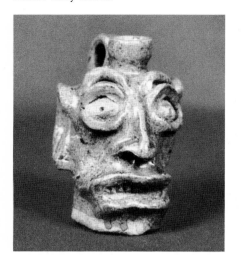

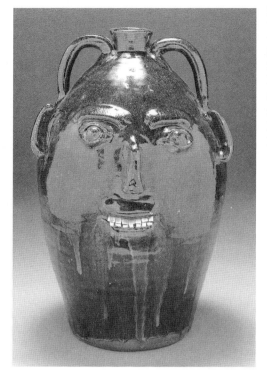

than I think. That was exciting. It was this unconscious attraction ... and you don't know exactly what to do with it.

The transition between the two series was easy to make because I treated them very similarly *(figs. 15 and 16)*. They did have a different visual feeling because one was hand-made and the other was generated on a potter's wheel. The criticisms I remember hearing were that they were much stiffer, they were more mechanical, but those were things I already knew they would be. I don't think stiff is necessarily a negative.

MRL

In New World *you started working with a master potter who created the formal vocabulary that you then fashioned into sculpture. This arrangement has carried on into the* Reclamation *series. Can you describe your working relationship?*

ML

I think in terms of the anonymous potters that were anonymous only because their pots had no name on

them. In my case, Chris [Daniels] makes the pots for me under my complete supervision. He is able to skillfully throw my forms as I see them. It's not a collaboration. It would be different if Chris insisted on a very personal throwing style, such as the one used by Peter Voulkos. I want to limit the expressionism or individuality of the pots Chris makes for me. I'm more interested in an archetypal shape that suggests the vessel. I want them to be smooth, just a generic vessel, so it can assume symbol status.

Chris and I have many times discussed the notion that the potter's wheel is just a tool and one aspect of a larger picture. I feel that by working with someone like Chris, who really has no ego invested in the process, I'm not taking away from him or denying his name. Chris will tell you himself that the forms I have him do, he would never have done. I remember when we were in New Mexico a few years ago, I asked Chris to make big teardrop bottles that are big and

soft at the bottom and become really small at the top. He told me, "Michael, I can't do that," and I said, "No, you go littler, and littler...." Well, he did it and he said he didn't realize that he was capable of attaining the shapes I wanted.

MRL

What was your motivation for placing the Pre-Columbus *series into a dialectical relationship with the* New World *series?*

ML

It was literal. I wanted to address the issues implicit in post-contact history. That's why I called them *Pre-Columbus*, instead of pre-Columbian, and *New World*. The idea was to link South America and Columbus and pre-Columbian. I never really understood the historical implications of the terminology. I just used my own reasoning. I wanted to indicate life before the arrival of Columbus and after the arrival of Columbus to suggest how things started to change.

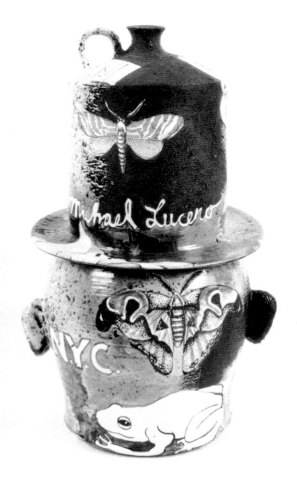

Fig. 19 Michael Lucero. *Anthropomorphic Jug Form with Poppies (New World Series)*, 1994 (recto). Wheel-thrown and altered white earthenware with glazes, 22 × 14 × 17 inches. Collection of the artist. Photo: Jerry Stuart.

Fig. 20 *Anthropomorphic Jug Form with Poppies (New World Series)*, 1994 (verso).

MRL

It was around the quincentenary that this material came about?

ML

That was the reason why I wanted to switch the series and refer to the New World. I had to somehow make the distinction between the New World and the previous world. It wasn't easy.

MRL

In the New World *series, you extended your concern with colonial activity to include that of North America. I'm referring, in particular, to slavery and to a pottery tradition among African Americans that has inspired you. How long have you been familiar with* African American ceramics and, in particular, the Edgefield face jugs?*

ML

As I began referring to pottery or vessels in the *New World* series of sculptures, I thought it was a perfect time to express my interest in the face jugs, which I've appreciated for some time *(figs. 17 and 18)*. I always knew that the maker's anonymity was a subtext of the highly collected Southern form popularized by white potters. I wanted to celebrate the Afro-Carolinian tradition.

MRL

To what extent have the earlier face jugs influenced the way your pieces have evolved?

ML

I like the older ones, Dave the Potter, for example, even though I didn't know who Dave was at the time. I always loved the face jugs, but never knew how to position the form in my work. It took me twenty years to feel confident as a ceramic artist and to feel comfortable enough to present it in my work as a major subject. Subsequently, I felt like I could redo them, put them back on a pedestal, and reevaluate them on my terms *(figs. 19 and 20)*. In addition, I loved the idea of being able to personify a pot. That part was equally powerful to me, and thus the figurative element remains

continuous in my work, but from a different perspective.

MRL

What kind of liberties did you feel that you needed to take in working with the form?

ML

Though I have great passion for pre-Columbian art and I look at it frequently, I'm not very knowledge-able about the material. I didn't want to learn too much about specific regional characteristics because I felt it would inhibit me from experimenting with particular aspects of the forms. Instead, I approached the forms visually.

MRL

Are you saying that your approach to the face jug form was similar?

ML

Well, I knew that the slaves were the initial ones that made the wonderful forms with very black-featured faces and I just felt I could do it too. So where the black face is concerned, definitely. I really did accentuate that. I didn't think it was a problem.

MRL

Humor is an important element in your work. For example, sometimes your sculptures are overtly funny, sometimes wry or camp, sometimes subtly cynical and irreverent. Even so, do you feel that the humor is constructive?

ML

It's not that I think the humorous aspect of the work is not serious, I feel just the opposite! I think that it helps make it more serious. Hopefully, it doesn't read as self-conscious. My pieces are a little looser and have a bit of humor to guide you into their depths.

MRL

I know some have periodically expressed criticism over your use of cultural forms outside your own heritage.

ML

I have always identified with African and American Indian art. Even so, the instructors or the people that I encountered through my artistic pursuits always discouraged me from explicitly describing my interests through my work. Therefore, I always skirted around the idea of being too culturally specific. They would say, you don't want to be too derivative of African art, especially when it means nothing to you. Well, I felt it must mean something to me if I identified with it because it interested me on more than a visual level!

Picasso, who used African art, is a prime example for me. Many academics say that he was only interested in it formally. I disagree with that. Once I heard a lecture and I stood to ask a question. I said, "You talk about primitive or African art having inspired Braque and Picasso on a formal level, but how about on a spiritual level?" I think I'm attracted to the spiritual aspect of the work. So you depict these shapes in your artwork and you love it so much that you keep doing it and then it becomes this academic exercise of dissecting the human figure, as seen in Cubism. I think formalist readings are quite shallow, an academic bore! I think a more fascinating question is to discover to what extent Picasso experienced spiritual affinities with the work. I think he did, and he expressed it by painting it over and over, and the more comfortable he became with it, the more he realized how he could geometrically dissect, reshape,

and resculpt illusionistically on a two-dimensional surface.

I think that in choosing to explore African-based forms, I wanted to ignore the academics and go right toward the spiritual center. It is a humanoid, it's like the anthropomorphism of this humble pot. So that attracted me. I didn't want to invent a new academic formula. That part doesn't interest me.

I always liked American Indian things. In my Adam and Eve figures *(fig. 21)*, there is something very direct about the way I built them, the rhythm, the methods, the repetition, the whole process, that was very interesting and important to me. And it reminds me of beading or layering or sewing or stitching or tying or weaving. The work has a lot of that in it. It was probably my intuition working with me that enabled me to express all those things. It wasn't until later when I moved to New York and I got out of graduate school that I was comfortable enough to say, "Hey, I like American Indian art and I want to express it." I thought, to hell with it! I like it, I'm going to use it. I don't have to answer to my teacher saying, "But you're not an American Indian . . . how personal is it to you?"

MRL

But it clearly was.

ML

It took more courage on my part to let go of all the hang-ups of having to justify my actions.

MRL

Is it by promoting ecumenicism that you hope to engage the concept of humanism?

ML

I think so. I now believe, perhaps

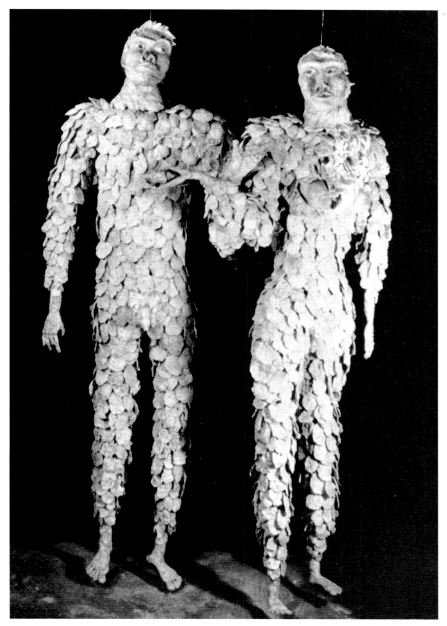

Fig. 21 Michael Lucero. *Untitled (Adam and Eve)*, 1978. Hand-built white earthenware with underglazes, stain, human hair, and wire, 72 × 36 × 10 inches each. Collection of the artist. Photo: courtesy of the artist.

because I'm older, that seeing shows of Latin American art or artists whose heritage is not our own, for example, exposes us to things aesthetically different that we have missed. We have not acknowledged these artists' works. I do think there is something fascinating about knowledge and cultural materials outside of our own traditions. Each culture embodies inherently different attitudes and values, and these are naturally expressed in and

through their cultural forms. That's why their work comes out looking different. The colonial, "European" aesthetic wasn't a part of their development as thinkers and makers of art. They have a different kind of hands-on approach. It has a different look. That's wonderful to me. I've learned a lot by looking at those artists' work in context with each other.

And I think the same for women's art. I think that women

sometimes have more courage to depict certain things than maybe a man would have. There are certain things that I would never do that a woman would do and I think that maybe it's because there is a difference in gender. I don't know why else, but I do think there is a definite difference that is specific for why they are the way they are. They just are.

...........

MRL

In the Reclamation *series, your current project, you've taken a bold step by introducing original, but damaged, artifacts into your work. What precipitated this move and what, presently, are your objectives for the series?*

.........

ML

For me, the idea of reclamation seemed to come at a time when found objects interested me more and more. I frequent thrift shops, antique shops, antique malls, and antique fairs. This habit of mine might be considered my way of attempting a social study of American culture, of other cultures, of this conglomerate of all sorts of things from different times and different places. Different worlds collide in these places, and that really interests me. Often in my cross-country travels, I find myself stopping at every antique mall across Route 40. I would see all these wonderful things, but I never knew how to use them in my own work. Even though I'm such a collector *(fig. 22)*, I was so sick of accumulating junk. So I decided that I would only buy things that I could somehow incorporate in my work. The baby carriages seem to me to be predecessors for this new idea, but they were still associated with the *New World* series.

Fig. 22 Detailed view of the artist's library and object collection with *Anthropomorphic Boy Form in Yellow Chair (New World Series)*, 1992. Photo: Jerry Stuart.

Among the new pieces in *Reclamation*, the one that's particularly fresh is the *Female Ohr Santo*, the little girl, that adolescent figurine that I found in an antique store in upstate New York. It's a wonderful wooden form. She's old, perhaps a Catholic figure of some kind, headless and armless. The image just plagued me! So I called the shop and had her sent to me. I felt that as an artist I could readjust the form. I wanted to reassess an image that was on its way out. As it

was, it was degraded, dismembered, and disfigured. I wanted to add to it, to reclaim its status as a valuable, meaningful symbol, but in a contemporary context. I did that in the *New World* series using stylistic quotations from George Ohr and appropriating the face jug motif from the American South.

I want to look at these forms anew and I want to think about them again. To do so will hopefully lead me into something else. That seems to be how all my series begin

and end. They each speak somehow to me. When the idea evolves to such a height, I know it has to move on to something more complicated.

MRL

In others, Yoruba Carolina (colorplate 69) *and* Baluba, Carolina (fig. 23), *you link the rich, little-known history of the face jug form with decapitated African figures by surmounting the wooden torsos with face jugs. How do these hybrids come together for you?*

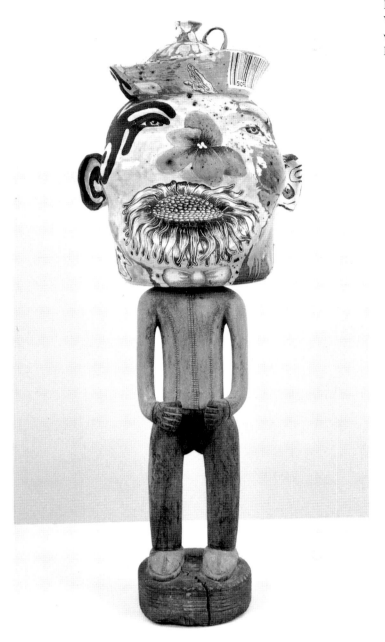

Fig. 23 Michael Lucero. *Baluba, Carolina (Reclamation Series),* 1995. Wheel-thrown and altered white earthenware with glazes and wood, 47 × 19 × 14 inches. Collection of Stephen and Pamela Hootkin. Photo: Jerry Stuart.

with other images from my culture, I decided I would sidestep the coloration of the clay, which as stoneware we'd normally think of as dark and dank. I just gave *Yoruba Carolina,* for example, a pink, fleshy face suggesting a racial switch or the turning of the tables. I did it because it just seemed like the right thing to do.

MRL

Do you see yourself being more interested in engaging artists outside of Western culture? You have worked more specifically with non-Western cultures and played non-Western concepts against Western ideas to examine those histories and their relationship to one another.

ML

I think because of the material I chose to focus on that there are inherent assumptions that come with the territory. I came out of California in the seventies. Japanese inspiration permeated much of the thinking and production of the time, with Bernard Leach and Shoji Hamada being such powerful influences on the academic ceramic world. That used to make me wonder what I could do. I don't have any connection, I don't really understand it, I don't have any feeling for it! So I often wondered, even back then, how could I make things that pertained to something I was more interested in or excited about? That's when I believe I was thinking subliminally about American Indian pottery. I never saw many people outside that

ML

I think it was instinctive. As I found these damaged African pieces, I became attracted to the fact that they were figurative, as was the adolescent santo figure. I had no idea that I would eventually use a face jug on it. I assumed I was going to add a George Ohr–derived form to it, thereby speaking of my love for Ohr's ceramics and my love for African sculpture. The result would be a clashing of those cultures in and through the information

presented. But it wasn't until I had that form in my studio and I began looking around at the old pieces I had never finished that I thought I could put that face jug on it and comment upon the origin of the ceramic form. I wanted to twist it all around. So it was just an ironic connection that was so obvious, but I didn't even know it. It was right in my face. That's when I decided that instead of doing the obvious, and painting the face jug as I had previously painted them, treating them

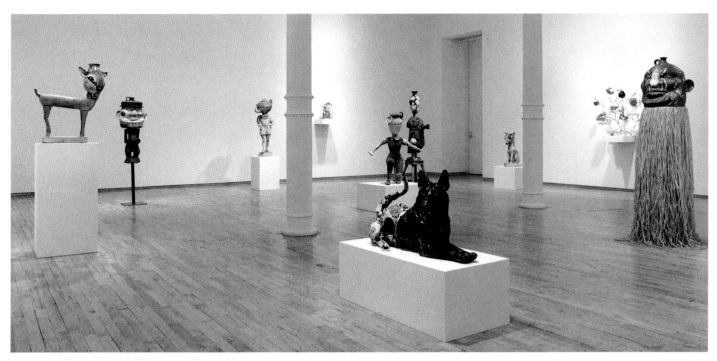

Fig. 24 Michael Lucero. *Reclamation Series*. Installation at David Beitzel Gallery, New York, May 4–June 17, 1995. Photo: Jerry Stuart.

culture using it as a reference point or as a point of inspiration that was obvious in the work. I always saw Japanese references. I saw a little pit-fired material, but not much, and it never made direct reference to American Indian ceramic traditions. It was a sacred place that no one wanted to violate. I look at it now and I think there is so much potential there that was never really actualized.

I was very interested in pre-Columbian art as symbolic forms I could connect with. But I want to speak a little about the idea of the flea markets and how they seem to me like some archaeological vault of information seen in social debris. Antiques dealers, in a way, have a less than important status in the field of cultural material, but I think of them as brilliant! They reclaim all these images and present them again to us for our picking and noticing, and it's all about our culture. It's all about our world that we live in. I

just love it and I think that it's so important. It's like going down into the museum and seeing all the shelves of images, but they do it in a different sense, it has a little commercial twist to it. It's more accessible and it's more available if you are inclined to see the importance of how it relates to you. I really just feel that that element has made my work a lot more knowledgeable. I'm not a scholar! But visually, I see the connection. It's very inspiring to me.

MRL

When I consider Pre-Columbus, New World, *and* Reclamation *together, I can't help linking them to your ancestry and to your background. I wonder if this project hasn't been a catharsis of sorts for you, an attempt to uncover some deeper meaning and to come closer to your own ancestral roots and to a fundamental expression of humanity and its dynamic richness?*

ML

I think that you're right. Historically and ancestrally there's a connection, but basically I'm an American. That is what I think separates my work from the colonial behavior often implicit in European art. When I went to Spain a few years ago, I loved the work I saw, but I felt that my aesthetic and the things that I would do were night-and-day different from anything that I saw there. I really felt like a crazy American.

MRL

I think what you're describing is a state of mind experienced by many if not all of us who struggle to make sense of our hybrid status as Americans.

ML

Yes, because I think America's a melting pot of all cultures *(fig. 24)*. I went to school with blacks and whites, Asians and Filipinos, and I never thought anything of it. To me that was the world and it still is!

FLOWERS AND SONGS THAT INTERTWINE

Lucy R. Lippard

At first glance, Michael Lucero's work is a vigorous example of contemporary ceramic sculpture with a background in 1960s California art and a foreground in New York eclecticism. However, the figurative forms of the recent work go back farther—to pre-Columbian Mesoamerica. The imagery that slides in and out of Lucero's complex glazes is art about art, art about place, art about self. It is an art of accumulation, even excess, echoing the information overload that characterizes our time. However, Lucero's layers are not simply pictorial. Like geological strata, they are laid down from various depths of the artist's experience and unconscious. His art is an important signpost along the way to a multicentered society.

From the Iberian peninsula to Mexico to New Mexico to the San Joaquin Valley, California, to the Northwest to New York and often back to northern New Mexico: this is the centuries-long trajectory of Lucero and his family, which encompasses a singular chunk of this country's history and is reflected in his art. Such long-timed, long-distanced journeys and returns map our lives more often than we realize. In Lucero's case the history of clay art is introduced as a parallel for geological and human history.

He chose clay because he could both sculpt and paint it, make one thing and then transform it into many images. However, it has long been popular wisdom in the art world that West Coast ceramic sculpture is validated as art while East Coast work remains a "craft." For years, clay art from California, but not from New York, used to make it into Whitney *Annuals/Biennials*. Aware of these biases, and preferring the *idea* of clay to its utilitarian implications, until recently Lucero was never interested in making the vessels for which clay is historically known. It is the material itself that draws him.

Clay is "an image of the earth, made from part of the earth," he says. "Clay has to be respected . . . clay is, in essence, what the pieces ultimately are." Lucero works with clay and metal—both born of the earth itself, material microcosms of the landscapes that sometimes adorn his surfaces. But clay is his real love. Despite early misgivings about its art-historical significance, he returned to it after two years of working in bronze with renewed commitment and a greater understanding of why he had been carrying the torch. Now, "back down in the belly of ceramics," he is back to making things by hand, *hecho a mano*. In his respect for clay as a metaphor and for the rituals involved in its manipulation, he approaches the reverence of the Pueblo potters who created the first pots he noticed as a child. This revived appreciation of the possibilities of clay, which many ceramists take for granted, losing touch with its unique materiality, sparked the *Pre-Columbus* and *New World* series. They also provided the site for Lucero's negotiation with his Hispanic and recently uncovered Sephardic backgrounds.

After a decade of talk about constructed identity politics in the art world, we have a certain access to work as complex as Lucero's. It is not, of course, just about identity, any more than is most of the art discussed in those terms. But the cultural layers that have produced it fuel the intercultural discourse, even as true identity—a cumulative personal process—always remains hidden. "Even though the [pre-Columbian] images represent a specific time and culture and place and history," Lucero says, "I can use them and think about them and load them with content. And the fact that they are related to me and my history and my family and my past excites me and also makes me excavate my own history" *(fig. 1)*.

As a child Lucero often made summer visits to his mother's parents, the Tapia family, in Las Vegas, New Mexico. They owned a general store and were not poor, but he recalls that the adobe house where they once lived in the country, with muslin tacked across the ceiling (to disguise the old-fashioned *vigas*, or wooden beams), had a "different feeling" from his modern California home. He played in the arroyo and found Indian beads, but was more interested in the horned toads and anthills. He was "infatuated" by animals, insects, reptiles, and amphibians —the creatures that still surface in/on his work. Hiking with his father to his now-abandoned childhood village

Fig. 1 Mexican. *Man and Woman, Seated Pair*, Classic type, Tarascan. Red earthenware, 8½ × 5⅝ × 6½ inches. The Seattle Art Museum, Eugene Fuller Memorial Collection. 58.25.1–.2

in the Sangre de Cristo Mountains, he saw herds of antelope. The burnt remains of his grandmother Lita's house were nearby, and he poked around in the ruins and found a huge pueblo pot, orange and black and white, which his family took home with them and he took to school for show-and-tell. "It was an incredible pot," he says. "It was perfectly innocent."

The fact that it was made by Indians made it all the more compelling in the context of American fascination with all things stereotypically Indian. (Lucero was also much taken with the huge advertisements for Indian arts along the highway as they drove from California; a large papier-mâché jackrabbit on which children could ride and be photographed is a particularly treasured memory *[fig. 2].*) Lucero now acknowledges the impression Native pottery made on him, more so than the traditional Hispanic arts (tin, raffia, and woodwork being more prominent today than pottery) that he must also have seen in New Mexico.

The connection with his family's history clearly enriches Lucero's work, although he tends to take a "no big deal" kind of attitude toward it. His parents and grandparents spoke both Spanish and English in the home, but he seems to have been blissfully unaware of cultural differences while growing up. The family was Catholic and the artist, although he believes in a God, is a recovering Catholic ("it's like an archaic mentality"), still indebted to the "wonderful symbols and images"

that he was raised with. Recently he found out that there was a centuries-old Jewish strain in both sides of his family. Lucero sees similarities between Judaism and Catholicism; again, no big deal.

Since most Mexicans and original New Mexicans are descendants of indigenous peoples (in New Mexico the settlers intermarried with Apaches, Pueblos, and others, even as they clung and still cling to their "Spanish" identity for status), Lucero could carry in his veins the blood of three or four major components of American society: Jewish, Spanish (which can incorporate African blood through the long Moorish occupation), and Native American. His sculptures integrate all of these influences, consciously and perhaps unconsciously as well.

It is only recently that the Sephardic ancestry of many Hispanic people in New Mexico has been revealed and explored. The so-called crypto-Jews were people who fled Spain for New Spain in 1492, when the Inquisition decreed that Jews must convert (become *conversos)* or face exile, imprisonment, torture, and death, not to mention the loss of all their property and material goods. Portuguese Jews were expelled in 1497. (In the New World the word Portuguese was often synonymous with Jewish.) Despite detailed official investigations of all colonists and settlers, many crypto-Jews immigrated successfully, especially to Nuevo León, in northern Mexico, where Jewish *conquistador* Luis de Carvajal was governor. The Inquisition followed. By the late 1500s, when the *conquis-*

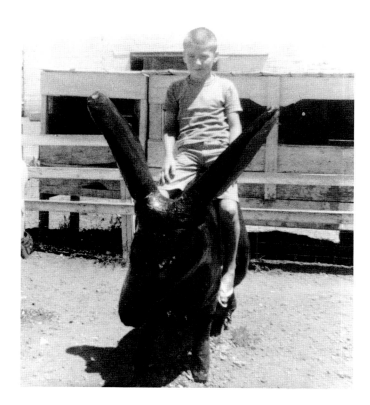

tadores and then settlers began to move north, it was expedient for Jews to be in the vanguard. Castano de Sosa, lieutenant governor of Nuevo León, led an illegal expedition to New Mexico in 1589, but the Spanish Crown forbade it, specifically selecting Gentiles to lead the invasion. It was illegal for Jews to receive land grants, although it appears that they sometimes succeeded in bypassing the laws. These "Judaizers," or public "New Christians," who privately continued the practice of their own ancient religion in an increasingly diluted form, were called colloquially *marranos*, or pigs. There was some persecution in the 1580s and 1590s, and again in the 1640s; then it subsided as the Church and the Inquisition lost their power in the early eighteenth century.

Already intermarried with both indigenous peoples and Spanish Catholics, in New Mexico the crypto-Jews continued to assimilate and continued to practice the remnants of their faith. Elements of Jewish culture found their way into the unique Penitente religion, itself a hybrid, that evolved when even the Catholic Church abandoned these isolated "barbarians." (I am told that some of the music performed in the *moradas* for the Tenebrios ceremony during Holy Week resembles Hebraic chants.) Later generations had little understanding of the substance of inherited rituals. One family might light candles on Friday night, another might not eat pork; children played with *dreidels* at Christmas/Hanukkah; women said prayers in Ladino (Judeo-

Spanish). According to Reverend Symeon Carmona, a Russian Orthodox priest of Jewish ancestry, there are as many as fifteen hundred families in New Mexico who have kept the secret of their Jewish origins. Only in the early 1970s, at a time when "minorities" all over the U.S. were rejecting the melting pot and reconsidering their own roots and New Mexico's closed village societies were opening up to the larger world, did many apparent Catholics in New Mexico begin to realize and accept their Jewish background, often instigated by increasing contact with Anglo Jews. The result has been true identity crisis for those with long cultural ties to the Hispanic community. In his history of Jews in New Mexico, Henry Tobias quotes an anonymous Chicana who feared ostracism and retribution: "All of a sudden you're not Hispanic any more. Suddenly you're Sephardic. And you don't 'belong' any more."[1]

It is a curious history, finally—comprised of both colonized and colonizers. The Jews expelled from their Spanish homelands ironically found themselves invading another homeland, victims made conquerors. Perhaps because of his multiple origins, Lucero expresses no political bitterness about Columbus's "discovery," "encounter," or "invasion" of the Americas, perceiving that event as a multicultural bonanza rather than as a portent of genocide. However, *Big Feet*—prehensile, one blood red, one prophetically inscribed with the bar codes of a consumer society juxtaposed with fragments of a woman's (Sonia Delaunay's) art, and encroached upon by a sly turtle—benignly suggests the ongoing conflicts of nature and culture, greed and progress, that followed in Columbus's big footsteps.

And indeed, on the brighter side of pre/post-Columbian analysis, reciprocity—a philosophical and religious tenet in many indigenous societies—is the most productive way of looking at the history of encounter. Ideas and symbols were exchanged as well as subsistence techniques. Disregarding the blood that fertilized it, the ancient Nahuatl poet Tecayehuatzin saw indigenous intercultural contact as "flowers and songs that intertwine." These ideas are loosely applicable to today's self-conscious adoption of "multiculturalism."

Lucero's sculptures also reflect the hermetic quality of this history. The significance of undertones, transparencies, glimpses, hints, and clues can be read back into the five-hundred-year-old past. (Ursula Ilse-Neuman has

remarked on his translation of mythic images into "stroboscopic flashes reflecting the impatience of our contemporary culture."[2]) He is interested in the "illusionism" in pre-Columbian art, the ways slips and glazes are used in relation to underlying forms, to the arms in particular, and the resultant plays of two- and three-dimensionality. Curiously, he realized he had already had these ideas: "Spooky.... It was like maybe I really do have a connection to these, more than I think. So that was exciting. It was this unconscious attraction.... There's this love, but you're awkward.... Familiar but not completely.... Maybe it's my own way of just going through that history intuitively."

Because Lucero wants to make his work as personal as possible, this kind of seeing through history to the past, to the "essence" (now forbidden by postmodern theory), is compatible. The imagery that he has selected from the pre-Columbian is relatively random, not specifically rooted in any particular culture *(fig. 3)*. He goes to museums and looks at books and then his attractions are absorbed into his art in the studio. He seems to have chosen these figures as the ground in which to plant his own content, perhaps a metaphor for the way history

Fig. 3 Remojades culture, Veracruz, ancient American. *Seated Figure*, A.D. 200–500. Terra cotta; black resin, 13⅜ × 11⅜ × 10½ inches. The Seattle Art Museum, Gift of Katherine White and the Boeing Company. 81.17.1376. Photo: Paul Macapia.

is the ground in which the present is nourished. He is also aware of the possibility of a dimly inherited recall of things shared with the makers of those striking and highly sophisticated ancient works.

Or perhaps it is nothing so arcane, but simply the fact that during the 1970s (following the political reclamation of many cultures in the 1960s), the art world rediscovered yet again so-called primitivism. Living in California, Lucero must have been exposed to the Chicano revival of the mestizo heritage that was prevalent in Latino art, murals, and theater, as well as in the political movement. (He was in high school in the early 1970s.) But it was not only Mexican Americans who were made aware of the power of pre-Columbian art. Simultaneously (and the politics of this exchange were rarely acknowledged at the time), Anglo artists all over the U.S. became aesthetic wannabes, mining archaeological sources in both objects and site works. This longing for spiritual or sensuous connections with a "Nature" not provided in a military/postindustrial society was in a sense the soft by-product of the hard revolutionary impetus of the late 1960s and early 1970s, although many artists on the neoprimitive track probably paid little attention to their political antecedents, if they were even aware of them. "Neoprimitivism" was an "art movement" above all, inspired in part by the feminist movement's searches for female history among "pagan" religions.

Lucero had realized that he felt little affinity with either the Minimalism that dominated the New York scene or Northwest Coast Japanese-inspired ceramics (Leach, Hamada, et al.). The artist who offered a highly original and decidedly "American" model was "the mad potter" of Biloxi, Mississippi—George Ohr, who boasted around the turn of the century that he made "disfigured pottery." In the 1970s his work was posthumously rediscovered in all its inventive glory. Lucero now has a collection of Ohr's small pots. Although they bear little direct resemblance to his own work (except for the occasional "ruffle" and the sinuous, tendril-like handles that correspond to some of the *Pre-Columbus* figures' arms), it is not difficult to understand their fundamental importance to him. Ohr's brilliantly crinkled, crumpled, blotched, and asymmetrical forms give potters permission to be sculptors. The ways his pots broke out of Western convention offered formal revelations that paralleled those of "other" cultures.

When Lucero went to Spain he loved the art (especially Joan Miró's and that of a country potter who worked with him), but felt like an American: "I think

my work is a real mutant." At the same time, he does not want to be "lumped in with Mexican American artists," even though he is belatedly becoming aware of the aesthetic contributions of Latin American artists—"a different kind of hands-on approach." There is a bias in the art world against those who are not "artists first," idiotic as this either/or imposition is. (Those who think they are artists "first" and people with lived experiences "second" are denying the fact that artists are inseparable from their lives, which inescapably affect every aspect of their arts even when they are not visibly reflected in them.) Ignoring the social and aesthetic confusion, or ambivalence, produced by one's cultural background and medium is one way of dealing with this issue. With the *Pre-Columbus* series, Lucero began to confront the huge question of intercultural influences. He feels, for instance, that his propensity for bright yellows and reds may be somehow genetically inspired by his Mexican background and its unrepressed celebration of color.

His intercultural influences are not only Meso-american (Spanish and indigenous) but African and African American (the bottle tree and face jugs) as well. "I always identified with African art, I always identify with American Indian art," he says, but he is wary of "too much knowledge" about any culture that might inhibit him from borrowing from it. He is convinced that Picasso's use of African art was not merely formal, but also spiritual: "I think that the initial attraction is a spiritual attraction, and therefore you depict these shapes in your artwork and you love it so much that you keep doing it. . . . Through African art I wanted to cut out all the academics and go right towards the . . . spiritual thing." But the spiritual thing is not necessarily a personal thing, and Lucero does not want to have to answer for his personal connections to the imagery, or lack thereof. For instance, the frog, an emblematic child-hood obsession, is a symbol of lust in the Catholic Church (and is an ancient symbol of the uterus in some other cultures). On a recent piece a girl baby is invaded by a leaping frog painted on it. Lucero doesn't know what he meant by it. (Maybe the tentacles of original sin reaching out from his parochial education?)

In the early 1970s Lucero bypassed the Chicano movement but was waylaid by the women's movement. He says he learned a lot in art school from women artists and fellow students in the Bay Area who were discussing Judy Chicago and feminist art. He found himself "adapting the feminist arguments" to his own "little weirdness" and identifying with the bricolage process, concepts of "alter-

native crafts," and connections to everyday life emphasized by feminists. The demystification of macho art was appealing, as was the "tedious process-based labor" that so many women artists were exploring. He felt he could identify with compulsive activities like embroidery and quilting: "I thought, it's not just for women, I can do it too." Later, when he was first in New York and had no access to clay facilities, he made wooden pieces from such found materials as crates from Chinatown, perhaps a throwback to boyhood finds as well as a nod to feminist art. He also worked as an assistant to the eminently independent sculptor Louise Bourgeois, who had made stacked wooden pieces and whose work has other affinities with his.

By the late 1970s, Lucero was making figures that seem to have clear sources in Mexican arts *(Untitled [Hanging Ram]*, 1976, and *Untitled [Devil]*, 1977; *colorplates 1 and 2)* and Native American arts *(Untitled [Lizard Slayer]* and *Untitled [In Honor of the S.W.]*, 1980; *colorplates 4 and 3)*. The hanging ram (a familiar sight in Hispanic communities where mutton is often publicly butchered for domestic and communal use) has gold horns, gold hands for front legs, and cloven gold high-heeled boots for rear legs. His hide is made of ceramic leaves, so he becomes not only food, but a symbol of natural bounty, a ceremonial presence, a sacrifice incorporating the limbs of his sacrificers. *Untitled (Devil)*, another hybrid, is also garbed in ceramic leaves, one foot cloven, the other human, one hand a pink pitchfork, the other human. The corkscrew, snakelike arms are those still found on the recent *New World* series. The devil's head recalls Guerrero masks from Mexico, while the petal-like coverings are reminiscent of the garments of Jaina figures from the classic Maya period.

The stick figures of *Untitled (Lizard Slayer)* and *Untitled (In Honor of the S.W.)* both appear to derive, though not literally, from Native American petroglyphs, or rock art, the latter's triangular body in particular. Both pieces are, however, deliberately transtemporal and cultural. Both have Greek pots or vases for heads *(fig. 4)*. The latter is "hairy" (fine wires protrude from the body), suggesting an animal component, and the former is connected to nature through the leafy birchwood staff it holds. (Having delivered myself of this cross-cultural rhapsody, I have to say that Lucero himself was bemused, or amused, by it. His main visual source was not the New World, but Greek art; the devil was one of a series of biblical pieces; and the triangular body of *Untitled (Lizard Slayer)* [the figure is based on the classical sculpture of

Fig. 4 Etruscan, classical. *Oinochoe, Wine Pitcher,* 5th century B.C. Bronze, 10½ × 20½ inches. The Seattle Art Museum, Norman and Amelia Davis Classic Collection. 62.156. Photo: Susan Dirk.

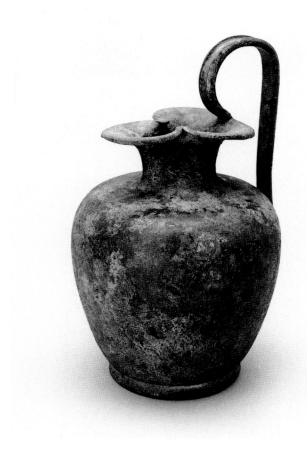

that name] was simply a formal reduction to a primal shape. Such are the pleasures and dangers of interpretative criticism.)

By 1982 Lucero's static anthropomorphs had come to life. *Untitled (Snow-Capped Mountains) (colorplate 5)* is curvilinear, open-centered, still petal-covered (the shards were handmade, not smashed pots), but dancing in space. It holds its masked head in one hand, replaced on the neck by a cubistic landscape. The theme of interconnection with nature continues, but without any direct cultural references. Scale (and its implication of sculptural ambition) was a major issue in this group of twelve-foot-high stick figures hanging free in space. They were fired in pieces because kilns weren't large enough, and can be seen as studies in the relationship of part to whole. Clay was the whole vessel, as well as the bones. "I had all the little shards, like Humpty Dumpty being put back together," says Lucero, perhaps unconsciously putting his own hybrid parts together, as well as making an archaeological reference to cultural reconstruction.

Around the same time (1983), Lucero made his first totems. One is a stack of seven "heads" (the classic anatomically correct proportion) beginning on the ground with the most abstract form, which resembles a stone, the primal creation. A staff dangling from the second head from the top partially transforms it into a shoulder and the totem into a lopsided figure. The totems literally "stand for" the human, reaching toward heavens or other worlds. These works were consciously, if nonspecifically, cross-cultural, referring to Northwest Indian art and African art, among others *(figs. 5 and 6).* Lucero also saw them as "vertical landscapes, like earth's striations crushed." The later totems were encrusted, archaeological, as though unearthed (the Jungian metaphor for seeking the unconscious). One totem, *Spirit,* has a heart and a brain: "I wanted to make a sculpture with a heart and soul" *(colorplate 26).*

The *Dreamer* series of 1985 has less overtly cross-cultural references, but these are still evoked because of the importance of dreams as prophecy and omen. Other writers have mentioned the resemblance to Constantin Brancusi's *Sleeping Muse;* Lucero has stated unequivocally that "Brancusi was always my hero" (though a curiously "pure" one for this artist of color and texture). I was reminded of the massive sleeping/dreaming goddesses in Maltese temples. Lucero's dreamers (heads on their sides) and his daydreamers (heads upright) externalize the content of their visions. The head is not only a vessel for the conscious and unconscious, but also becomes both projector and screen, where outside and inside worlds meet; so do nature and culture. In *Pink Nude Dreamer,* the encounter "takes place" in wild and domestic landscapes, the latter rendered in "woodcut" style and dominated by a large turtle, suggesting the "Turtle Island" concept of the earth held by the Iroquois nations, among others *(colorplates 7 and 8).* The folds of the earth on the "wild side" are sensuously body-evocative and recall New Mexican topography. *Northwest Dreamer* has on one side an eerie night landscape dominated by a raven-topped totem pole, while the other side depicts a snakelike plant, rocks, and molten sea. The predominant image in this series is geological, with writhing, textured rocks and hills suggesting untamed forces—both natural and cerebral.

That same year Lucero did an installation, *Earth Images,* at the Linda Farris Gallery in Seattle, which was more biological in character. In 1985 and 1986 he cross-fertilized reptiles, fish, insects, opening up the relatively natural-

Fig. 6 Native American, Tlingit. *Shaman Figure*, c. 1880. Yellow cedar, red and black painted, carved, 12¼ × 3 × 3¼ inches. The Seattle Art Museum, Gift of John H. Hauberg. 83.235. Photo: Paul Macapia.

istic three-dimensional forms through two-dimensional images of skies, lakes, mountains, and other species. Frog, cameleon, Hercules beetle, and pike perch become symbols of the biological community and the environments that support them. Here again, one can read into these pieces a reflection of ancient and indigenous belief systems about the interconnectedness of everything.

As though going on a vision quest himself, depriving himself of light and color, Lucero then worked for two years in metal and bronze. This is his most abstract work to date, and while the totem form persists, the obvious references seem more likely to be Western modernists (Julio González, Alberto Giacometti, David Smith, David Hare) than cross-cultural sources. The exception is a fusion of Giacomettiesque elongation and Mexican *cala-*

veras (skeletons). The white-painted skeletal *Spirit*, 1988, although topped by a sort of sports trophy figure rather than a skull, rides a red-wheeled cart that refers directly to the Mexican vernacular death carts, in themselves syncretic objects *(colorplate 26) (fig. 7)*.

Around 1989, Lucero returned to clay: "It's taken twenty years for me to feel confident enough as an artist to come back around to make sculpture with pots, which I could never have done back then . . . it makes more sense for me now." He returned via the disembodied heart, which has a hybrid history eloquently related by Olivier Debroise.[3] The Sacred Heart of Jesus first appeared as a separate entity in ecstatic visions to several geographically separate cloistered nuns between the end of the eleventh and the mid-fourteenth centuries.

Fig. 7 José Inez Herrera (active 1890–1910). *Death Cart*, El Rito, New Mexico, late 19th century. Gessoed and polychromed cottonwood root, pine, metal, rawhide, horse and dog hair, 30½ × 25 inches. Denver Art Museum, Anne Evans Collection. 1948.22. Photo: Lloyd Rule.

Originally the Church was not enthused, wary, I suspect, of the female sources of these "fantasies of absorption and consumption, of rejection and surrender, this path from the repugnant to the ecstatic and all that this implies at the level of human emotion." It was primarily a southern and Catholic, later baroque, phenomenon; in northern countries the heart was an abstract emblem. Yet for both, as Debroise points out, the heart is at once "container and content.... The exposed heart signifies the exteriorization of the interior," a visceral image of the spiritual.

In the western hemisphere, the Catholic heart was superimposed upon the Aztec use of the heart, which also connoted "redemption, self-sacrifice, and interchange with the deity" *(fig. 8)*. It has become a prime syncretic image of mestizo culture (itself pure syncretism), rivaled only by the conflation of Coatlicue/Tonantzin/the Virgin of Guadalupe, also ubiquitous in contemporary Mexican and Chicano art. For Debroise, the heart is a universal symbol—"the heart which loves and suffers,

which bleeds and dies and is revived, which contains all and gives all back to us as well."

Lucero himself has called the heart "a beautiful vessel," but his use of the organ is far less loaded, although, having been raised Catholic, he can hardly be ignorant of its meaning. His hearts evoke no religious references. They seem to refer less to individual humanity than to a universal nature. They are (nonsurgically) opened to display not only blood red orifices but the refuges, the origins of dreams, of self in place, and place in self. The hearts evolved directly from the bronze work, and from *Spirit* (1988), which included a heart and a brain, or "heart and soul." The veins, or gates, necessary to bronze casting, through which the molten metal flows, were the inspiration—a way to "entwine the content and the process," which is also the basis of Lucero's work with clay. The deer in *Big Heart (Deer)* is only a word slipping between giant tree trunks, but the word is as potent a symbol in our society as the image (and the heart) of the deer has been in others *(colorplates 32 and 33)*. Lucero says about the heart series: "I'm speaking about the Earth. These pieces are completely about our world and our earth."

Fig. 8 Mexican (Nayarit). *Seated Male Figure with Bloodletting Implements*, 100 B.C.–A.D. 250. Red-slipped earthenware with polychrome paint, 16 × 10 inches. Mint Museum of Art, Charlotte, North Carolina. Gift of Dr. and Mrs. Francis Robicsek. 85.102.11. Photo: David Ramsey.

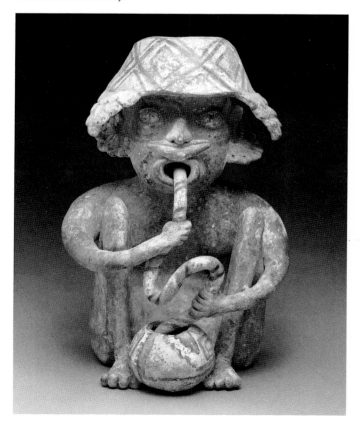

Recognizing that smaller works don't invade space but can carry as large a burden of meaning as big pieces, Lucero made the *Pre-Columbus* and *New World* series on a more intimate scale. This decision can be seen as part of the newfound confidence in his own directions. He observed that his pre-Columbian sources were "almost like a doll or baby and they didn't need to be any bigger. Maybe they weren't intended as sculpture, but as fetishes or something" *(fig. 9)*. Archaeologists have few interpretations for the infantile (sometimes fetal) features of some pre-Columbian figures. Fertility and reincarnation are possibilities. Lucero has taken the idea and pushed it (in strollers) into the twentieth century. His "anthropomorphic infants" are "composite vessels"—presumably containers ready to be filled by life or social constructions—riding their found vehicles into the future. Like their *New World* parents, they are writhing with life forms that connect them to their origins. *Lady with Roots*, possibly a reference to the famous Frida Kahlo painting, for instance, has two ethnically different heads for breasts (culture as nurture?) and holds two more pot heads, one screaming like the ancient Mexican Xipe Totec figures or Siqueiros's revolutionary newborn *(colorplates 57 and 58)*. *Young Lady with Ohr Hair* also has kids as breasts, one in a baseball cap, and a white hand (the dreaded *mano blanco?*; a reference to rock art or colonial rape?) over her crotch *(colorplates 45 and 46)*.

Lady with Two Curls* is a particularly complex piece *(colorplates 39 and 40)*. The "curls" resemble the Hopi squash-blossom hairdo (worn by unmarried girls). She holds an ancient black-and-white Pueblo pot; half her face is a pre-Columbian face and the other (perhaps) a nineteenth-century colonial landscape. On the back of her head is yet another face, as well as a European teapot, dripping paint, and another landscape. Not only is she bar-coded, but a plaque on her arm announces naively that she is "made by Michael Lucero in Santa Fe N.M." This is a typical amalgam of cultures and puns and art references. Lucero dips into many different indigenous styles and cultures in this series. The boneless and/or elongated arms are found in Mexican Nayarit works, among others; the dogs are from Colima; the big heads and short stubby legs span thousands of years all over Latin America *(fig. 10)*. Nazca ceramics are often covered with painted images; several different mythical animals might merge on a chieftain's mantle as densely populated as Lucero's clay bodies. One can find resemblances in Moche masks, in pottery from Santorem, Huaxtec, Mixtec, Aztec, Maya, Olmec, Chimu cultures, and so

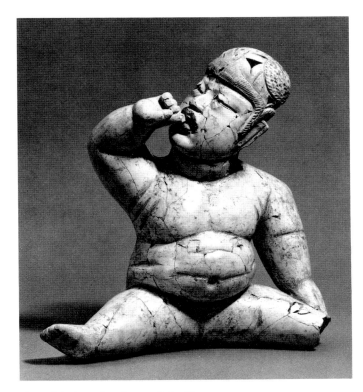

Fig. 9 Mexican, Las Bocas. *Baby Figure*, 1000 B.C.–A.D. 300. Ceramic, 13⅜ inches. The Metropolitan Museum of Art, The Michael C. Rockefeller Memorial Collection, Bequest of Nelson A. Rockefeller, 1979. (1979.206.1134.)

Fig. 10 Mexican (Colima). *Dog Effigy*, 100 B.C.–A.D. 250. Red-slipped pottery, 8⅜ × 10 inches. Mint Museum of Art, Charlotte, North Carolina. Gift of Dr. and Mrs. Francis Robicsek. 86.75.112. Photo: David Ramsey.

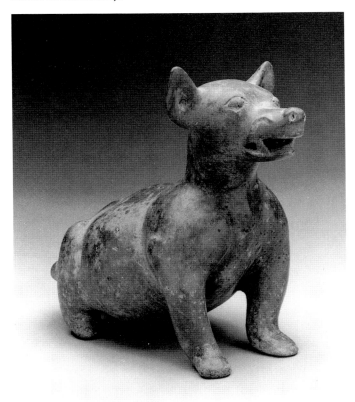

forth *(fig. 11)*. Lucero prefers that these references be "recognizable" but not too specifically traceable to one culture: "They belong to a particular area and time. I began to get a little worried with what they would suggest without me knowing, they're so powerful. . . . They are timeless, representing ancient history, but are futuristic looking and almost alien looking."

The *New World* series maintains the same sources, but Lucero sees them as "more mechanical" than the *Pre-Columbus* group, referring to a modern world obsessed with machines and gadgetry. Their execution reflects this change in focus. Where the *Pre-Columbus* series was hand-made, the *New World* series displays the ridges of its making on potters' wheels. Like the pre-Columbians, but also like the Dadaists and Surrealists, Lucero endows his images with multiple meanings: a moth, a beetle, a violin's scroll, or a dog's nose for a penis; a mouth or a flower or a bug for a woman's sex. (The *Fourteen-Year-Old Girl in Eames Chair* seems to be pregnant, and could

be a parody of Balthus's nymphets.) Sometimes the visual puns are pretty broad, like the lady with literally beehive hair.

Disembodied eyes (a Surrealist favorite) are everywhere. Lucero's eye totem might be a takeoff on Marcel Duchamp's ready-made bottle rack and the Dada rejection of "retinal art," while his two *Eye Ohr Teapots* might resurrect it *(colorplate 64)*. A metal tree *is* a bottle rack, but with the bottles, upside down and transformed by winged insects, commenting on the "useless vessel" explored by Ken Price and offering a bridge between "high" and "low" art (a can of worms I won't open here). Lucero discovered that once bottles are turned upside down, they "hover and become weightless in a conceptual and spiritual way." Here it is tempting to think he is familiar with Robert Farris Thompson's *Flash of the Spirit*, which traces Southern bottle trees back to African cultures. (Bottle trees are not limited to African Americans; there is a lovely Hispanic one bristling with blue bottles on the main street of La Jara, in southern Colorado.)

All the animals, insects, reptiles, landscapes, flowers, and plants that clothe the figures from a past that was closer to "nature," suggest a unified cosmology translated

Fig. 11 Mexican (El Chanal/Colima). *Tubular "Incensario" Stand with "Tlaloc" Face*, A.D. 900–1200. Buff pottery, 23½ × 14 inches. Mint Museum of Art, Charlotte, North Carolina. Gift of Dr. and Mrs. Francis Robicsek. 81.107.9. Photo: David Ramsey.

Fig. 12 Mimbres. *Dancing Manbear Pot*, Swarts Ranch. Style III, classic black-on-white, 3½ × 9 inches. Peabody Museum, Harvard University. Copyright © President and Fellows of Harvard College. All rights reserved. Photo: Hillel Burger, 1982. Photo no. N30446.N30446.

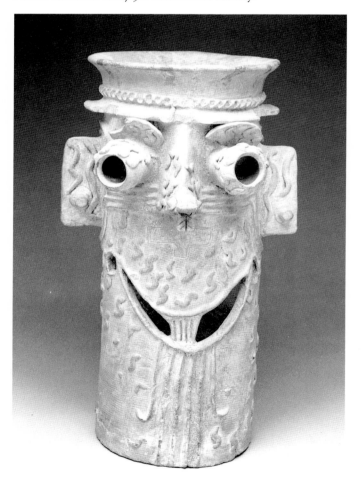

into the hot flashes of an aging Western society. The stunning classic Mimbres painters (probably women; c. A.D. 1000–1150) have been mentioned in regard to Lucero's work, although the influence of their geometric figures and "abstractions" painted on the inside surfaces of shallow bowls, usually found in the context of burials, ritually broken, or "killed," seems pretty distant *(fig. 12)*. However, like Lucero's, many Mimbres figures, for all their apparent naturalism, are fantastic hybrids—a catfish with human legs, a masked coyote/reptile, insects inside rabbit heads. Their meanings appear to be overlapping, neither this nor that but both. "Visual puns are the heart and soul of Mimbres paintings," writes J. J. Brody,[4] and their ambiguities make them fine-arts fodder in the twentieth century.

Complex cross-class, cross-cultural visual puns are the core of Lucero's newest work, which constitutes a rescue mission epitomizing a syncretic approach. Broken garden statuary and dismembered antique sculpture are "kept alive" by Lucerian prostheses. For instance, a large cement dog naturally embellished with a mossy green patina awaits a ceramic muzzle, and two cement *conquistadores*, one of whom will have a yellow glass dish for a ruff, will find themselves pot heads. The ironies of incorporating these efforts at elegance into the pretentions of "high art," which can in turn mock both them and itself through deliberate incongruity, offer a new angle on the hybrid image.

A different aura pervades those works that alter found objects that have been the sites of more than superficially social content: a handsome, headless old African (and Picassoid) woodcarving of a female figure awaits a new clay head; a lovely weathered and decapitated *santo* figure (perhaps from the Philippines), with short "skirt" and "knee socks" suggesting an adolescent girl, has been re-headed and armed with a great round cadmium red head and metal side curls that suggest both Hopi and George

Ohr. Here the appropriation is more loaded, and Lucero will have to deal with more baggage, since both of these pieces have pasts as sacred objects. Though he found them, uprooted, in antique stores, he might be accused of desecrating the original artists' intentions. On the other hand, it seems more sensible to praise him for reclamation with respect. Either way, the original culture will inevitably have a stronger voice in its transformation than it did in the *Pre-Columbus* series. It is a measure of Lucero's sculptural confidence that he is willing to collaborate with these ghosts.

When images and ideas from one culture are transported into another, they are inevitably changed, especially when the original meanings are inaccessible. What they come to mean is what we want them to mean (although "we" may disagree). Aware of this unavoidable intellectual colonization, the confusion in the fusion, Lucero is concerned "to make something that recycles back, that flips the symbol." He is not so much paying homage to the past as acknowledging its power over him. The hectic field of disjunctive images with which he has sprayed the surfaces of his placid figures is nothing like the densely balanced patterns of his sources. Based in no specific cultural vision, but committed to clay itself, his sculpture is cut loose into the visual blitzkrieg of the contemporary art world.

NOTES

1. Henry J. Tobias, *A History of Jews in New Mexico*, p. 195.

2. Ursula Ilse-Neuman, "Michael Lucero," in *Explorations: The Aesthetic of Excess* (New York: American Craft Museum, 1990), p. 27.

3. Olivier Debroise in *El Corazon Sangrante/The Bleeding Heart*, pp. 13–61.

4. J. J. Brody, in Townsend, *Ancient Americas*, p. 97.

MINING FOR MEANING:
SUBVERSIVE IMPROVISATION AND RESONANT EMPATHY IN THE WORK OF MICHAEL LUCERO

Barbara J. Bloemink

Reality is no longer a given, a natural, familiar environment. The self,
cut loose from its attachments, must discover meaning where it may.[1]

The highly seductive surfaces and variety of forms of Michael Lucero's work can blind viewers to its underlying intelligence. Only through an overview of the last twenty years of his production can one get a sense of the wide range and prescience of his investigations. While most artists in our culture leapfrog forward, attempting to break through past innovation and achieve their own voice, since the 1970s Lucero has consciously moved backwards and sideways through the history of art, all the while maintaining a constant dialogue with traditional attempts to categorize not just the creative act, but artists' media and methods of working.

This ever-present subversive anarchy has as its closest antecedent the original underpinnings of Dada and Surrealism. "Dada's only programme, was to have no programme . . . and, at that moment in history it was just this that gave the movement its explosive power to unfold *in all directions*, free of aesthetic or social constraints. This absolute freedom from preconceptions was something quite new in the history of art."[2] Members of the Dadaist movement went on in the early 1920s to create Surrealism in their quest for a new world view. The three core elements of Dada and Surrealism, established in the early decades of this century by such figures as André Breton and Georges Bataille, are echoed in an updated manner in the work of Lucero.

The first of these elements involved the Dadaist and Surrealist rejection of the notion of stylistic unity and evolutionary aesthetics. They refused to idealize humans over other forms of life and, like Lucero, consciously set about undermining the authority of Western thought and values by privileging difference, disjunction, multiplicity, rupture, diversity, and incongruity. Briony Fer has characterized Surrealism as "a shifting terrain of represen-tation that constantly uses difference to generate meaning," a definition that is equally valid when applied to Lucero's work.[3]

Second, the Surrealists suspended boundaries between traditional forms of consciousness and linear time. Like Lucero, their eclectic intellectual explorations, interests, and influences validate not only the history of the visual arts but also that of anthropology, psychology, philosophy, and past and future politics. The Surrealist view of cultural history emulates historical sedimentation, in which different cultures coexist, each laden with its respective cultural myths, oral narrative, and ideas about magic, superstition, religion, education, and rationalism. In his first *Manifesto of Surrealism,* Breton declared the future goal of the arts to be the "resolution of these two states—outwardly so contradictory—which are dream and reality, into a sort of absolute reality, a surreality."[4]

Third, the Dadaists and Surrealists, like Lucero, accepted the universal need for myth-making and "correspondence" and celebrated the power of unexpected syntheses and juxtapositions to evoke new images, associations, and emotions reflecting the lost paradise of the *surréel.*[5] Dada founder Tristan Tzara, drawn to tribal cultural arts as examples of human creativity in its purest form, felt they reflected the integral relationship of all things in nature and the associative power of forms to suggest other images, emotions, or ideas based on the principle of "universal correspondences." For the original Surrealists, as for Lucero, "Simultaneity is the restless product of a long history of miscegenation, assimilation, and syncretism *as well as* of conflict, contradiction, and cultural violence." Visually this simultaneity was mani-fested through the juxtaposing or collaging of disassoci-ated images which in turn pose difficult philosophical

questions of meaning and relationships and underscore the problem of realizing new forms of identity as part of the creative process.

From the beginning, in 1979, Lucero signaled his refusal to conform to or be classified within traditional hierarchies of artists' materials by deciding to work in clay. Lucero's definition of "fine art" was not limited to paint and canvas, stone, metal, or wood. Instead, as is the case in many non-Anglo cultures, for Lucero the concept of fine art equally defines archaeology, including ceramic-based vessels and figural forms. While working in the Bay Area, Lucero realized, "I don't have to weld or chisel wood or carve stone to be able to make sculpture . . . there were all these wonderful alternatives. . . . [Using clay I could] make something that was [as] justified or legitimate as anyone else. . . . The trick was to personalize . . . and have your own identity felt through the work." Once Lucero identified that he wanted to work primarily in clay, he determined to grant it the primacy traditionally given oil paint or marble. This implicit faithfulness to the integrity of his material permeates all his work:

I started out right . . . but I was plagued by the same notion as to why in hell are you sitting in this ceramic studio fussing with this material that everyone thinks is only good for teacups and teapots. I had this burning desire to say, "Well, I think I can make something that you will take seriously, that you will consider to be an invasion of space like a sculpture or that it can have scale and relate to a person on a human scale much like a real sculpture does". . . so I had to go back to using clay and they sort of literally built themselves. . . . I said now I'm here with the material and I love it and I know it can give me good results I can't get in anything else. So why not celebrate the fact that it is something different?

Beginning with the simplest techniques of hand-building, pinching, and rolling out forms, Lucero created an enduring affinity between himself and his chosen material. Even when he worked in other materials, as when drawing, the techniques of working clay quickly became apparent *(fig. 1)*. In a series of drawings with oil crayons, for example, Lucero first covered the background with myriad colors, then coated the whole surface with black crayon. Finally, taking a sharp stylus, much as a potter would carve into the surface of bisque, Lucero scratched out the central image through the black ground, the technique and the result resembling sgraffito designs on clay.

While in graduate school Lucero spent every night in the library reading, indulging his profound, voracious

Fig. 1 Michael Lucero. *Untitled*, 1979. Crayon on paper, 30 × 22 inches. Collection of the artist. Photo: Ellen Page Wilson. Even Lucero's drawing reveals techniques of working clay.

interest in the history of art. This curiosity continues, as can be seen from glancing at the eclectic mixture of books shelved throughout his home *(fig. 2)*. As early as the 1970s, Lucero openly appropriated motifs and images from historical precedents, recontextualizing and personalizing them to suit his own developing visual language. In his early ceramic figures Lucero experimented with small-scale work, explicitly borrowing associations and overt symbolism from the history of Western art. In one work Lucero imaged himself as a fecund animal in the pose of professional artist *(fig. 3)*. Poised with eyes closed, palette in hand, he paints an abstract yellow pattern on his blue-toned skin as though suggesting that greater creativity is possible if hidden behind a costume, or that creativity is as much a visceral, animal act as a rational one. The details of these works demonstrate that even at this early stage, Lucero had an extraordinary command of his technique and materials.

I did not want to make pretty colors and things that had no reason to be there. . . . Because I worked in clay I think I tried harder to make serious use of it. . . . I tried to make an

Fig. 3 Michael Lucero. *Self-Portrait as Ram*, 1975–76.
Hand-built white earthenware with glazes, 20 × 10 × 8½ inches.
Collection of Elaine and Joseph Monsen.

identification of the materials as primary to the concept of the piece; the material is crucial to the idea, not secondary. The clay-ness is what the importance of my work is all about.

The motifs of ram and raven recall myriad historical references from Picasso to Poe and persistently challenge the sculptural versus the "decorative arts" traditions usually associated with clay. From the beginning Lucero consciously strove to differentiate his work from Western and Asian decorative arts:

I didn't want to be decorative ever. . . . I never had an inclina-tion toward that kind of work. The Japanese big crusty pots and glazes are beautiful but I never had an affinity with them. I was interested in other things. . . . I was trying to make sculpture. Sculpture. And I was looking at work by people like Segal and Marisol. I saw their work and thought, "I like this," particularly

the visual connection with the figure and different personal ways of using it.

As he enlarged his scale, Lucero took his figures off their pedestals and continued to play off traditional subjects from the history of Western sculpture and Christian iconography. Clay, an organic material derived from the earth, became a metaphor for the act of creation: "I wanted to mix symbols so there was no one religious meaning. . . . There is something very primitive about the way I made them; the whole process, the rhythm, the method, the repetition was very interesting to me."

As in Genesis, Lucero created figures out of bits of clay pinched together and strung on metal armatures, making such full-sized hanging figures as *Untitled (Devil) (colorplate 2)*. Again, reflecting aims similar to those of the French

Surrealists of half a century earlier, Lucero was not interested in portraying any specific ethnic reference for his figures, preferring instead that they be read as "a combination of the Neanderthal or evolutionary theory and like the Christian theory of evolution . . . so [the figures were] not Chinese, Mexican, or another ethnicity. . . . [I wanted them to be] pure without specific cultural context. I avoid specifics—religion, gender, ethnicity—I want to speak on a broader level." The figures of Adam and Eve, for example, are racially ambivalent; their skin color is albino washed in tones of pink, white, yellow, and blue.

The use of clay in shard form led the artist to extensive inquiries, metaphorically and physically, between interior and exterior space, volume and surface, structure and context; and toward questioning the decomposition of the human figure. This in turn prompted Lucero to break through the surface "skin" and concentrate on his figures' linear armature. In his next series, the artist created volume through enticing the viewer to sculpt air conceptually around shard-covered, angular skeletal forms. In *Untitled (Lizard Slayer)*, a work titled after a Greek statue recalled from early art-history classes, Lucero opposed the source's classical origins by creating a visually primitive "stick" figure whose body has been reduced to its most elemental shapes *(colorplate 4)*. The figure's head is replaced by a two-handled Greek black-and-white ceramic pot recalling Carter Ratcliff's statement that Lucero's work, like the Surrealist object, "yields its meaning when it is broken down into the data of a spiritually privileged sort of anthropology."[6] This work was the first in which Lucero allowed himself to place a traditional ceramic vessel in his sculpture. In so doing he pays homage to both his initial inspirations, traditional ceramics and classical sculpture. The figure's vessel head becomes a metaphor as the "holding vessel" for the center of human "superiority" and consciousness: the brain. The resulting work is a dynamic, complex synthesis where opposites are juxtaposed and interconnected in such a way as to suggest endless new possibilities.

The human body was similarly a central form for such Surrealists as Breton, who described it as a "communicating vessel,"[7] and Michel Leiris, who saw the human figure as a "mysterious theater" where exchanges between interior and exterior as well as sensory, material, and intellectual oppositions occur.[8] In both painting and sculpture, Surrealist figures often convey the body in a fragmented, emerging/decaying, deformed, changing state. In so doing, they shatter anthropocentric and logo-

centric views of humankind by showing the body as a hybrid of human/animal/plant/cosmic/object possibilities. Like Lucero, the Surrealist artists refuted the idea of the body as an organic, integral whole. Instead, Surrealist figures resist all constraints of classification. They collapse usual boundaries separating humans from other species: "While they retain some sort of grounding as humans, they are nonetheless informed by an aggressively heteroclite, resolutely anti-idealist attitude."[9] Missing, dislocated, and disproportioned body parts call attention to the body as a disunified entity, rejecting conformity or classical ideals of beauty. In 1982 Lucero made a transitional work, the last in this series of stick/shard figures, titled *Untitled (Snow-Capped Mountains)* *(colorplate 5)*. In it, the body is further fragmented. It has no "center," and its head is placed casually on the figure's arm. In its place Lucero created a stylized architectonic form of brightly colored planes held up by the neck. A single large hand twists forward on a curled arm, adding animation and gesture to the figure.

Taking an art-historical reference to the creation of the human figure—a Renaissance formula suggests that proportionally, the ideal body is the size of the head multiplied seven times—Lucero next created a small series of totem figures combining different cultural references, from Amedeo Modigliani to African and Mexican art *(colorplate 6)*. This represents the beginning of Lucero's concentration on body fragments, another characteristically Surrealist feature of his work. In 1985 Lucero went to work at Lake Placid in upstate New York where he had access to huge kilns and so could begin firing large, single-form ceramics. He began a series of larger-than-life-scale heads, which he titled the *Dreamer* series after Brancusi, whom he later described as being "always my hero" *(fig. 4)*. David Bonetti, writing about Lucero's *Dreamers*, stated that they "were an appropriate surrealism for the 1980s, that decade when dreams and desires so often became effortlessly real."[10]

In the *Dreamers*, Lucero opposed the form of the dreamer head (relatively constant throughout the series) and surface decoration. In these works, the surface narrative does not complement the form, but instead the form and decoration are simultaneously in play, fighting with each other for the viewer's attention. This decision represents the beginning of the complex visual amalgamation characteristic of Lucero's mature work—a seemingly chaotic jumble of imagery fighting against form, recalling Tzara's definition of Dada in his "Dada Manifesto" of 1918: "Dada. . . . Freedom: Dada Dada Dada, a roaring of

tense colours, and interlacing of opposites and of all contradictions, grotesques, inconsistencies: LIFE."[11] The dream motif is fraught with symbolism from Freudian psychology to the most basic tenet of Surrealism: a belief in the validity of dream time and unconscious association. The Surrealists incorporated the resources of the unconscious into works of art in order to give them the suggestive and consciousness-expanding power of actual dreams. Similarly, Lucero uses the calm surfaces of his *Dreamers* to externalize the inextricably ordered stream of unconsciousness taking place behind the docile, slumbering facial mask.

The surface imagery of the *Dreamers* is crowded with personal icons from Lucero's life, including the ceramic

teapots he rebelled against making, images of Northwest Coast totem poles recalling his years in Washington State *(fig. 5)*, and the characteristically red earth and rugged landscapes of New Mexico where he spent childhood summers and has a home *(colorplates 7 and 8, Pink Nude Dreamer) (figs. 6 and 7)*. While he was making the series, Lucero was not aware of the dream symbolism. However, looking back, he has realized that many of the craggy landscapes and shaped rocks and cliffs derived both from childhood associations, such as Camel Rock, which terrified him as a child *(fig. 8)*, and from youthful nightmares:

As a kid when I had a fever, I used to dream I would fall into crags—one gets lost in the act of making and you are not always conscious until later of where imagery comes from. When I was young, whenever I was sick I would have the same dream of falling into a dangerous rocky place.

The conflation of surface and form allows Lucero to create a head illusionistically and then make it invisible; to reshape the head through landscape imagery. In many instances the landscape is not fertile and benevolent but barren and hostile, often desiccated, indicating perpetual destruction and reformation. *Lunar Life Dreamer (colorplates 11 and 12)*, for example, represents the aftereffects of a surreal cosmic-terrestrial cataclysm that destroys and

Fig. 4 Constantin Brancusi. *Sleeping Muse*, 1915. Gelatin-silver print, 6⅞ × 9⅛ inches. The Museum of Modern Art, New York. Gift of Edward Steichen. Photo: © 1995 The Museum of Modern Art, New York.

Fig. 5 Michael Lucero. *Northwest Dreamer*, 1985. White earthenware with glazes, 19 × 25 × 21 inches. Private Collection. Photo: Ellen Page Wilson.

Fig. 6 The rugged New Mexico landscape, 1993. Photo: Barbara J. Bloemink.

Fig. 7 Michael Lucero's studio in Santa Fe, New Mexico, 1993. Photo: Barbara J. Bloemink.

Fig. 8 Camel Rock, New Mexico, 1993. Photo: Barbara J. Bloemink.

redefines all elements. Breton described nature as functioning as *un pays de rêve*, where the restraints of society disappear and humans can exercise the deep inborn desires for turbulence and frenzy, not logic and control. For many Surrealists, nature represented a timeless narrative, with roots deep in a primordial past, which could disclaim illusions of harmony and human dominance, and exalt disorientation. In his 1929 article "Civilization," Surrealist Michel Leiris compared human and physical "eruptions," stating that culture, like the thin surface of ground and water, is fragile and often reveals fissures exposing "our frightful savagery" and the "crudity of our dangerous instincts."[12]

For Lucero, as for the Surrealists, nature is both victim and victimizer, absorbing the fallout of civilization. Further undermining Western authority and defying pretensions of evolutionary progress, Lucero shares with the Surrealists a view of evolution as not fixed, but subject to ceaseless change and diversification in which prime criteria for selection and survival are chance mutation and adaptation. The volcanic imagery on Lucero's *Dreamers* pointedly conflicts with the placidity of the

forms' sleeping visages. As the painted surface in several of Lucero's *Dreamers* indicates, as humans we "stand upon a volcano, but...our whole life, our very breathings, are likened to lava, craters, geysers and everything connected to volcanoes" *(colorplate 11).*

In 1986, tired of working on a relatively similar form and uneasy with the emerging decorativeness of the *Dreamers,* Lucero temporarily abandoned the human figure as the central referent in his work. Drawn to similar negations of the ideal as Surrealist Bataille, who suggested that life is only a "backward and forward movement from muck to the ideal and from the ideal to muck,"[13] Lucero began a series of works titled *Earth Images,* consisting of creatures, camouflaged in nature, that reside closest to the atavistic layers of the earth's skin:

I did the Earth Images *of earth, from the earth, made of earth, so again I am constantly questioning the use of clay.... I wanted each form to be special and individual and not to be redundant like the* Dreamers *were.... I wanted to show a real variety...and I wanted vertical, horizontal, and small and large scale.*

To accompany this grouping contextually, Lucero painted a canvas backdrop with black linear images of indigenous swamps and murky organic scenarios recalling traditional dioramas in natural-history museums. Furthering this association, Lucero's initial installation of *Earth Images* included a large ceramic microscope that was later destroyed. He placed each of his ceramic creatures on rigid, angular stands reminiscent of laboratory furniture, emphasizing the continuous tension between nature and the human quest for knowledge which, throughout history, has often threatened the very creatures we seek to understand. Lucero used *Earth Images* to explore alternate concepts of beauty by creating images of creatures that exist in the mud and blend into their surroundings for protection. The glazes are muted or acrid earth tones with occasional areas of bright sky blue.

To accommodate the large scale of the *Earth Images,* Lucero further experimented with ceramic process by dividing a number of the creatures into two parts, thereby reinforcing the physical and thematic diptych within each work. The *Earth Images* works continue his interest in detailed, painted surfaces whose imagery contains only oblique reference to their forms. The narratives on the works are complex, often offering contradictory views of similar themes. *Big Frog (colorplates 15 and 16)* contains paintings of evergreen trees on one side, deciduous trees with a painting of the exterior of the Taos Pueblo on the other *(fig. 9).* On its second section the artist painted an

Fig. 9 Taos Pueblo, 1993. Photo: Barbara J. Bloemink.

interior brick fireplace on one side, contrasting it with a ravaged, alien landscape on its back.

In 1987–88, as an experiment, Lucero temporarily abandoned clay for another medium, bronze. He continued the *Earth Images* motif of organic archaeology, creating tall, totemic works. The notion of totemic systems was central to Surrealist thinking as a disordered aggregate of cultural artifacts. Lucien Lévy-Bruhl noted that collective representation in a totemistic community meant that "every animal, every plant, every object indeed, such as the sun, moon, stars, forms part of a totem"[14] *(fig. 10)*. For Lucero's bronze totems, which resemble the metal contraptions of Jean Tinguely and the surreal, painted skeletal figurations of Yves Tanguy *(fig. 11)*, the artist combined organic forms with numerous man-made and manufactured items, all frozen in bronze and attached by sprues calling attention to the metal-pouring process. For *Greenhouse* Lucero found a pile of iron shards in a foundry and instead of melting them down, welded them individually into the totem *(colorplate 25)*. For *Fossil Fuel*, the final work in the series, Lucero cast models of miniature furniture, a tiny boat, and numerous pieces of metal scrap into a cyclone-swept tower of bronze *(colorplate 27)*. The title and visible motifs recall the idea of bronze becoming solidified as a fossil over time and, in the process, entrapping everything in its path so that the final result is a visual, vertical archaeological exploration of form.

Fig. 10 Native American Totems. In *Primitivism in 20th Century Art*, ed. William S. Rubin, vol. 2 (New York: The Museum of Modern Art, 1987), 573. Offset, printed in black, 12 × 8¾ inches. Photo: © 1995 The Museum of Modern Art, New York.

Within two years Lucero returned to clay, first building huge ceramic totems that initially look like bronze *(colorplate 24)*, and then gradually returned to the surface textures and appearance of glazed and unglazed ceramic:

In terms of immediacy, I missed all the wonderful, intrinsic qualities of the clay. [I decided] when I go back to working with clay . . . I'm going to let it build itself. . . . I started to dissect the material which was the earth, and I literally let the clay go all the way vertical, let it build itself.

In his next series Lucero isolated the human heart, making it the subject of numerous freestanding glazed sculptures and totems. The human heart carries myriad associations throughout many cultures and time periods. Lucero was drawn to the motif, as usual, as an outgrowth/ mutation arising from his prior work:

I think it began with the bronze and the idea of the veins. I bought a biological specimen of the heart which I used on one of my totems. . . . I thought I could make a big heart out of an earth heart . . . and [visually] severed the heart in two. [colorplates 32 and 33: Big Heart (Deer)]

Lucero's heart images are far removed from European, picturesque valentines or typical symbols of flirtation and romance. Instead, his wetly blood red, ventriculated muscle represents the Latino "sacred" or "bleeding heart," itself an inherently syncretic image. The image of the heart forcibly torn from the human body recurred in pre-

Columbian culture as a symbol of fertility and sacrificial rites and reappeared in Spanish-colonized Mexico as a Christian symbol of love, devotion, and sorrow. It is rarely seen as a subject of contemporary art outside of Latino cultures *(fig. 12)*. As described by Olivier Debroise, "The exposed heart signifies the exteriorization of the interior. . . . The arteries and veins, shown as if neatly sliced by the surgeon's scalpel, are open and reveal the 'emptiness' of the heart's interior."[15] Large, disengaged from, and existing outside of the body's systemic complex, Lucero's oversized hearts stand like sinister, brightly painted grenades, hollow but not empty, swollen with blood. In some of the bleakest imagery, the viscously painted blood red glaze contrasts with the matte finish of the landscapes. The only visual relief in one such form is the addition of modernist Robert Delaunay's color wheel, acting as a seemingly out-of-place aesthetic mirage.

Using the heart image allowed Lucero to pose basic aesthetic questions—Which motifs "belong" to which cultures and why? Artwork or artifact?—thereby continuing his constant composing and decomposing of culture's natural hierarchies. The artist has always been very attracted to pre-Columbian figures:

They are for me highly sophisticated. They seem so right. Positive/negative shapes, they are timeless, representing ancient history, but are futuristic looking, and they are almost alien

Fig. 12 Richard Notkin. *Heart Teapot: Sharpeville Krugerrand II*, 1990. Luster on stoneware, 6 × 11 × 5 inches. Collection of Garth Clark and Mark Del Vecchio. Photo: Susan Dirk.

looking. . . . Instead of calling them literally pre-Columbian . . . I wanted a little sense of humor and called them "pre-Columbus." But they were ugly, it was like opening a can of worms.

In *Big Heart (Deer)*, Lucero painted an image of a ceramic pre-Columbian figure at its apex, next to an image of giant redwood trees. This is the first occurrence of the pre-Columbian imagery that was to consume the next half-decade of his work. Lucero's heart imagery is replete with visual puns: in the past, mankind harvested the "heart" of redwood trees, much as the pre-Columbians tore the heart from human bodies during their rituals. Like the *red*wood trees, pre-Columbian figures have lasted for centuries and are now prized and admired. Lucero next continued his interest in cross-cultural appropriation through a series of ceramic totems made of richly glazed forms. In these works, such as *Self-Portrait as Pre-Columbian*, Lucero signaled a return to the full body, and he included a pre-Columbian seated figure at the bottom *(colorplate 28)*.

A commitment to global relativism and multicultural investigations was a central, founding thesis of Surrealism, just as it forms the basis for two phyla of Lucero's work: the *Pre-Columbus* and *New World* series. A crucial Surrealist aim was "to rediscover life under the thick carapace of centuries of culture—life pure, naked, raw, lacerated."[16] To its founders, Surrealism represented

a rebellion against nationalist and racist attitudes, especially their role in establishing hierarchies, divisive groupings, and an oppositional mentality. . . . Not only did they reject certain aspects of Western civilization but they also recognized that its rigid, often elitist conception tended to obscure or deny both critical similarities with and significant differences from other civilizations. Their interest in African, Oceanic, Native American, Asian, and prehistoric cultures asserted a will to expand beyond the confines and closure of Western culture while revealing the flux and variety of human expression.[17]

The Surrealist journal *Documents*, edited by Bataille, was published in 1929 and 1930. The journal featured an eclectic list of contributors including ethnologists, museologists, musicologists, orientalists, and assorted writers and scholars. The journal's title expressed culture as something to be collected. Its articles and illustrations offered an ethnographic display of images, objects, labels, resembling a playful museum that simultaneously collects and reclassifies its specimens.[18] *Documents*' basic method was juxtaposition—fortuitous or ironic collage. On its pages, the editors constantly arranged unexpected mixes

of cultural symbols and artifacts—"high" art combined with enlarged photographs of feet; folk crafts; Hollywood sets; African, pre-Columbian, and French masks; slaughterhouses; etc. By treating everything equally, *Documents* conveyed an order of chaos rather than unity. For the Surrealists, as for Lucero, the *currency* of the "other" (exotic, forgotten, excluded, devalued, ugly, bestial, excessive) was a constant theme, contributing to a relentless criticism of European "civilization."[19]

As he began his *Pre-Columbus* series, Lucero appropriated form, scale, and materials from various types of pre-Columbian art, but filtered each through his own personal vision. From the beginning, he combined forms from Mexico, Peru, Colombia, "all the different cultures of Indians . . . [including] features from East, West, North, South, as I wanted [them] to be recognizable but not too specifically one culture. . . . I dared myself to use them and if I used them I could never copy them exactly." Lucero borrowed the smaller scale from the original figures, speculating, "Maybe they were not intended as sculpture. They were representative of a particular fetish or something they wanted to document in this little ceramic form. It didn't need to be life-scale. If they wanted it to be life-scale they would have made [them] life-scale." Nonetheless Lucero began the series with an oversized pair of ceramic feet *(fig. 13)*, a metaphor for the arrival of European culture in the New World, as he explained,

in terms of stepping or conquering or exploring, walking through the earth, made of earth. It's a continuum of the material metaphor and how it can somehow connect with the idea. That's my biggest concern always. To make something that recycles back, that flips the symbol.

Feet provide the firm foundation necessary for the erect posture that distinguishes humans from animals. It is amusing to compare Lucero's *Big Feet* with a photographic collage from the 1921 journal, *New York Dada* *(fig. 14)*. The image contains a woman's stockinged, high-heeled foot that in turn reflects a man's face, several written notations such as "Watch your step!" and an incongruous sample of writing in which words are written backwards and upside-down. As in Lucero's sculpted version, the woman's leg is fleshy, with irregularities and potent curvatures.

To the syncretic, highly complex forms of pre-Columbian culture, Lucero indiscriminately added figural gestures from the Quimbaya, Nayarit, and Colima cultures, combining them with contemporary motifs. In

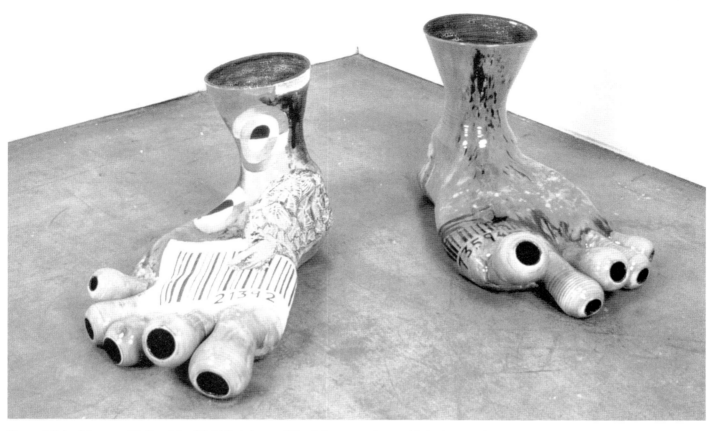

Fig. 13 Michael Lucero. *Big Feet (New World Series)*, 1992. Wheel-thrown and assembled white earthenware with glazes, each 17 × 36 × 33 inches. Photo: Ellen Page Wilson.

his versions, Lucero added surface decoration reiterating the motifs of modern art (Joan Miró, Robert Delaunay, Jackson Pollock, Pablo Picasso) with landscape/volcanic imagery and images of functional ceramics from various cultures. The painted glazes are thickly applied and appear wet and viscous, bleeding from one area into another in large drips. Through his use of illusionistic surface painting and segregated unglazed areas, Lucero forces the viewer's eye to refocus constantly and willfully in order not to miss some reference to past art or popular culture.

One figure titled *Lady with Two Curls*, for example, holds an Acoma black-on-white pottery bowl in her lap with one hand while the other reaches up toward her forehead *(colorplates 39 and 40)*. Beyond this initial reference to pottery and ceramic making, the figure's face is divided in two, one side bearing an image of a pre-Columbian gold mask and the other a beautifully rendered landscape reminiscent of the work of contemporary artist Joan Nelson. On the reverse, another open-mouthed mask image hovers above an unglazed image of a heart and a tall coffeepot, continuing the references to functional ceramics and to Lucero's earlier work. Beneath

Fig. 14 Marcel Duchamp. *Page from New York Dada (1921), from the Box of 1932*, 14½ × 10¹/₁₆ inches. Philadelphia Museum of Art: Partial and promised gift of Marion Boulton Stroud in honor of Alexind Duchamp.

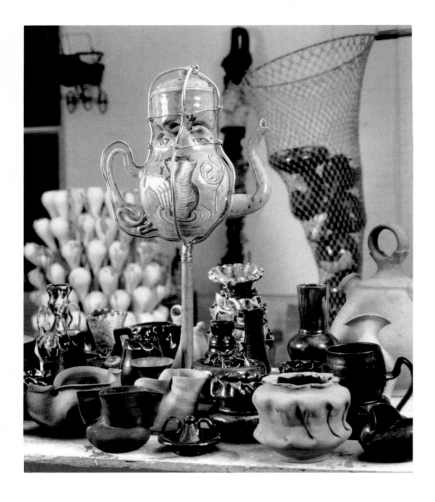

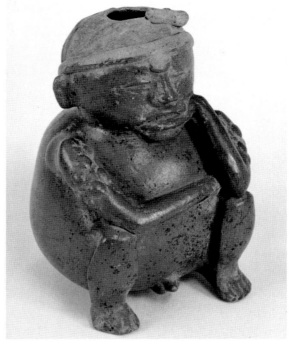

Fig. 15 Lucero's pink teapot wrapped with metal wire is reminiscent of the work of George Ohr. Photo: Jerry Stuart.

Fig. 16 Costa Rican, Guanacaste/Nicoya area. *Seated Figure*, 500–100 B.C. Earthenware, 8¾ × 5¾ × 6¼ inches. Mint Museum of Art, Charlotte, North Carolina. Gift of Mrs. Joseph A. Carruth. 67.11.3. Photo: A. Hayes Dunlap.

these, on the lower right, Lucero added a bar code, a prevalent symbol in contemporary Western society and a tongue-in-cheek jibe at the recent criticism of contemporary art as a commodity to be consumed by a voracious public. The glazed decorative narrative on the surface of the *Pre-Columbus* series is particularly complex and vivid, containing myriad images of things that attract the artist and engage the viewers' vision in a "push and pull" tension with the surface of the works. In this negation of form by surface imagery, Lucero's work recalls that of fellow contemporary artist Kurt Weiser, who often conjoins images of animals, insects, vegetation, and humans on the painted surfaces of his ceramic vessels.

Transmutation and hybridization of animals and humans were common in Surrealism. The animal hybridizations effectively deformed and debased the human image, indicating a fall from the hierarchical pedestal as well as a slippage into the savage and bestial. "No longer bound by a fixed identity, these animal/ human figurations take on forsaken, hidden, desired, feared, or contrary traits that both heighten an awareness of incongruity and blur the distinctions that affirm human identity."[20] As Bataille noted, in Surrealist mani-

festations these hybridized human/animals are often portrayed with exaggerated sex organs, indicating the potency of their bestial forebears.

Pre-Columbian ceramics are usually gender-specific, as are Lucero's figures, although with the visual clutter characteristic of Lucero's work, this only becomes evident through close viewing of individual pieces. The genital areas of Lucero's male *Pre-Columbus* figures are overtly referenced through the addition of humorous motifs whose only shared characteristic is their protuberant form. In some figures, the penis forms the snout on a long-eared dog; in others it is the curled termination of an upside-down violin or the thick body of a fat moth *(colorplates 37, 38, 41, and 42)*. Lucero's female figures can be identified by their painted breasts, usually consisting of two screaming or grimacing miniature heads—referring to pre-Columbian art as well as to the notion of infants crying to get attention and be breast-fed. Female genitalia are often discreetly hidden behind flowering petals or subtly connoted through a small hand separating the labia as in *Lady with Ohr Hair (colorplates 49 and 50)*. In this work, Lucero manually crumpled the top of the figure's head in the manner characteristic of Southern

ceramist George Ohr. Lucero collects Ohr pottery, and his tendency to similarly manipulate the clay is prevalent in much of his sculpture after 1990 *(fig. 15)*. Another *Pre-Columbus* figure by Lucero, *Lady with Bee Hive (color-plates 43 and 44)*, relates visually to a pre-Columbian seated female figure from Costa Rica *(fig. 16)*. In Lucero's image, a large pre-Columbian face is superimposed over the ceramic facial form in front and is echoed by a large white flower on the back. Her hair design resembles the coiled hair found in ancient West Indian sculptures or in Asian images of Buddha.

After the Europeans' arrival in Central America, the indigenous Indian cultures were irreparably changed. For his *New World* series, Lucero therefore decided to create works differently from the *Pre-Columbus* series, which was entirely hand-built. To that end, he began collaborating with a professional potter who used a wheel rather than hand-building ceramics. The resulting works "are made of clay on the wheel and then manipulated into these figures which, because of the nature of the symmetry

of spinning of the wheel, have a sort of alien look but they are so refined in a slicker sense . . . like the modern world . . . a world more interested in the gadgetry of machines." Lucero began to conceive partially wheel-thrown imagery such as *Anthropomorphic Female Form with Wig (colorplates 55 and 56)* which retains much of the same formal imagery as the *Pre-Columbus* series, but its basic body shapes resemble traditional vessels more closely than do the hand-manipulated figures.

As part of the *New World* series, Lucero made a number of face-jugs, reminiscent of Afro-Carolinian ceramic jugs made by anonymous African Americans and emulated more recently by Carolinian ceramists. A number of these jugs have Ohr-style crumpled hair *(colorplates 53 and 54)*, while others are wearing bowler hats recalling modernist works by Juan Gris and Marcel Duchamp *(figs. 17 and 18)*, in which the hat was a symbol of urban anonymity.

In the *New World* series, Lucero began appropriating existing objects such as wigs, glass hats, and baby carriages onto which he fused forms of his own design. In one work titled *Soul Catcher*, a term redolent with symbolic meaning and one used and enjoyed by numerous Surrealist and Modernist artists, Lucero attached ceramic bottles upside down on a large metal

Fig. 17 Juan Gris. *Man in a Café*, 1912. Oil on canvas, 50¼ × 34¾ inches. Philadelphia Museum of Art, The Louise and Walter Arensberg Collection. 50-134-94.

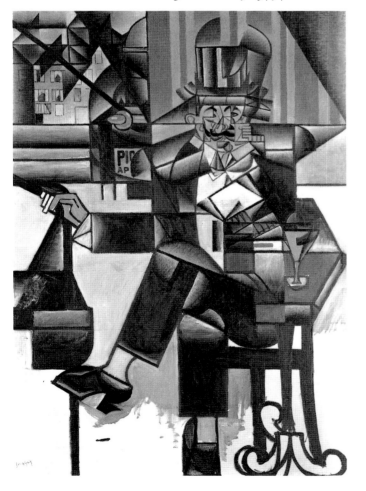

Fig. 18 Man Ray. *Marcel Duchamp Dressed as Rrose Sélavy*, 1924. Gelatin-silver print, 8½ × 6¹³/₁₆ inches. Philadelphia Museum of Art, the Samuel S. White, 3rd, and Vera White Collection. 57-49-1.

fixture *(colorplate 67)*. In *Hello Duchamp*, Lucero makes direct reference to a work from the first decades of the century by Duchamp *(figs. 19 and 20)* but alters its original form and perception by adding ceramic bottles to each of the spokes of an empty metal rack and inscribes on each the letters of his name. Lucero observes:

Duchamp said let's look at it as form and forget the function, so I just thought, well hey, I could give it back its function but put the bottles back on the rack and look at it again . . . and that's basically what evolved. And I have always just loved [Duchamp] in terms of his radical tendencies to ideas related to art that I felt always were interesting.

In *Anthropomorphic Infant Form with Tutu in Stroller*, the ceramic child with a thrown vessel-head virtually melts into the seat of a metal carriage bearing decals that are eerily similar to Lucero's own reconstituted imagery

(colorplates 62 and 63). Large caricatured eyes peer over the back edge of the carriage, repeating those of the small dog applied to the metal backing. Dislocated eyes appear regularly in Lucero's work, as they did in many Surrealist objects and films. In *Yellow Sky Totem* two eyes are suspended from long wires on either side of the central totemic form *(colorplate 61)*. Recalling imagery from F. Scott Fitzgerald's *Great Gatsby*, as well as Luis Buñuel and Salvador Dalí's film, *Un chien andalou*, and Surrealist works by Man Ray and Manuel Alvarez Bravo, Lucero's eyes maintain a watchful gaze on viewers *(figs. 21 and 22)*.

In his 1924 *Manifesto of Surrealism*, Breton voiced his wish that eventually the old antinomies "life and death, the real and the imaginary, past and future, the communicable and the incommunicable, high and low [would] cease to be perceived as contradictions." Toward that end, many of the Surrealists felt no qualms about unex-

Fig. 19 Michael Lucero. *Hello Duchamp (New World Series)*, 1993–94. Wheel-thrown white earthenware with glazes and metal stand, 57 × 38 × 38 inches. Collection of the artist, courtesy David Beitzel Gallery. Photo: Jerry Stuart.

Fig. 20 Man Ray. *Duchamp "Ready Made,"* 1914. Gelatin-silver print, 11⁷/16 × 7⁷/16 inches. The Museum of Modern Art, New York, James Thrall Soby Fund. Photo: © 1995 The Museum of Modern Art, New York.

pectedly juxtaposing dissimilar objects, even those from different cultures and time periods, in order to directly assault notions of a single, primary order. One result was the archetypal "chance meeting on a dissection table of a sewing machine and an umbrella." In "Beyond Painting," written in 1936, Max Ernst wrote of "the coupling of two realities, irreconcilable in appearance, upon a plane which apparently does not suit them."[21] By collaging images, many Surrealists displaced objects from their ordinary range of expectations and were able to transcend standard conventional interpretations and create new languages of meaning.

In his most recent work, which he is titling *Reclamations*, Lucero has a similar aim: "In a way, I guess that's living so much, carrying so many images in your head for so many years . . . all kind of mixed and running together and just sort of popping out . . . without having to look at a specific reference anymore." By haunting vintage thrift shops and galleries throughout Manhattan's East Village, Lucero has retrieved a number of objects from myriad cultures and sources: garden statuary, African wood sculpture, Latino *santo* figures, etc., and has combined

Fig. 22 Manuel Alvarez Bravo. *Optical Parabola*, 1931. Gelatin-silver print, 9½ × 7 inches. The Art Institute of Chicago. Restricted Gift of The Exchange National Bank of Chicago. 1975.315. Photo: © 1994 The Art Institute of Chicago. All rights reserved.

Fig. 21 Man Ray. *Eye That Beholds All*, 1919. Oil on paper, 11¹³⁄₁₆ × 9⅝ inches. The Art Institute of Chicago, Mary Reynolds Collection.

them with forms from his aesthetic to create exciting, bold new work. Recalling Duchamp's *Ready Made*s, in which the French artist drew attention not to the intrinsic beauty of such objects as bicycle wheels, shovels, etc., but to the conventions, habits, and prejudices that underlie our expectations of art, Lucero's aim is to further alter the way in which such objects are commonly perceived.

In works such as *Female Ohr Santo (colorplate 70),* for example, Lucero takes the notion of reclamation a step further and fuses his own ceramic additions onto existing but damaged "art objects" from the past. Recognizing that every object's expression and significance changes with its context, and that each generation creates meaning anew, Lucero creates collaged works that offer an empathetic appreciation for their original use, as religious and garden statuary or even as tourist art. However, by adding his own symbolic language onto that of past artists, Lucero reformulizes their works, causing us to "read" familiar and old elements differently from how they were originally intended. In one work, the elegant body of a cement greyhound is conflated with dense

abstract Celtic imagery at its front and a beautifully detailed new face on its reverse. The iconic presence and concentrated power of recent works such as *Angola Carolina (Reclamation Series)* are a testament to the success of Lucero's syncretic vision *(colorplate 72)*. The standing figure wears its heritage proudly, even defiantly. Through its imagery, it melds mud beetles as well as African and southeastern elements to convey the ultimate triumph of visual cultures over anonymity, geographic displacement, and reigns of cultural conformism. These austere, mysterious juxtapositions quietly reflect the globalization of the visual arts, in which few cultures can remain "pure" and unaffected by past connotations, by hybridization through mass media, or simply by the increasing physical movement of peoples across the earth's surface. Lucero's work can be compared to ceramic stone that gathers visual "moss" and aggregate imagery as it mutates, changes, and moves through time. As in the earliest pieces, its strength comes from a combination of extraordinarily fine technique, keen, wide-ranging intelligence, and the resonance brought to bear by past associations, cultures, and use.

The results are haunting, recalling Toni Morrison's statement: "How compelling is the study of those [artists] who take responsibility for *all* of the values they bring to their art. How stunning is the achievement of those who have searched for and mined a shareable language for the words to say it."[22]

NOTES

1. James Clifford, "On Ethnographic Surrealism," in *The Predicament of Culture: Twentieth-Century Ethnography, Literature, and Art* (Cambridge: Harvard University Press, 1981), p. 119.

2. Hans Richter, *Dada Art and Anti-Art* (New York: McGraw-Hill, 1965), p. 34.

3. Briony Fer, "Surrealism, Myth and Psychoanalysis," in *Realism, Rationalism, Surrealism: Art between the Wars* (New Haven, Conn.: Yale University Press, 1993), p. 171.

4. André Breton, *Manifestoes of Surrealism* (Ann Arbor, Mich.: University of Michigan Press, 1972), p. 14.

5. Clifford H. Browder, *André Breton: Arbiter of Surrealism* (Geneva: Droz, 1967), p. 61.

6. Carter Ratcliff, *The Intimate Infinite: Michael Lucero's Bronze Sculpture*, exh. cat. (New York: ACA Galleries, 1988), p. 16.

7. Sidra Stich, ed., *Anxious Visions: Surrealist Art* (Berkeley: University of California Press, 1990), p. 79.

8. Michel Leiris, "L'Homme et son intérieur," *Documents* 2, no. 5 (1930): 261, 266.

9. Stich, *Anxious Visions*, p. 31.

10. David Bonetti, "Ceramicists Give New Twist to the Cosmic Vision," *San Francisco Examiner*, May 9, 1991, p. 3.

11. Fer, "Surrealism, Myth, and Psychoanalysis," p. 30.

12. Michel Leiris, "Civilization," *Documents* 1, no. 4 (1929): 221.

13. Georges Bataille, *Lascaux or The Birth of Art*, trans. Austyrn Wainhouse (Lausanne: Skira, 1955, p. 32), quoted in Stich, *Anxious Visions*, p. 38.

14. Lucien Lévy-Bruhl, *Primitive Mentality*, trans. Lilian Clare (Boston: Beacon Press, 1966), pp. 8–9.

15. Olivier Debroise, "Heart Attacks: On a Culture of Missed Encounters and Misunderstandings," in *El Corazón Sagrante/The Bleeding Heart* (Boston: Institute of Contemporary Art, 1991), p. 19.

16. Maurice Nadeau, quoted in Stich, *Anxious Visions*, p. 14.

17. Stich, *Anxious Visions*, p. 15

18. Clifford, "On Ethnographic Surrealism," p. 131.

19. James Clifford, "Documents: A Decomposition," in Stich, *Anxious Visions*, p. 181.

20. Stich, *Anxious Visions*, p. 62.

21. Max Ernst, *Beyond Painting and Other Writings by the Artist and His Friends* (New York: Wittenborn, Schultz, 1948), p. 13.

22. Toni Morrison, *Playing in the Dark: Whiteness and the Literary Imagination* (New York: Vintage Books, 1992), p. xiii.

COLORPLATES

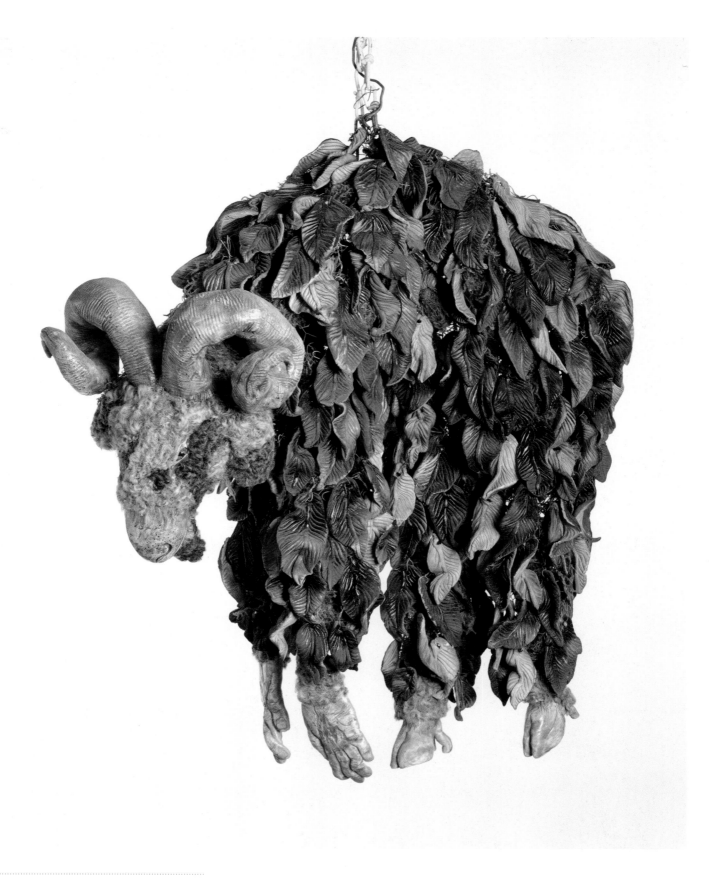

1. UNTITLED (HANGING RAM), 1976

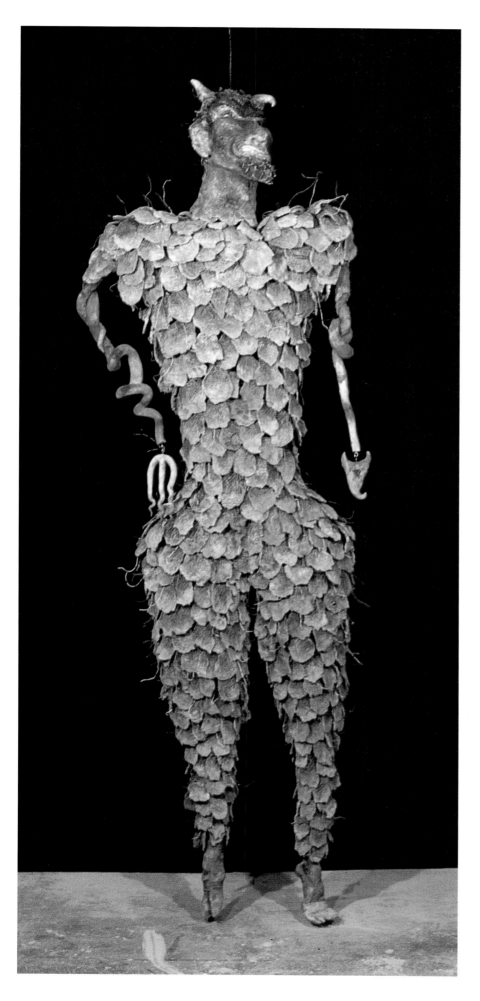

2. UNTITLED (DEVIL), 1977

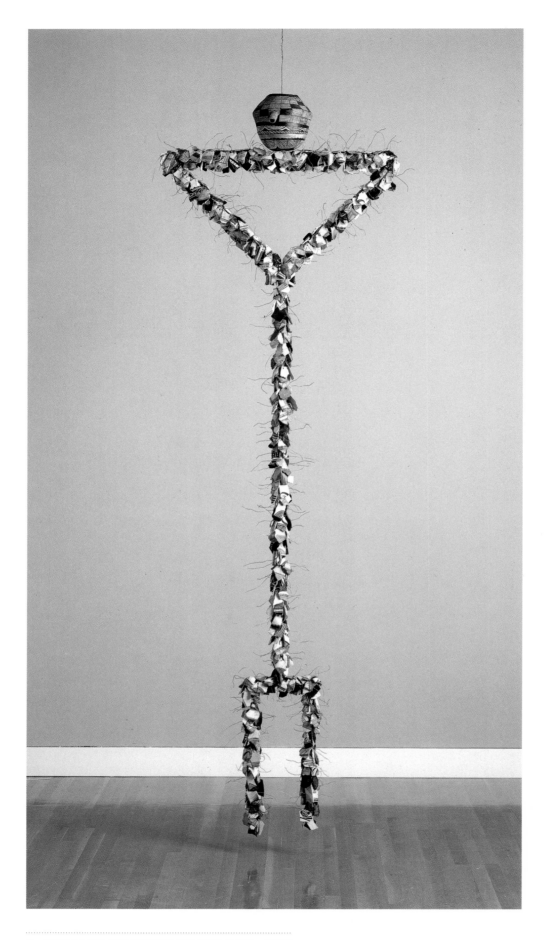

3. **UNTITLED (IN HONOR OF THE S.W.), 1980**

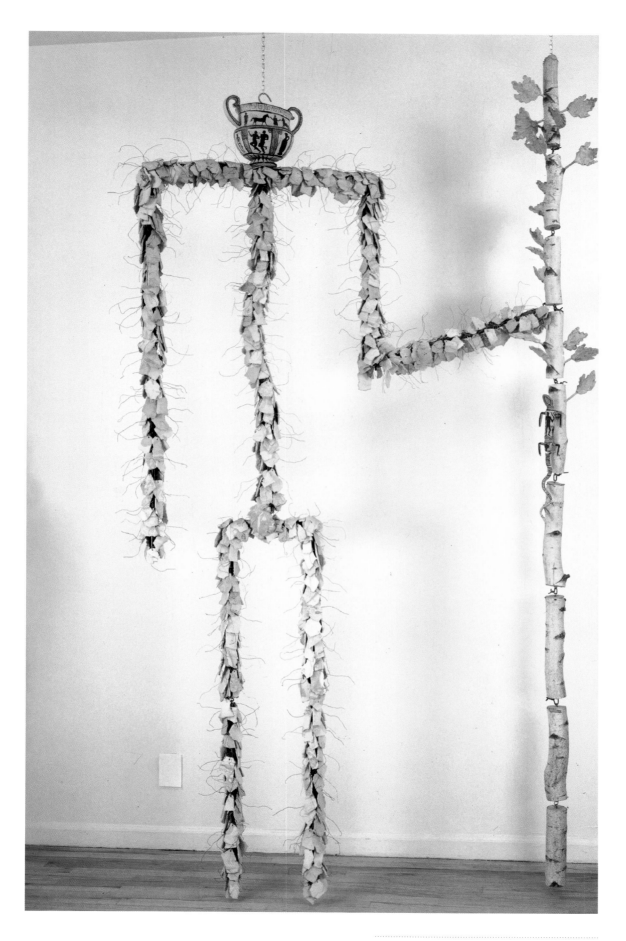

4. UNTITLED (LIZARD SLAYER), 1980

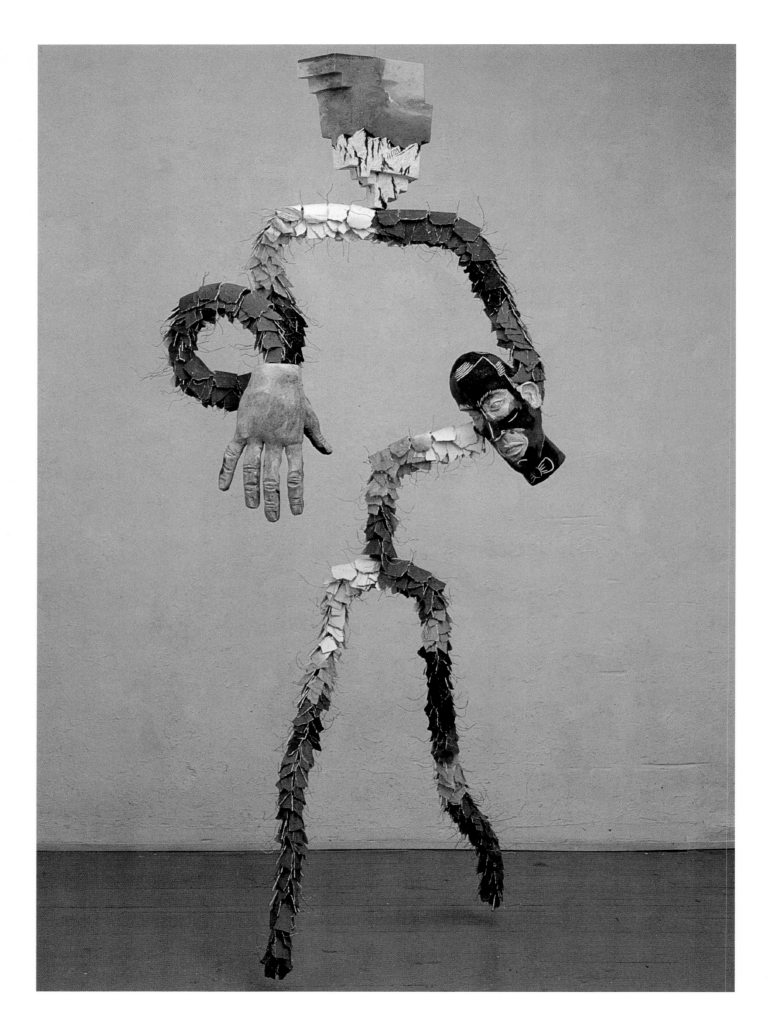

5. UNTITLED (SNOW-CAPPED MOUNTAINS), 1982

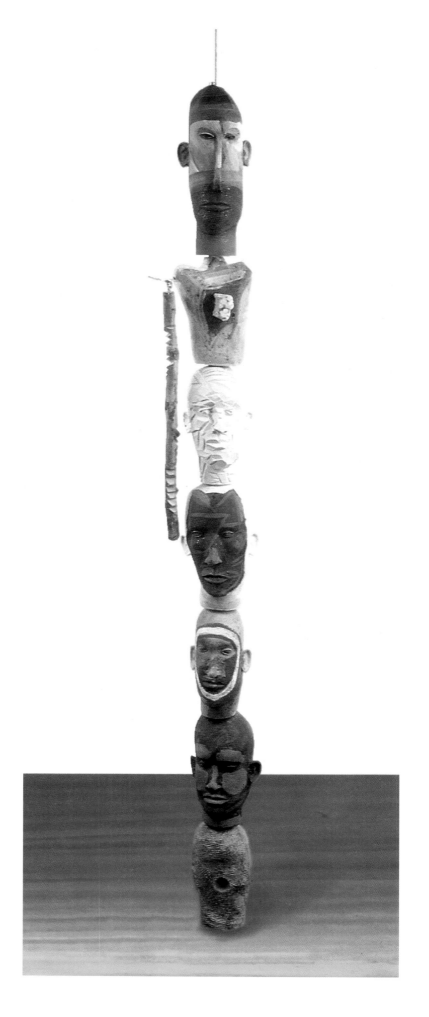

6. UNTITLED (STACKED HEADS), 1983

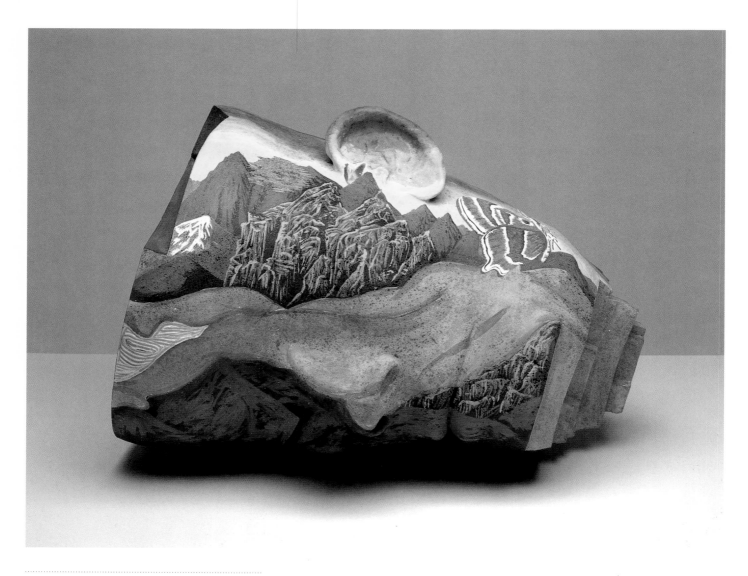

7. **PINK NUDE DREAMER, 1984** (RECTO)

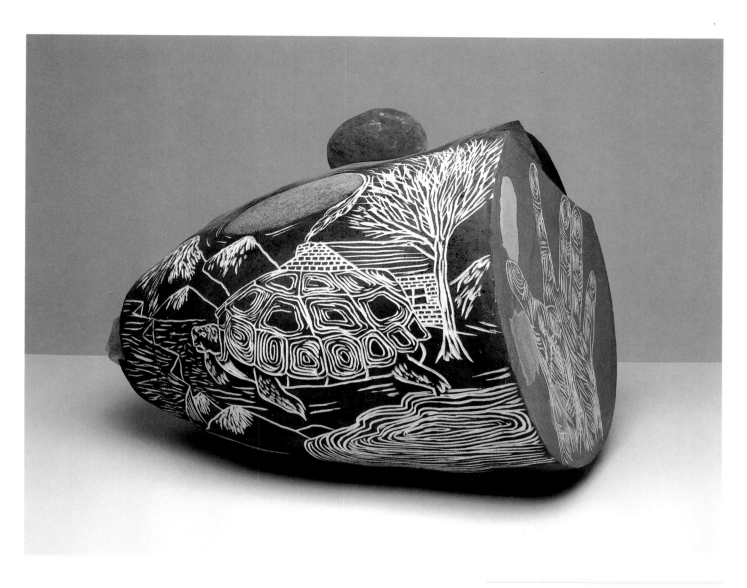

8. **PINK NUDE DREAMER, 1984** (VERSO)

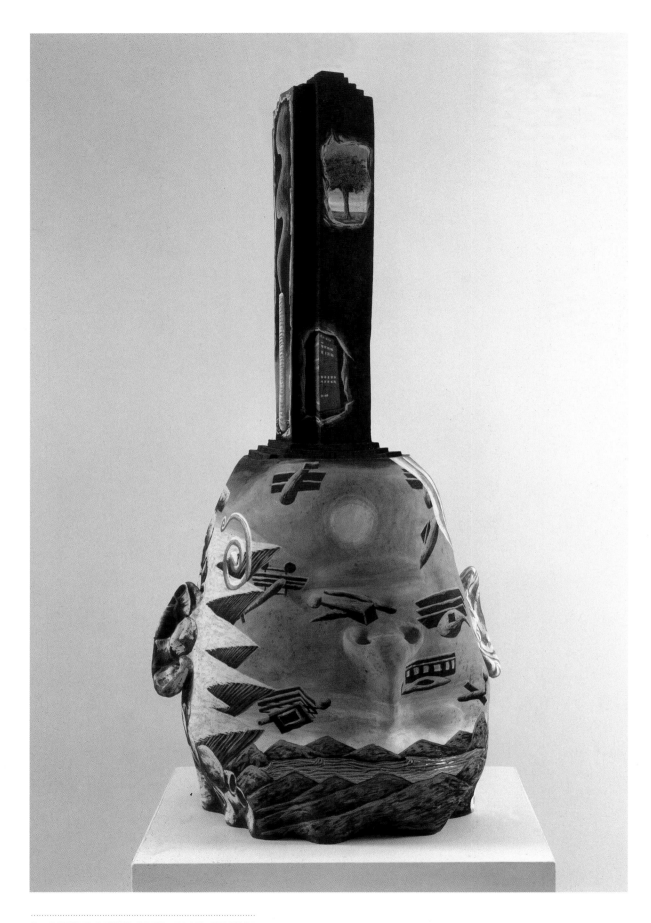

9. DREAM DEVELOPER, 1985 (RECTO)

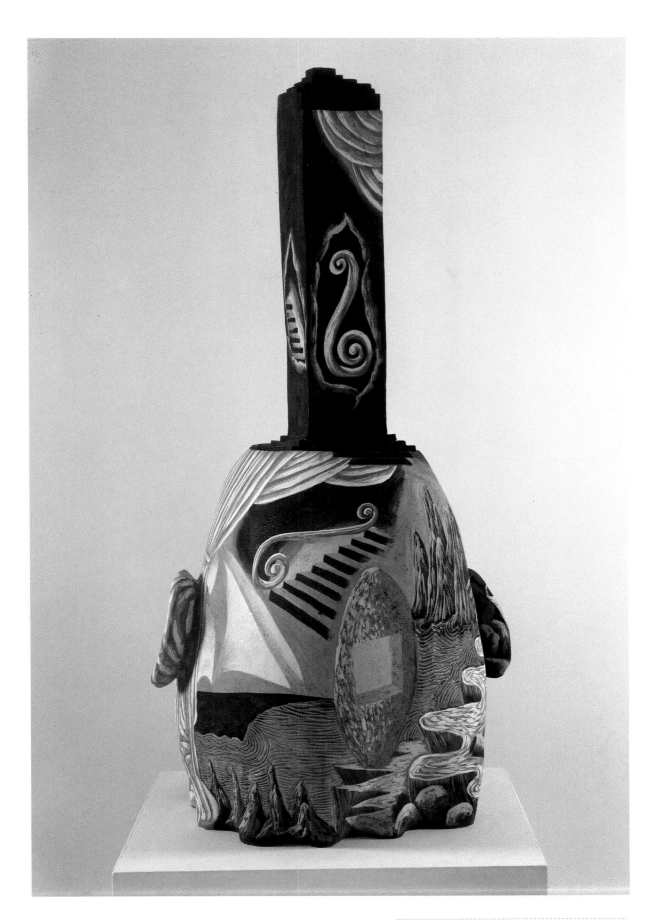

10. **DREAM DEVELOPER, 1985** (VERSO)

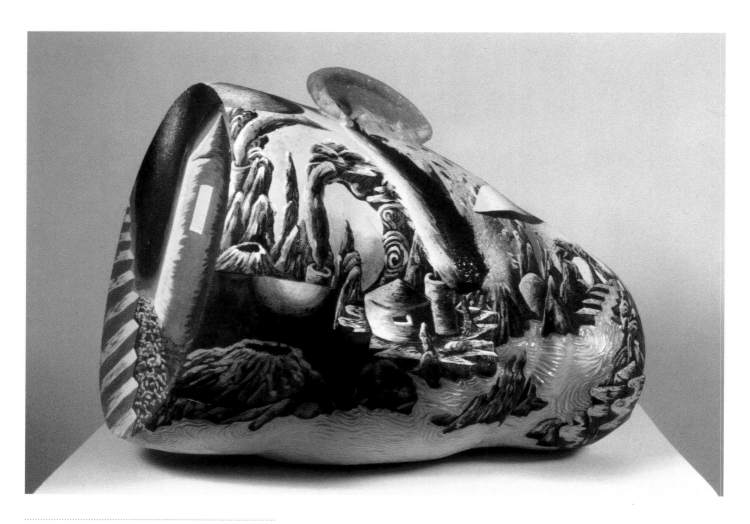

11. LUNAR LIFE DREAMER, 1985 (RECTO)

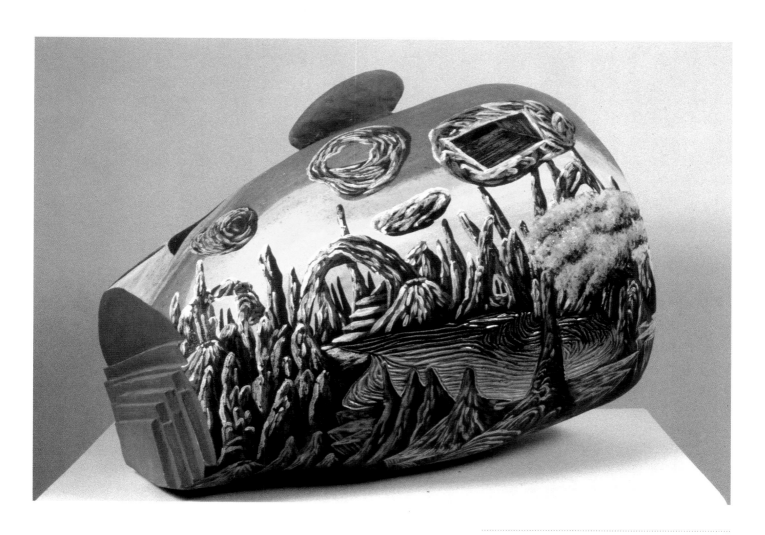

12. LUNAR LIFE DREAMER, 1985 (VERSO)

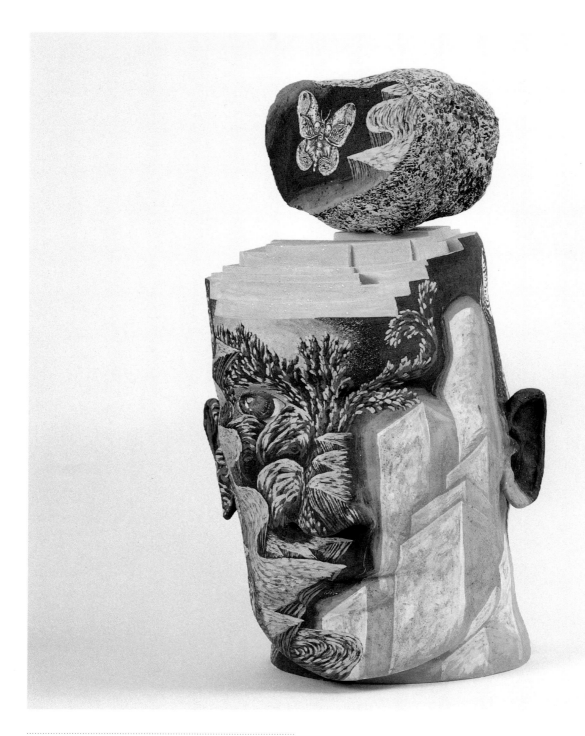

13. DAYDREAMER WITH ROCK, 1985 (RECTO)

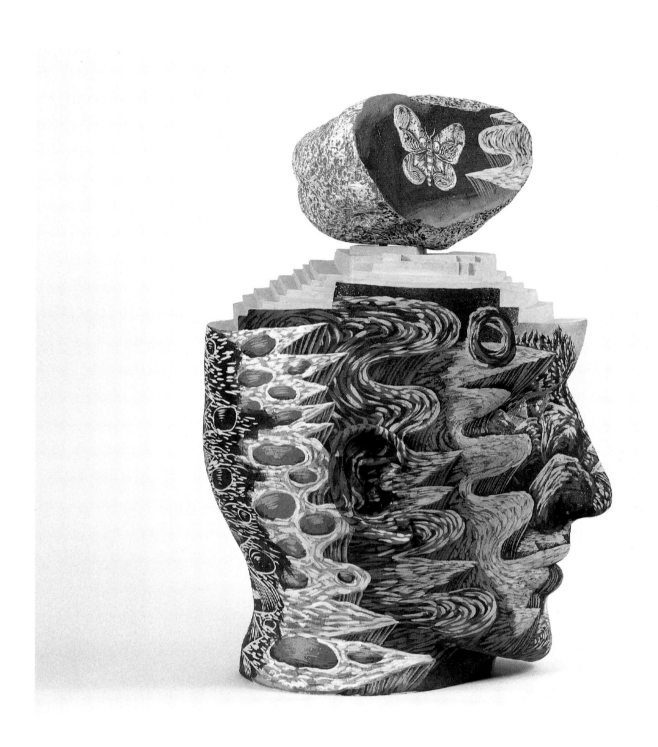

14. DAYDREAMER WITH ROCK, 1985 (VERSO)

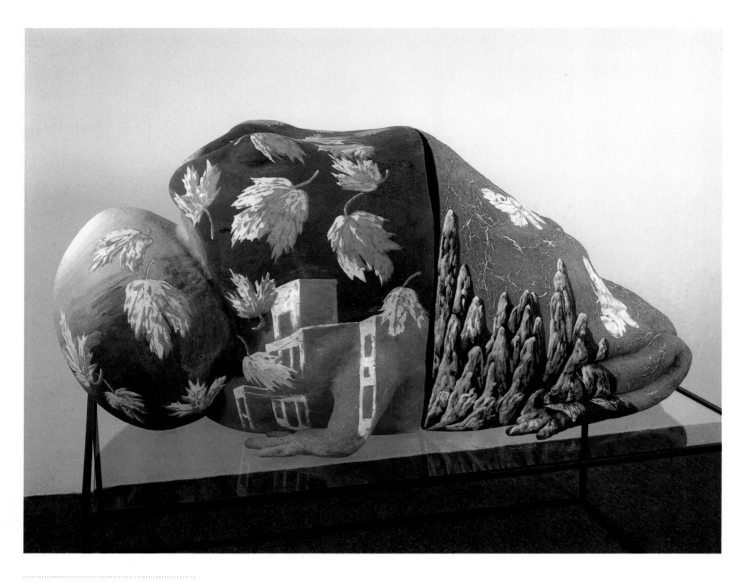

15. BIG FROG, 1986 (RECTO)

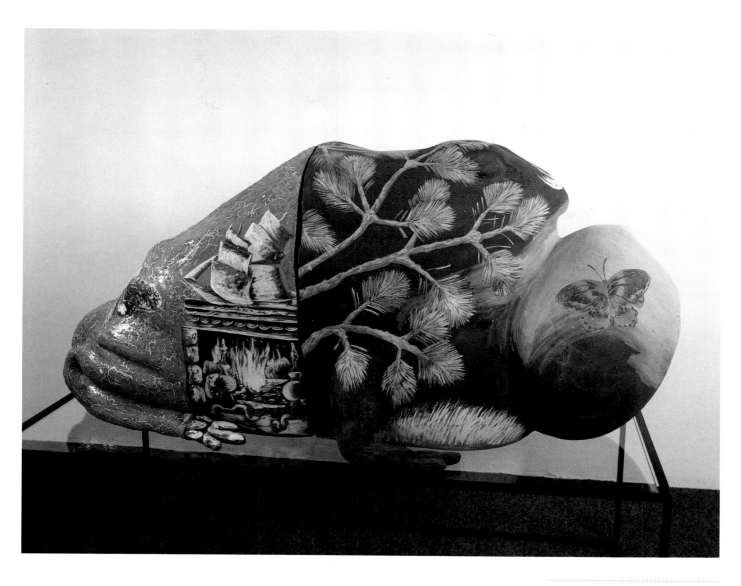

16. BIG FROG, 1986 (VERSO)

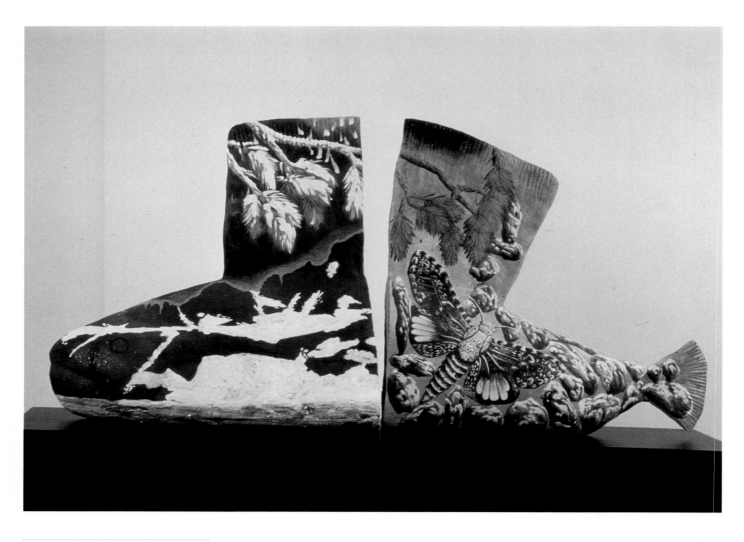

17. PIKE PERCH, 1986 (RECTO)

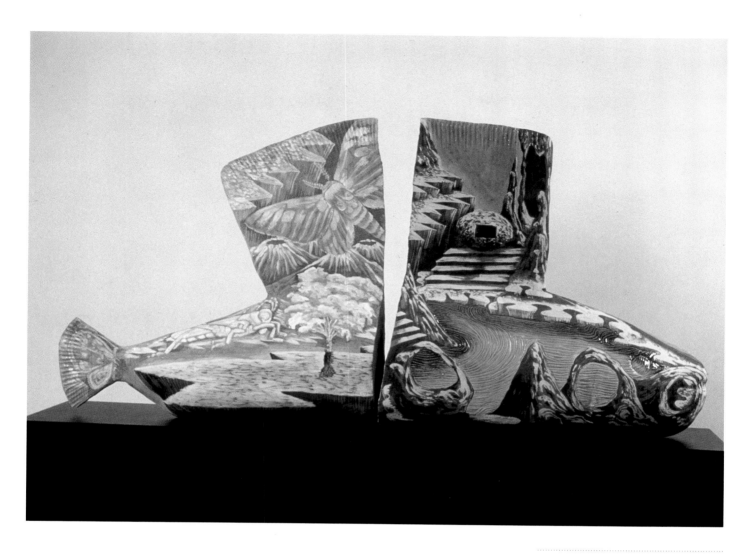

18. **PIKE PERCH, 1986** (VERSO)

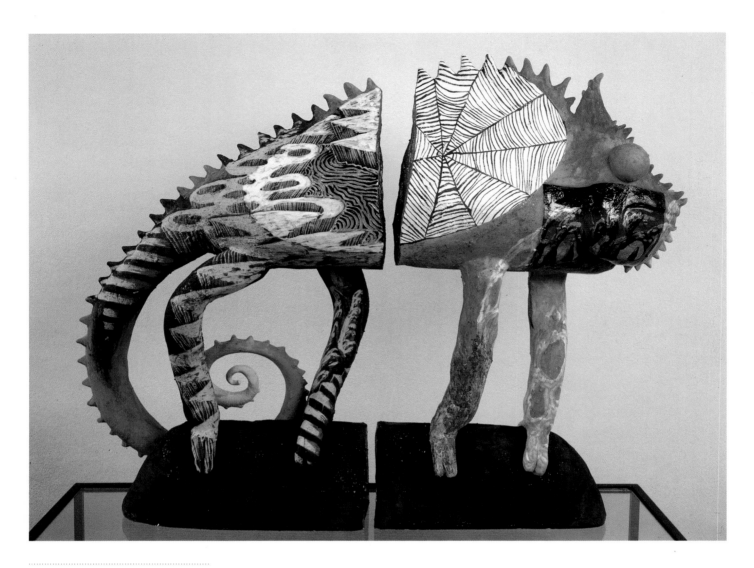

19. CAMELEON, 1986 (RECTO)

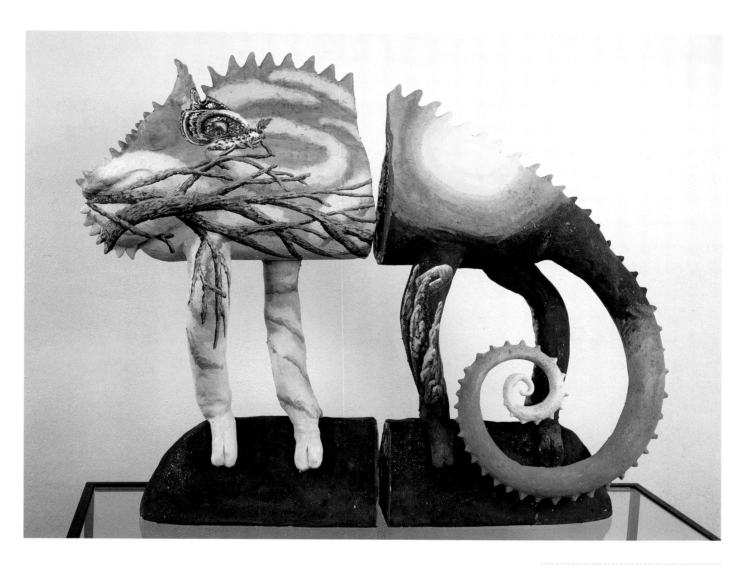

20. CAMELEON, 1986 (VERSO)

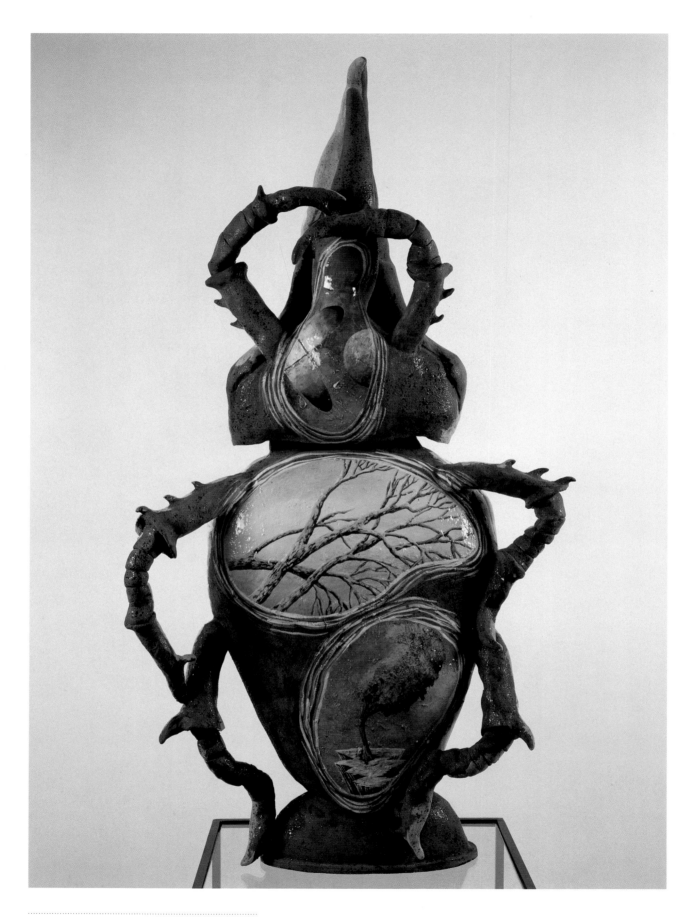

21. HERCULES BEETLE, 1986 (RECTO)

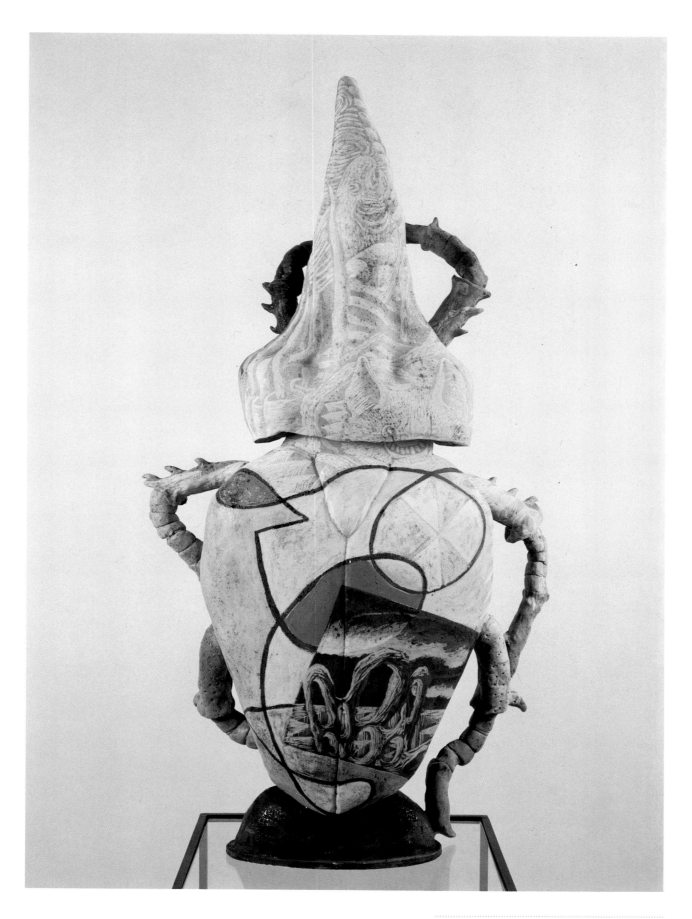

22. HERCULES BEETLE, 1986 (VERSO)

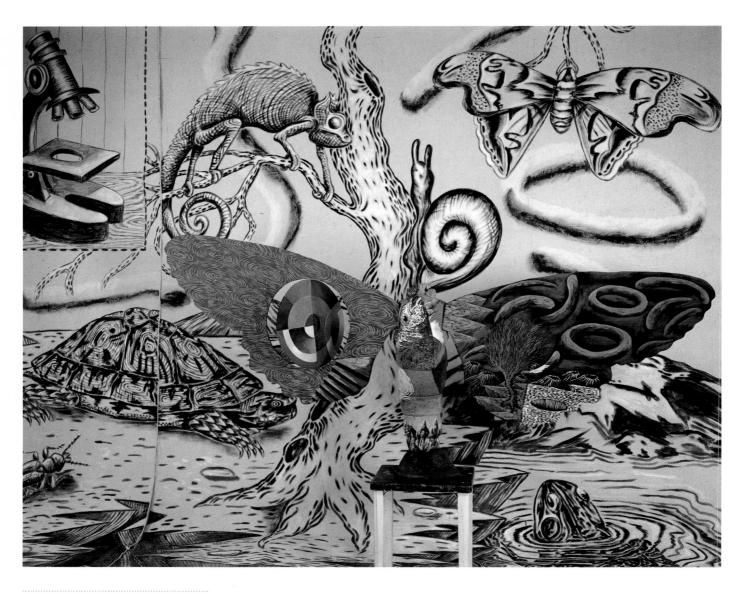

23. UNIDENTIFIED MOTH, 1986

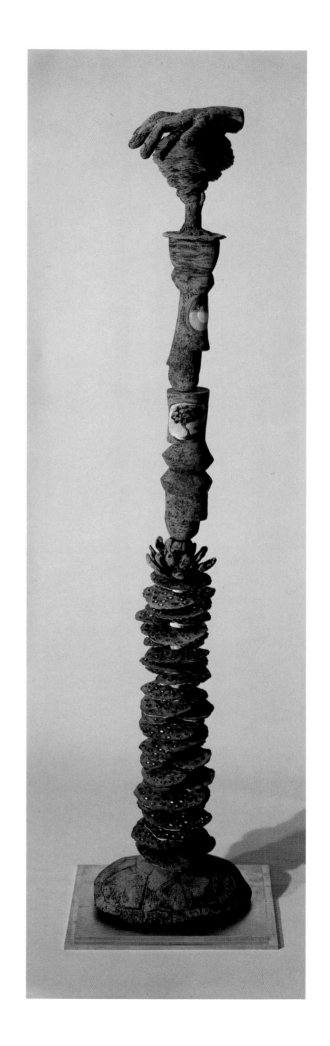

24. POND TOTEM, 1987

25. GREENHOUSE, 1988

26. SPIRIT, 1988

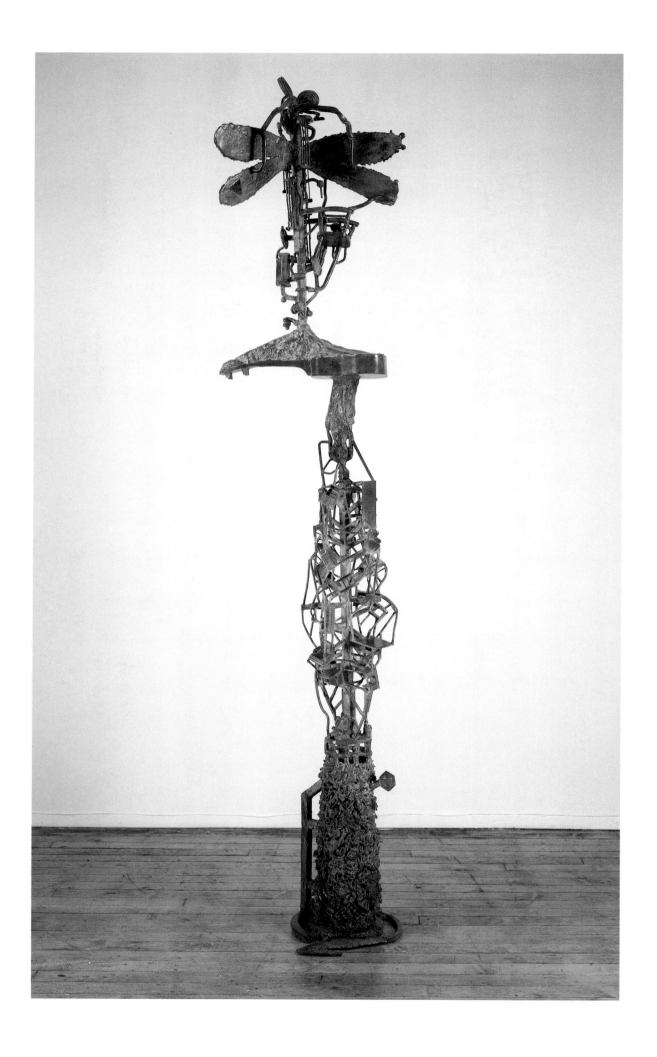

27. FOSSIL FUEL, 1988

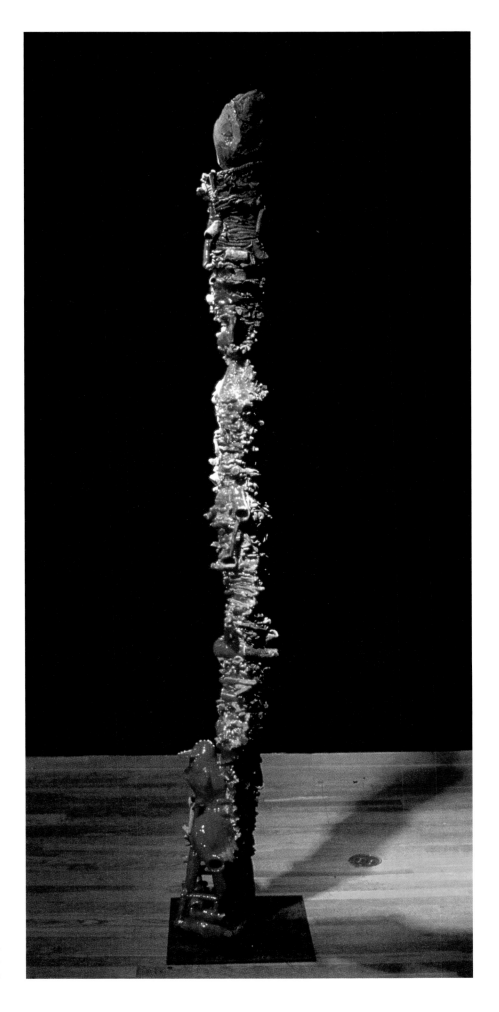

28. SELF-PORTRAIT AS
PRE-COLUMBIAN, 1989

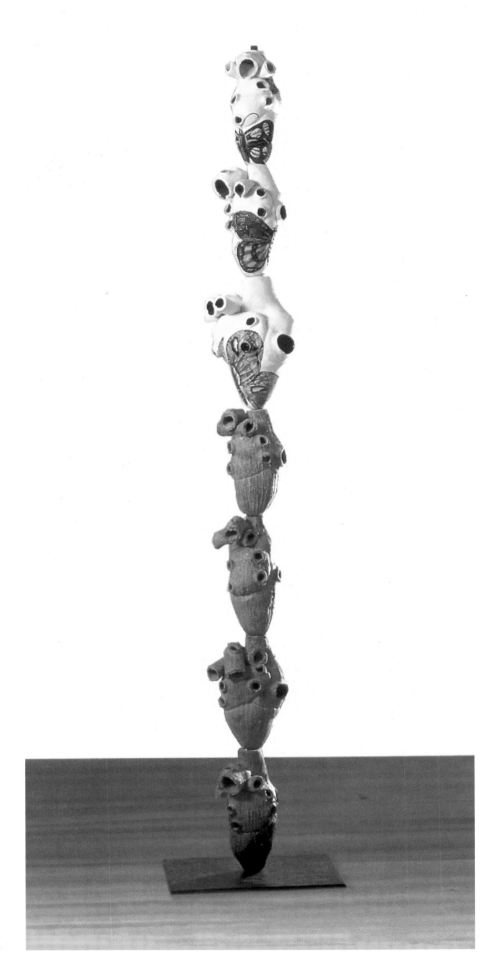

29. DRY LAND TOTEM, 1989

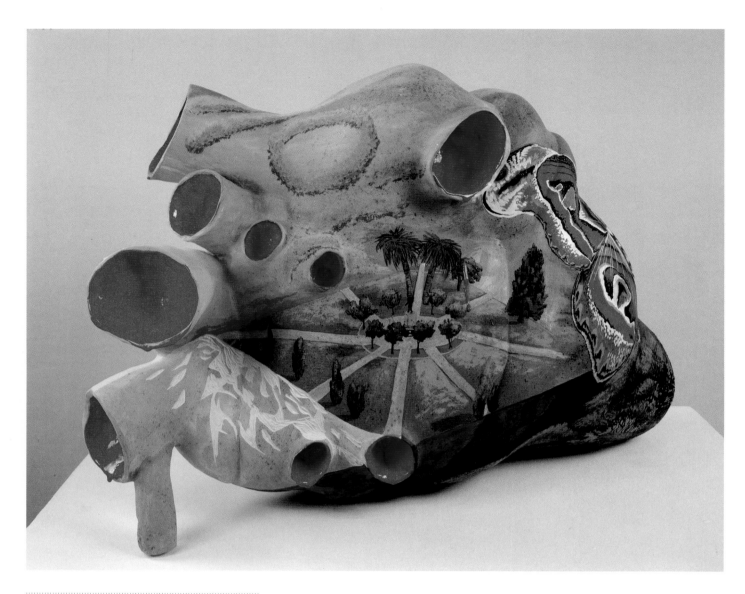

30. BIG HEART (PLAZA), 1989 (RECTO)

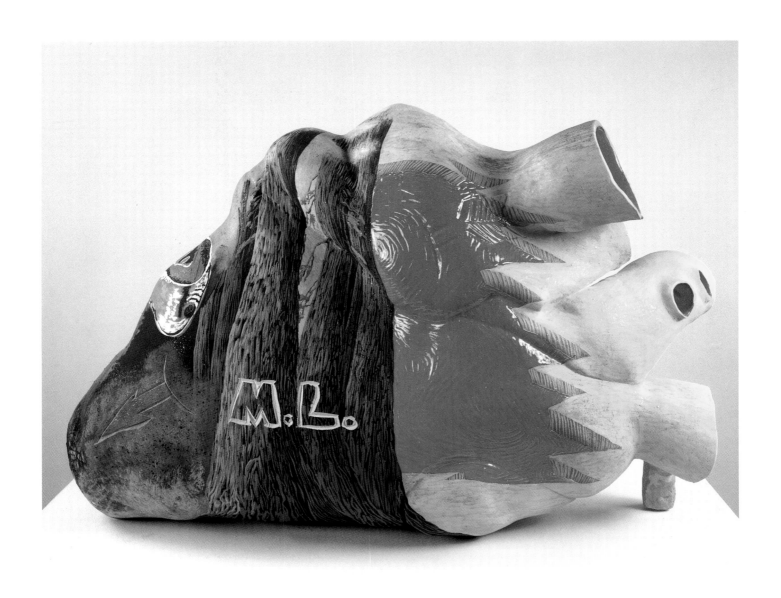

31. **BIG HEART (PLAZA), 1989** (VERSO)

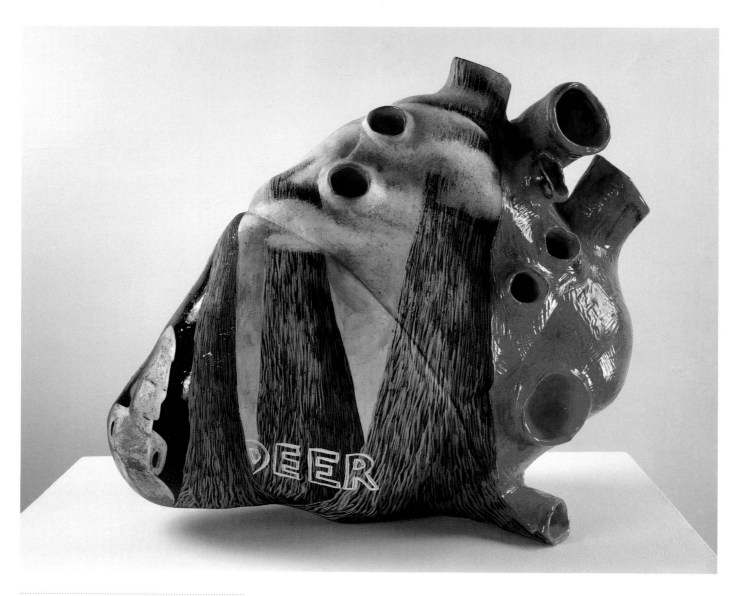

32. BIG HEART (DEER), 1989 (RECTO)

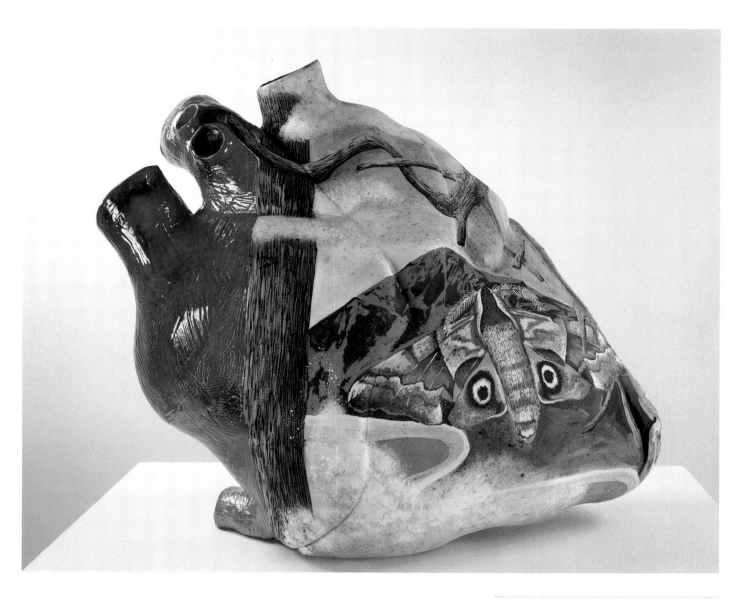

33. BIG HEART (DEER), 1989 (VERSO)

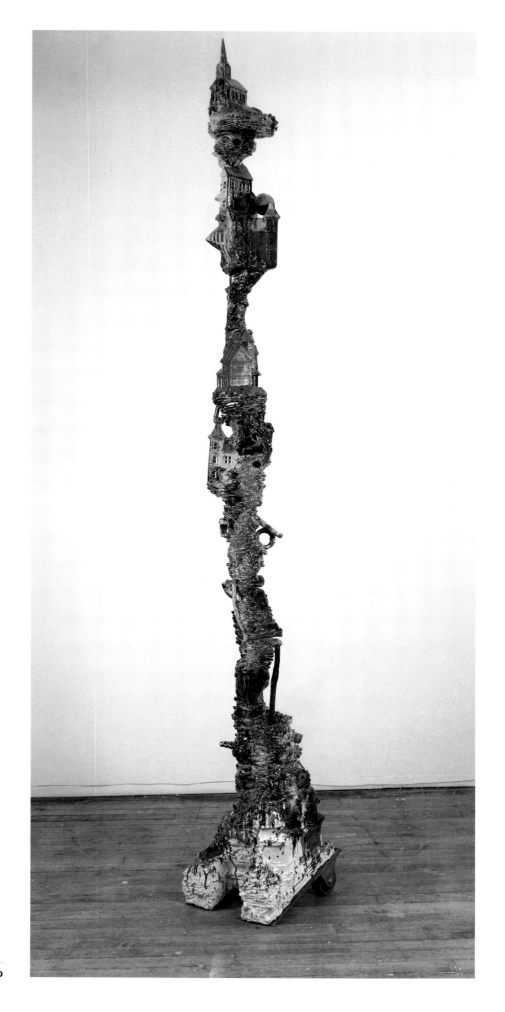

34. COHASSET, 1990

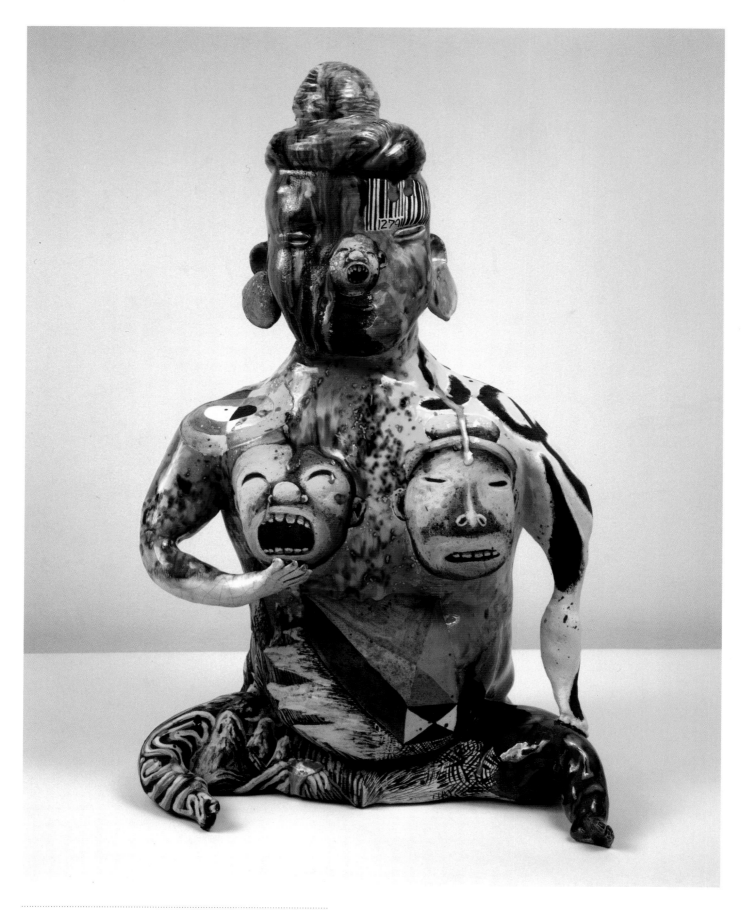

35. SEATED LADY (PRE-COLUMBUS), 1991 (RECTO)

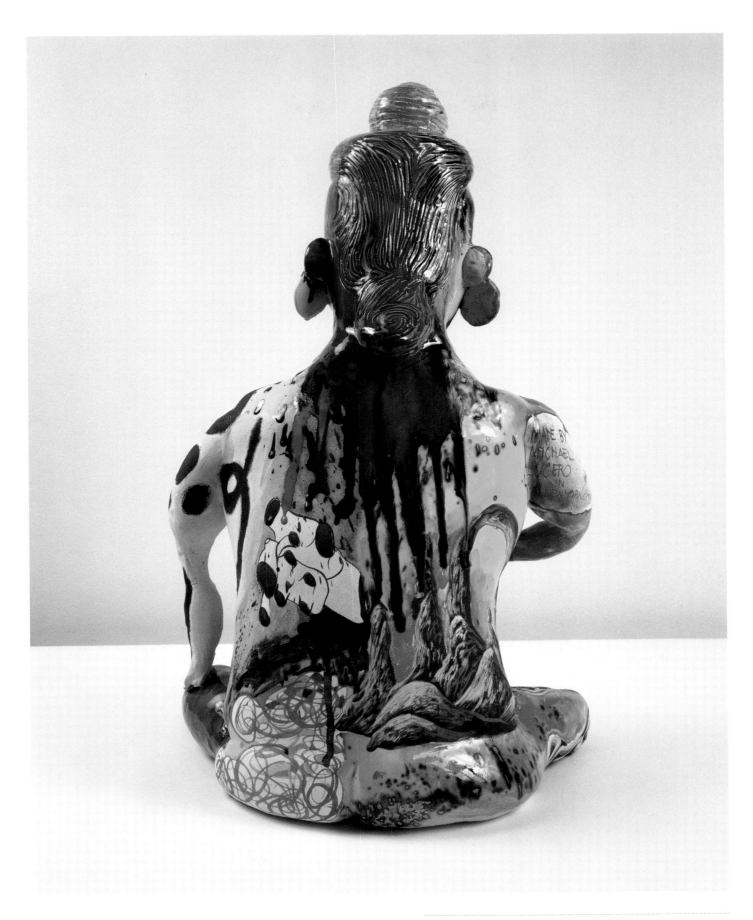

36. SEATED LADY (PRE-COLUMBUS), 1991 (VERSO)

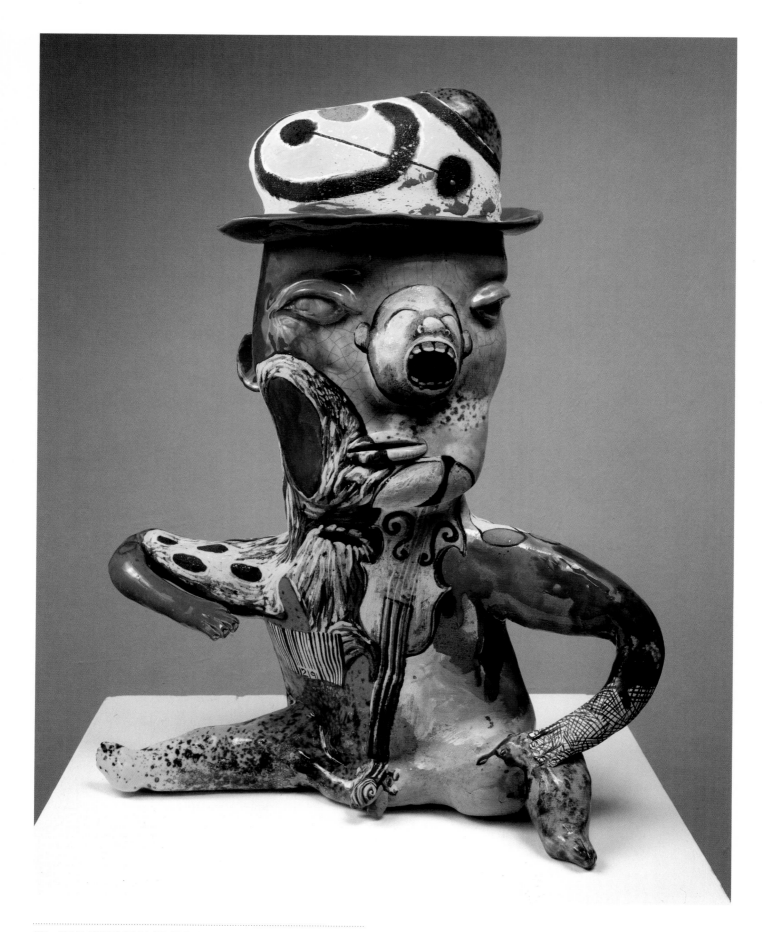

37. MAN WITH VIOLIN (PRE-COLUMBUS), 1991 (RECTO)

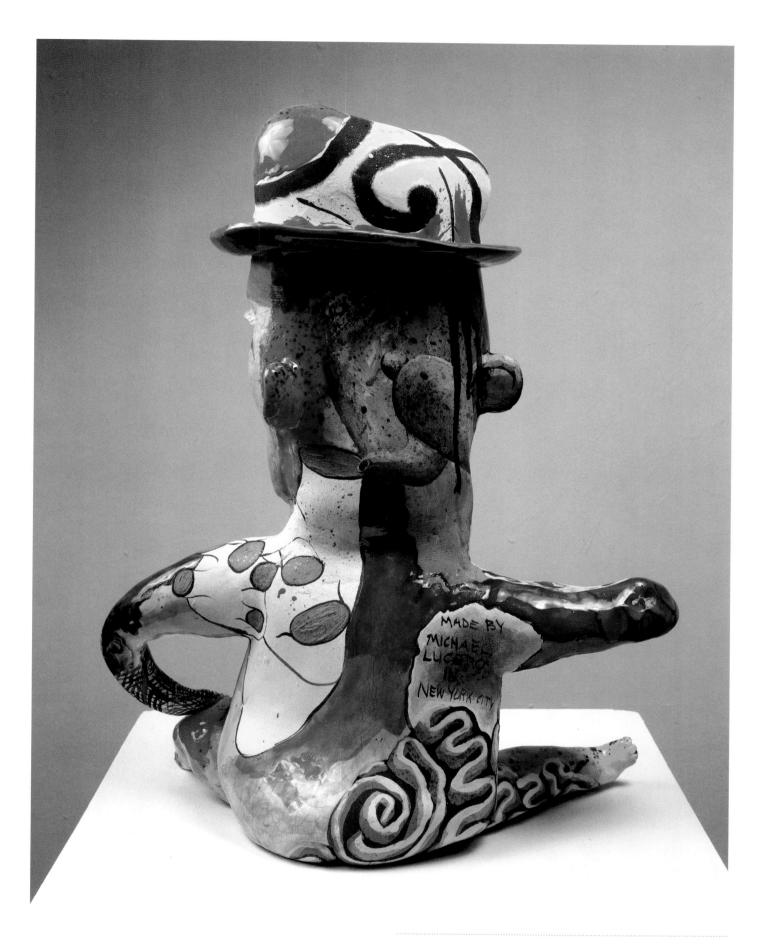

38. **MAN WITH VIOLIN (PRE-COLUMBUS), 1991** (VERSO)

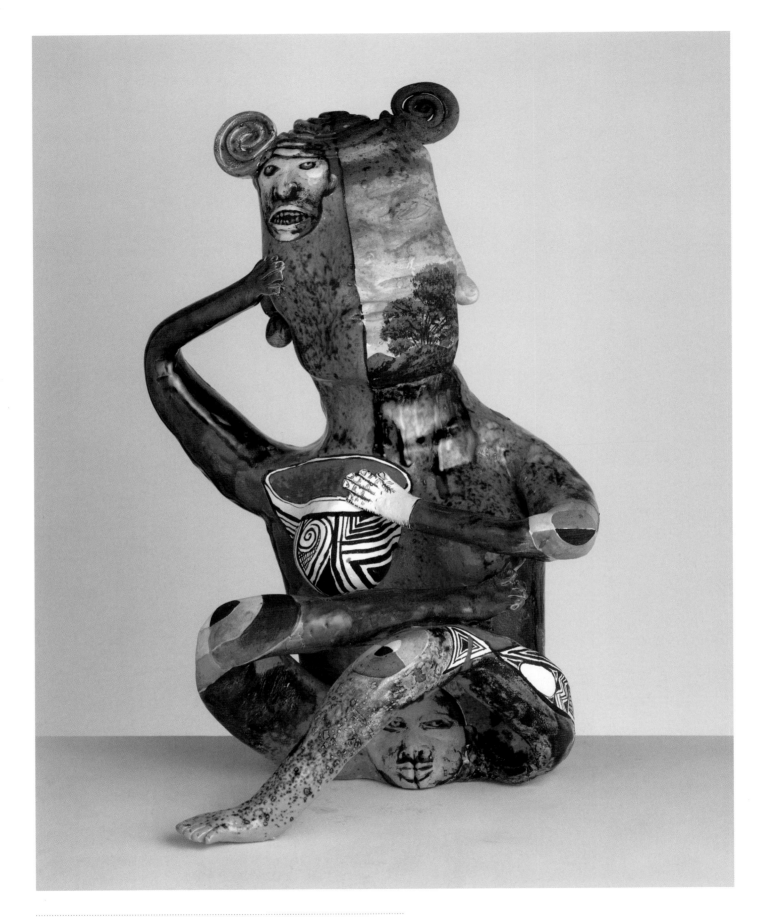

39. LADY WITH TWO CURLS (PRE-COLUMBUS), 1991 (RECTO)

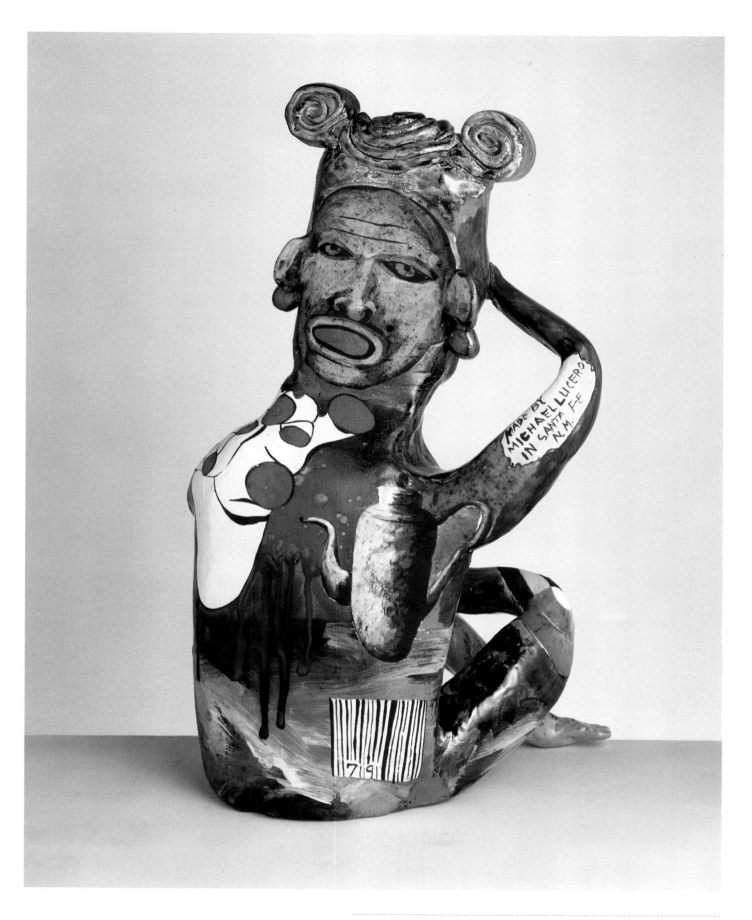

40. **LADY WITH TWO CURLS (PRE-COLUMBUS), 1991** (VERSO)

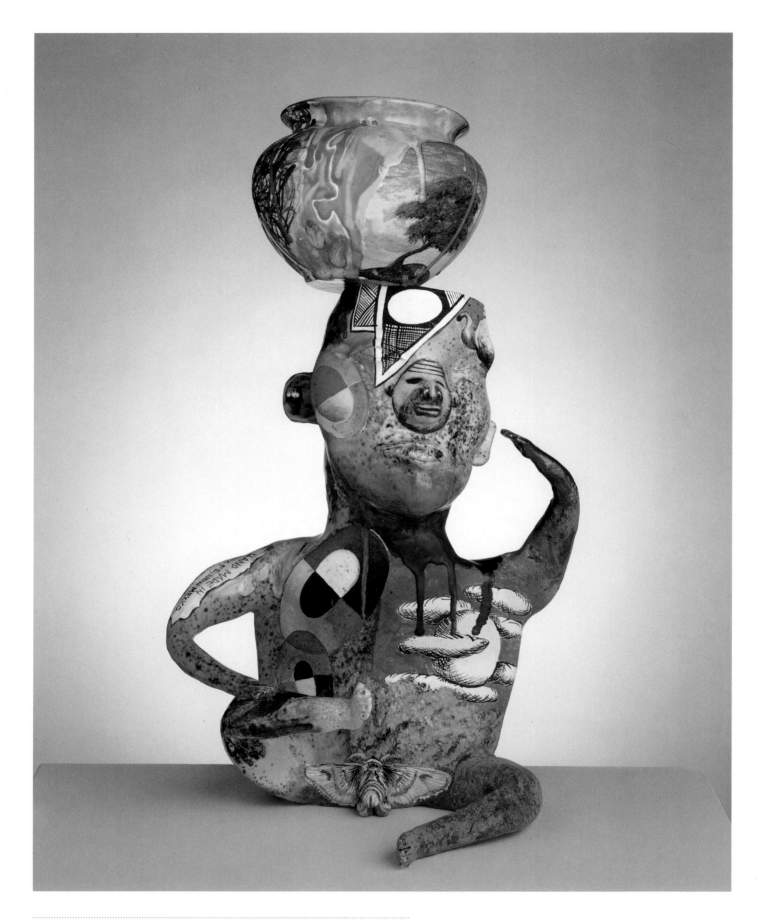

41. MAN BALANCING VESSEL (PRE-COLUMBUS), 1991 (RECTO)

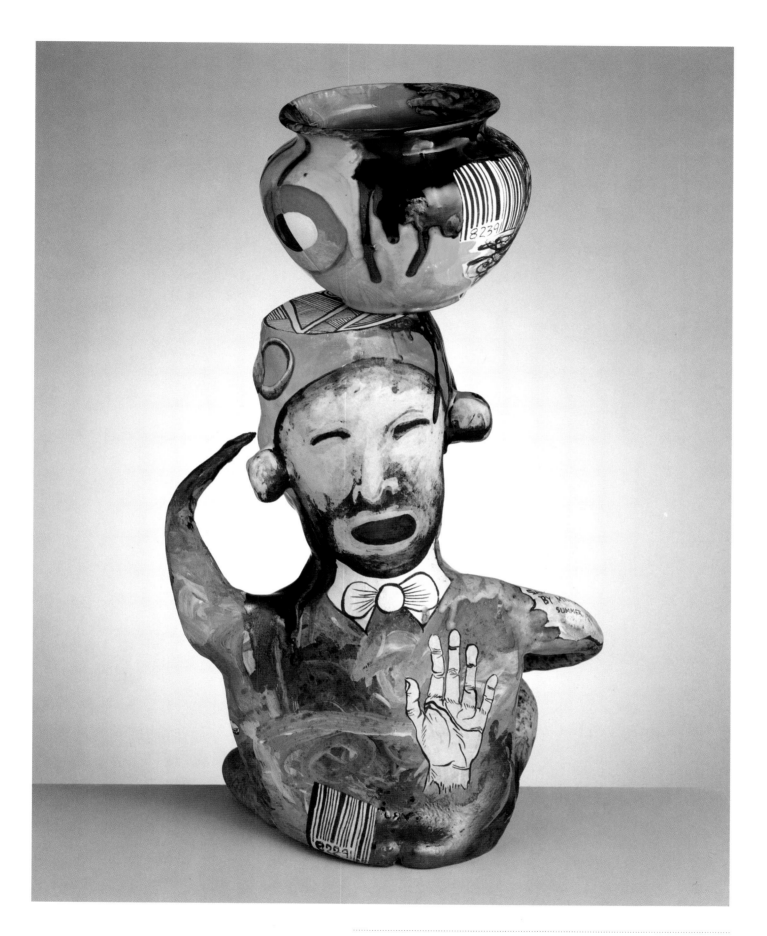

42. MAN BALANCING VESSEL (PRE-COLUMBUS), 1991 (VERSO)

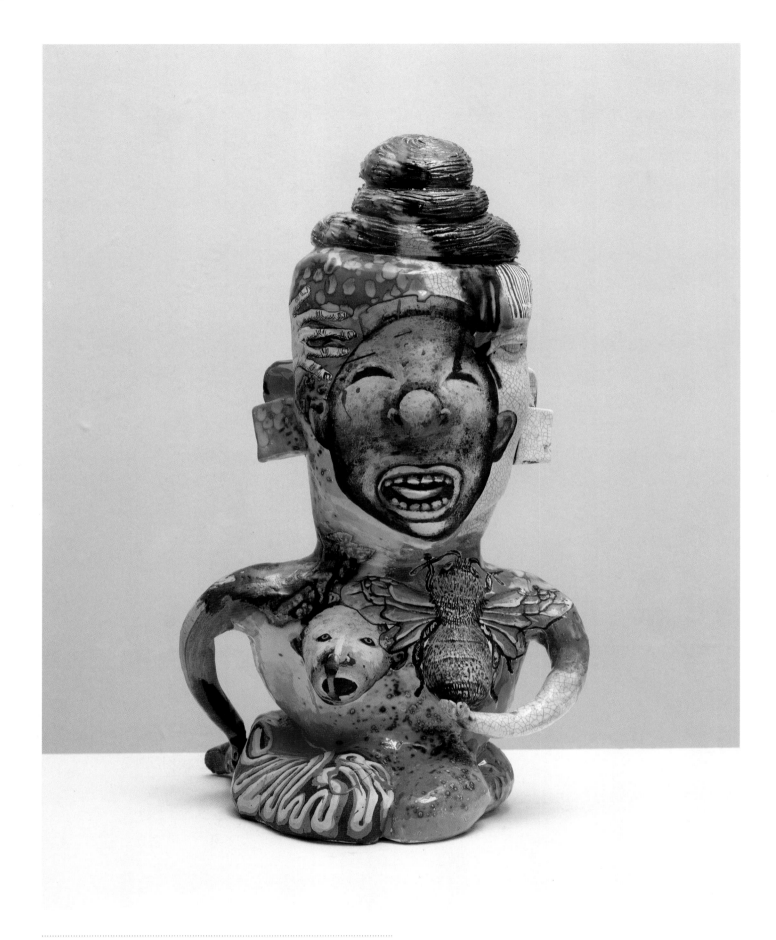

43. LADY WITH BEE HIVE (PRE-COLUMBUS), 1991 (RECTO)

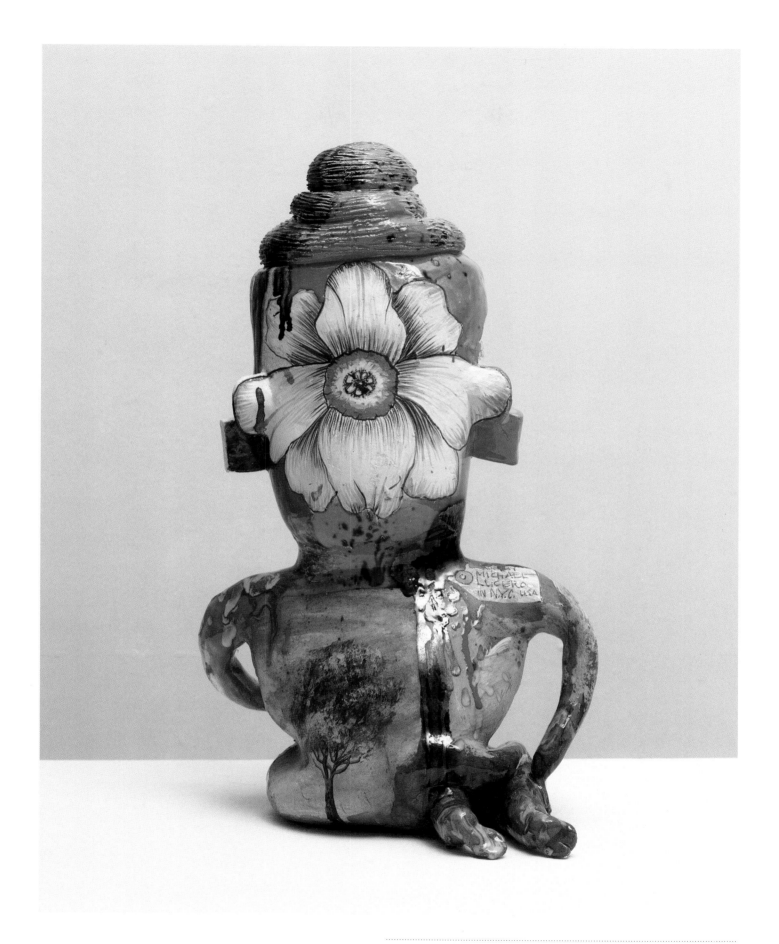

44. LADY WITH BEE HIVE (PRE-COLUMBUS), 1991 (VERSO)

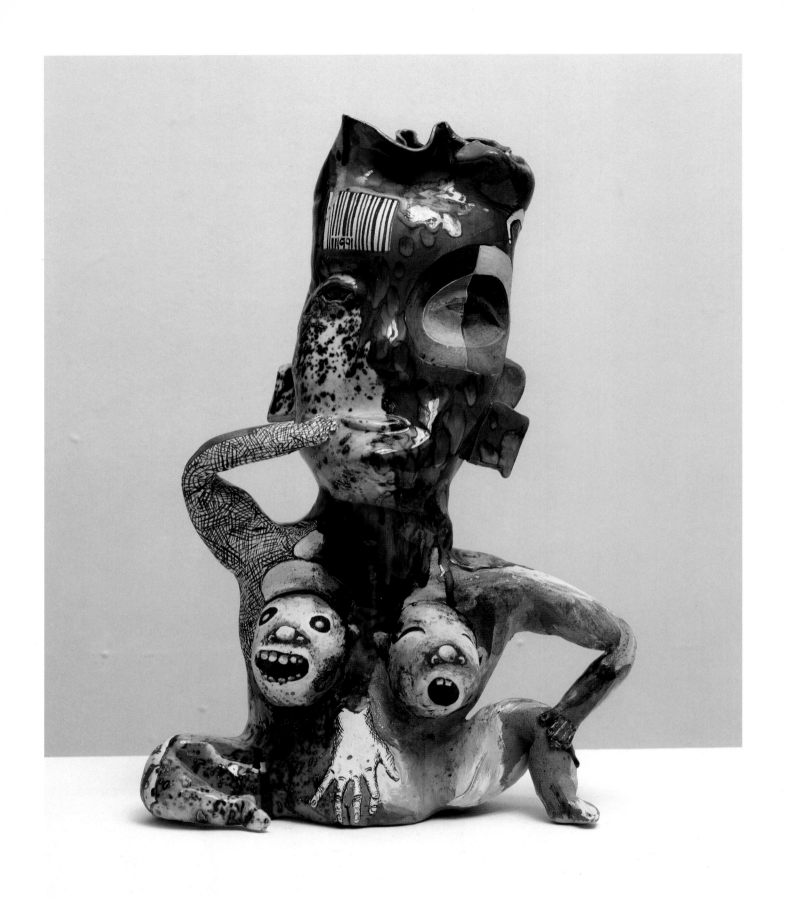

45. YOUNG LADY WITH OHR HAIR (PRE-COLUMBUS), 1991 (RECTO)

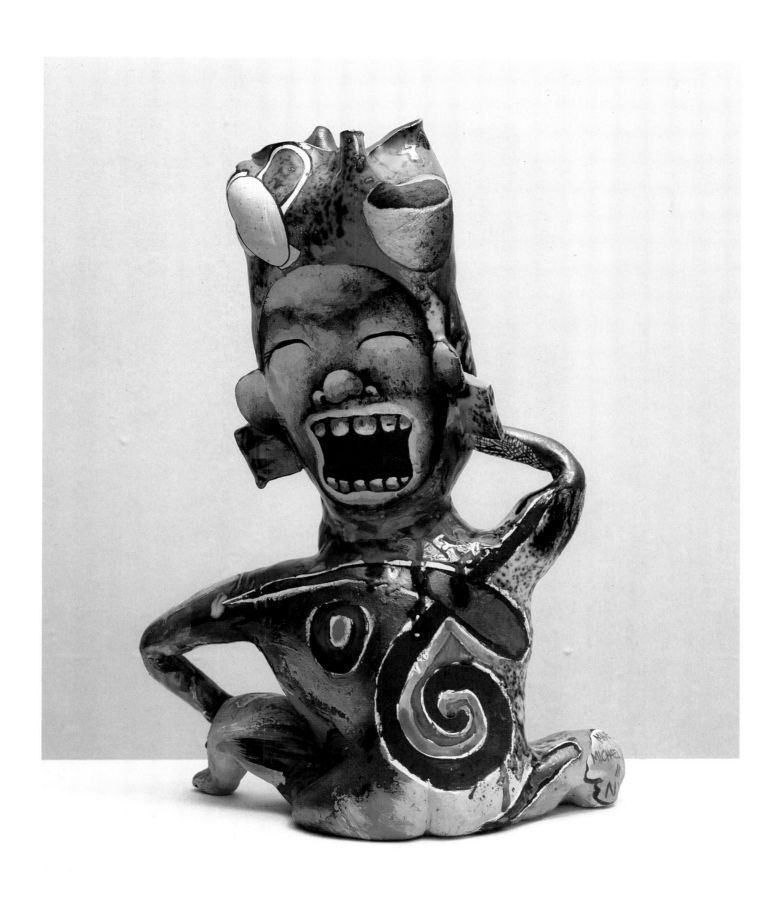

46. YOUNG LADY WITH OHR HAIR (PRE-COLUMBUS), 1991 (VERSO)

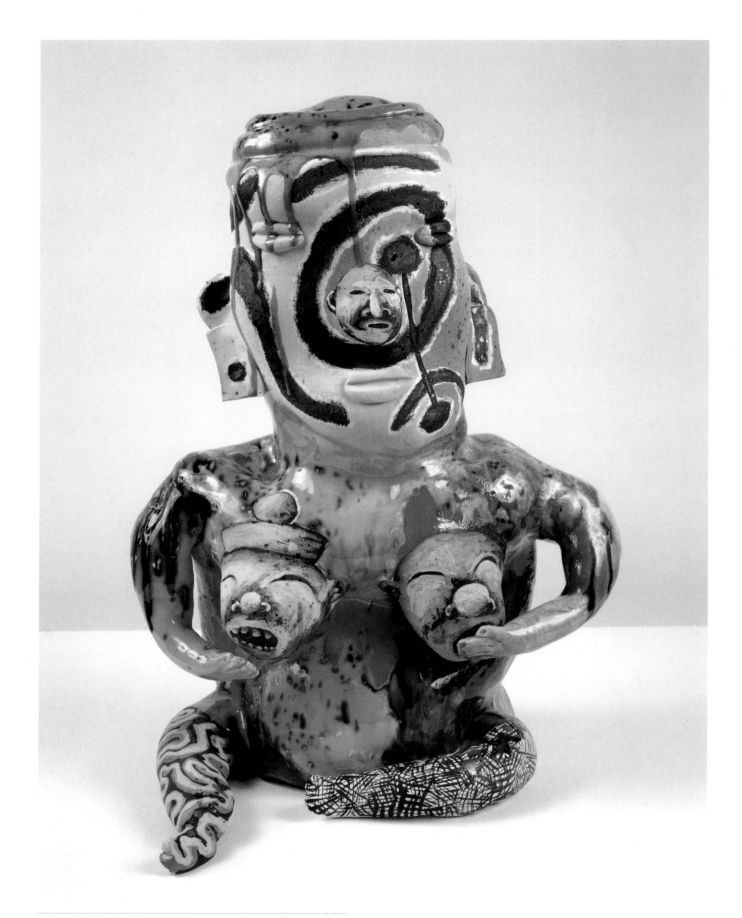

47. MIRÓ MOTHER (PRE-COLUMBUS), 1992 (RECTO)

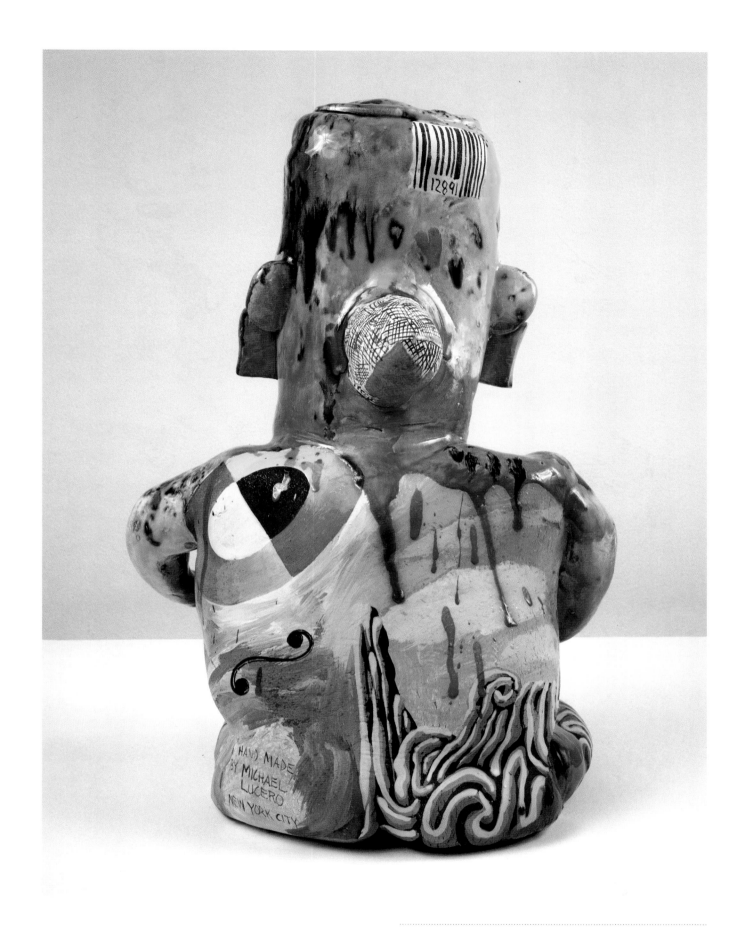

48. MIRÓ MOTHER (PRE-COLUMBUS), 1992 (VERSO)

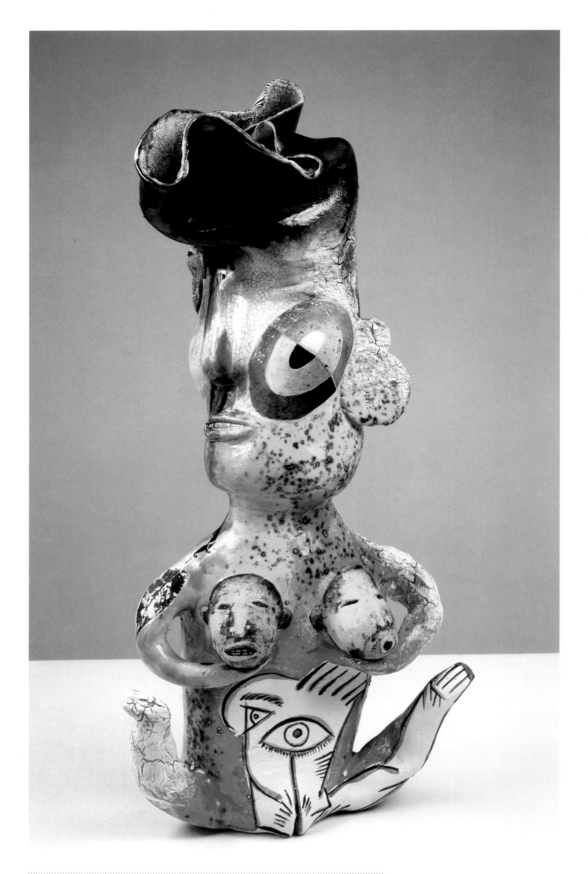

49. LADY WITH OHR HAIR (PRE-COLUMBUS), 1992 (RECTO)

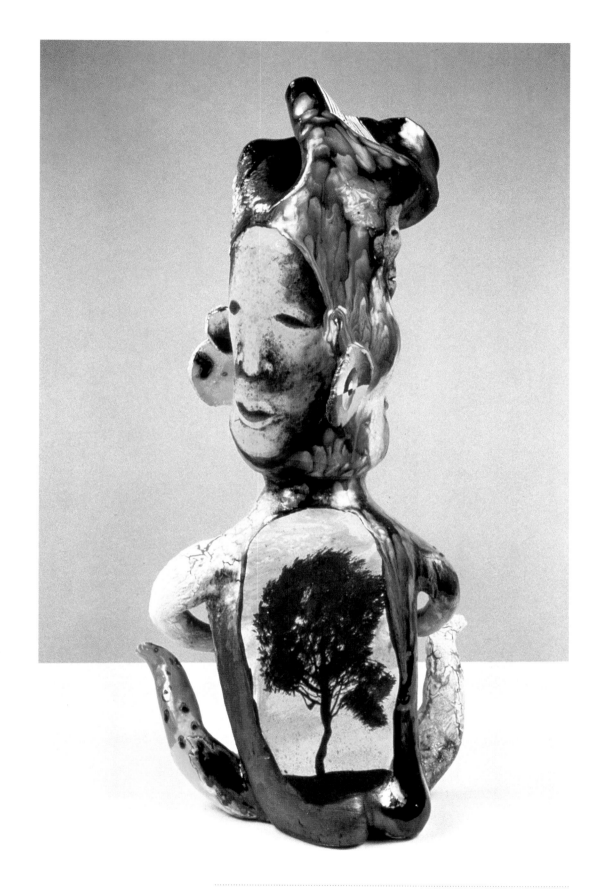

50. LADY WITH OHR HAIR (PRE-COLUMBUS), 1992 (VERSO)

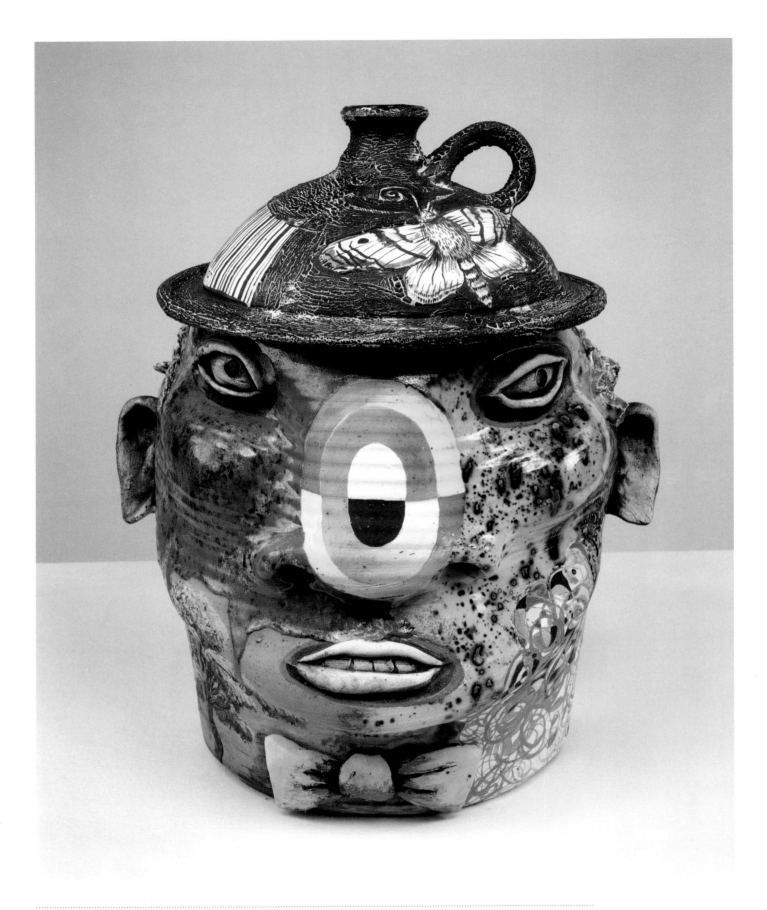

51. ANTHROPOMORPHIC JUG HEAD WITH MOTH ON HAT (NEW WORLD SERIES), 1992 (RECTO)

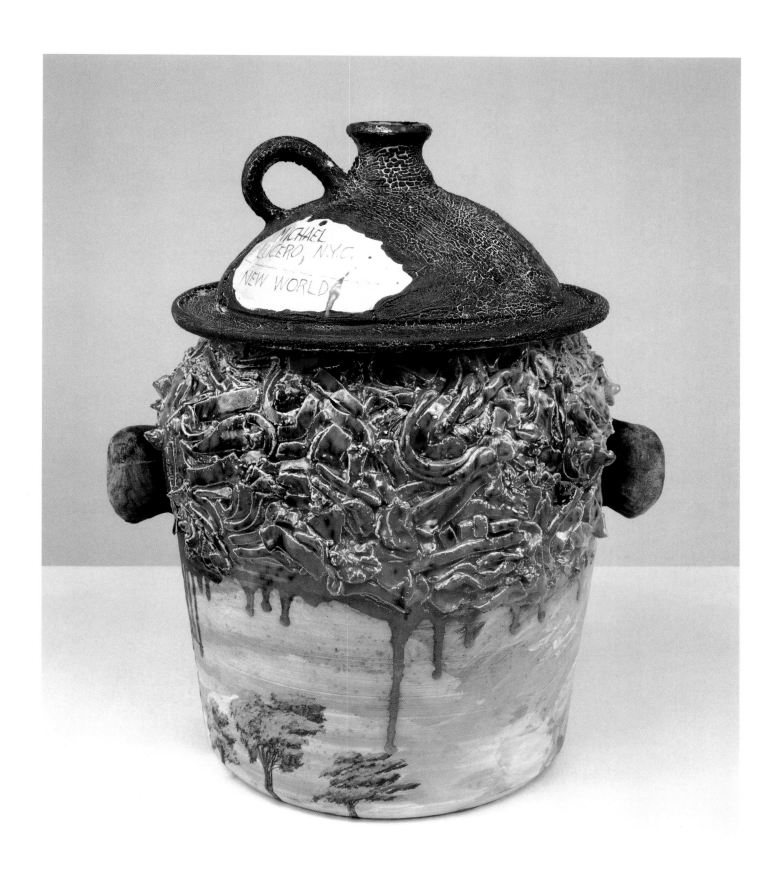

52. ANTHROPOMORPHIC JUG HEAD WITH MOTH ON HAT (NEW WORLD SERIES), 1992 (VERSO)

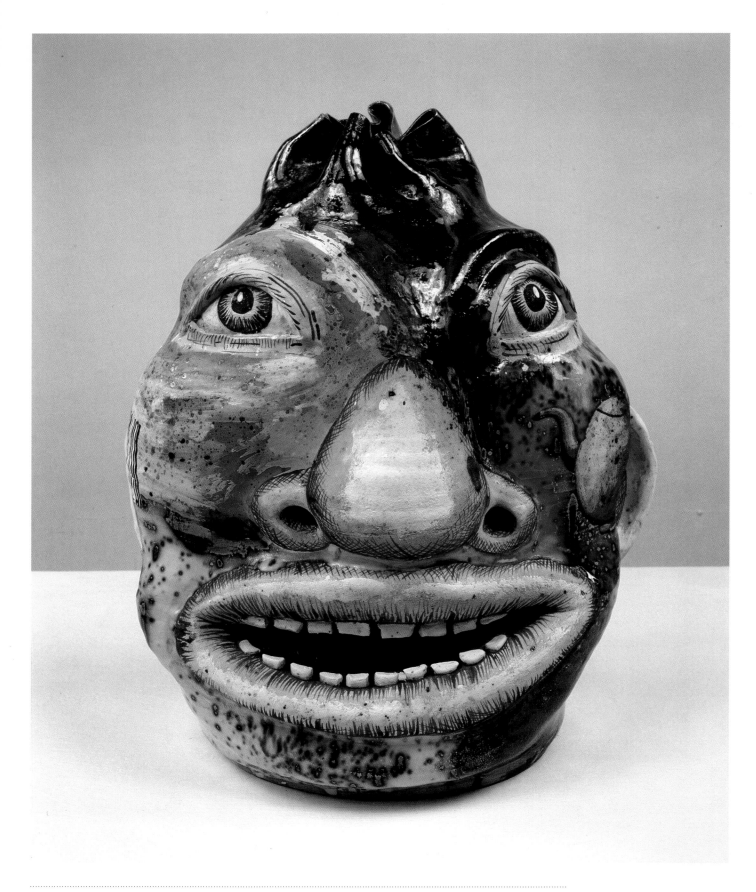

53. ANTHROPOMORPHIC JUG HEAD WITH OHR HAIR (NEW WORLD SERIES), 1992 (RECTO)

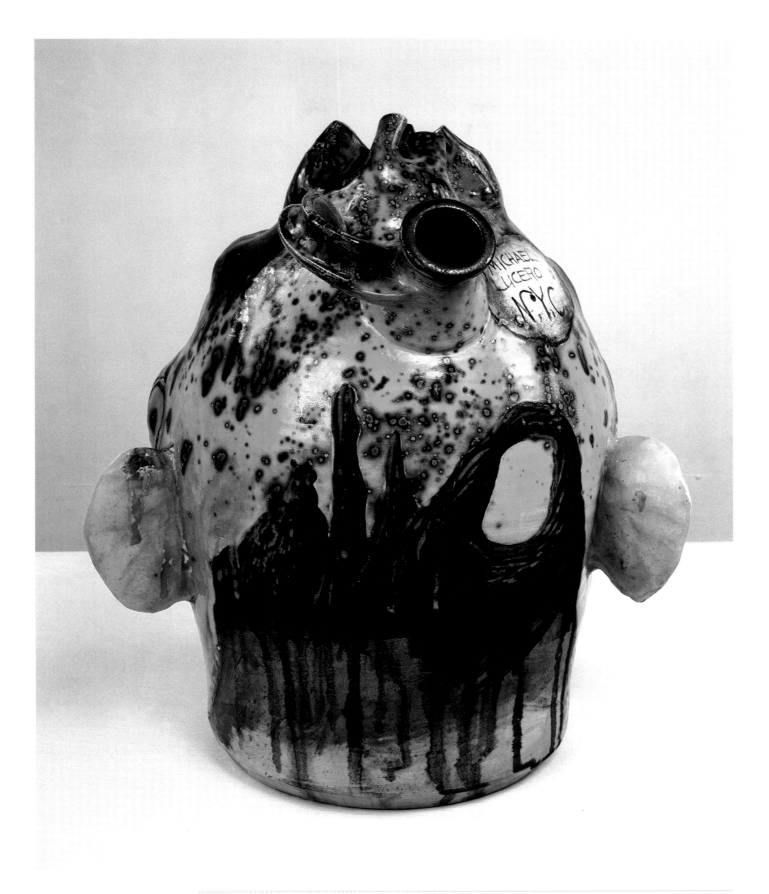

54. ANTHROPOMORPHIC JUG HEAD WITH OHR HAIR (NEW WORLD SERIES), 1992 (VERSO)

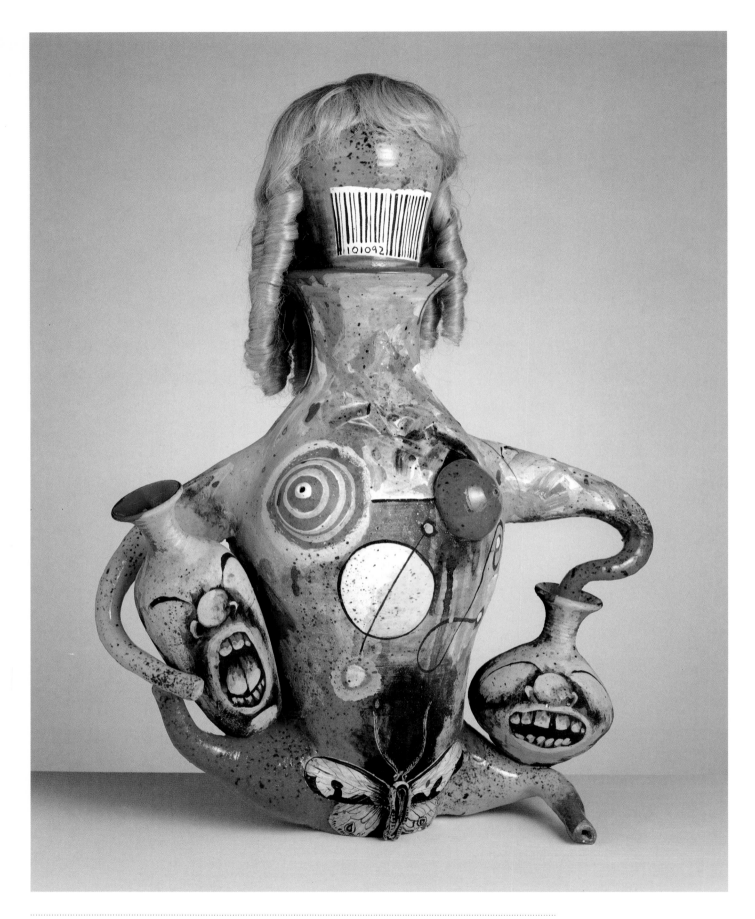

55. ANTHROPOMORPHIC FEMALE FORM WITH WIG (NEW WORLD SERIES), 1992 (RECTO)

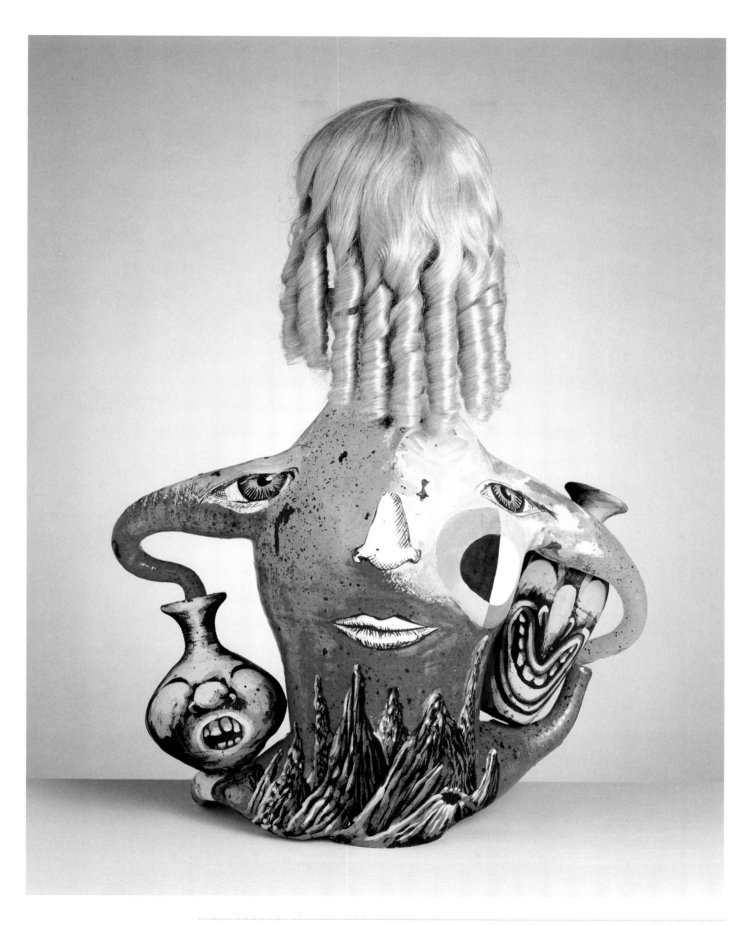

56. ANTHROPOMORPHIC FEMALE FORM WITH WIG (NEW WORLD SERIES), 1992 (VERSO)

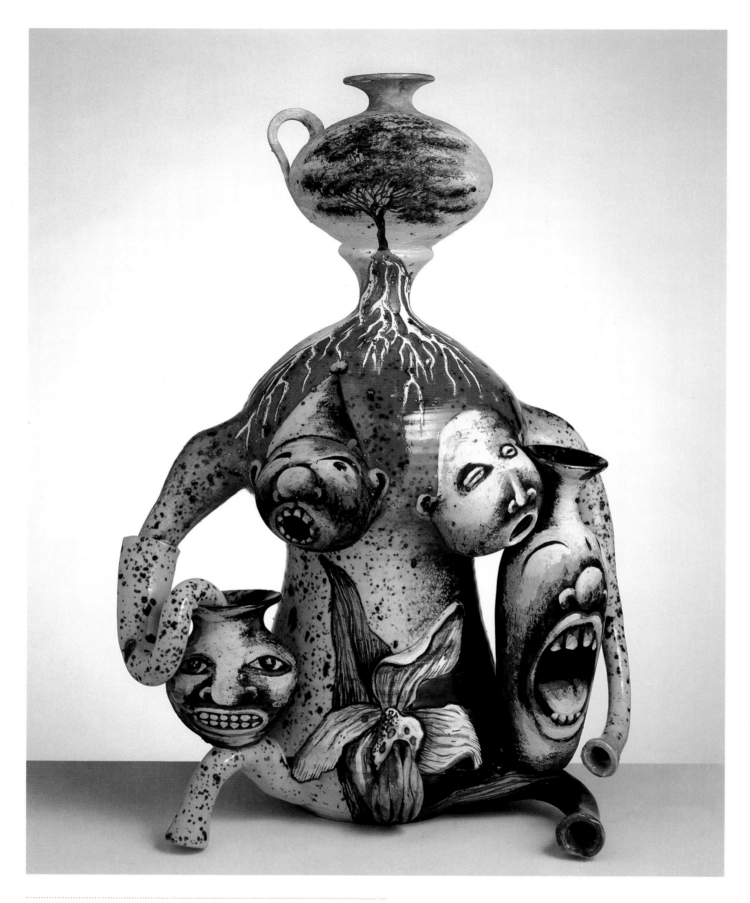

57. LADY WITH ROOTS (NEW WORLD SERIES), 1993 (RECTO)

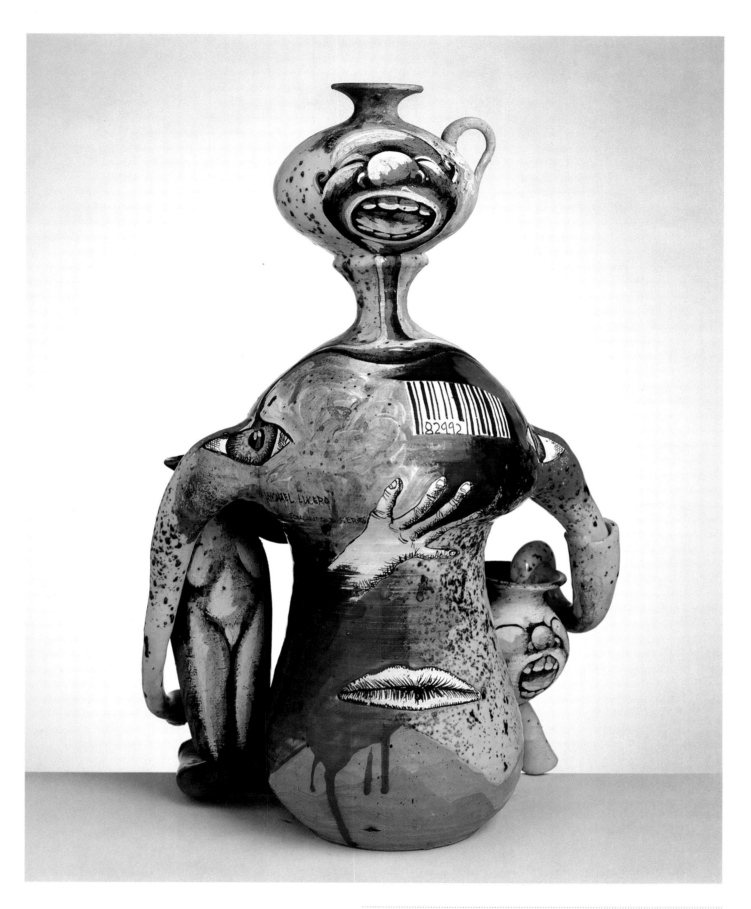

58. LADY WITH ROOTS (NEW WORLD SERIES), 1993 (VERSO)

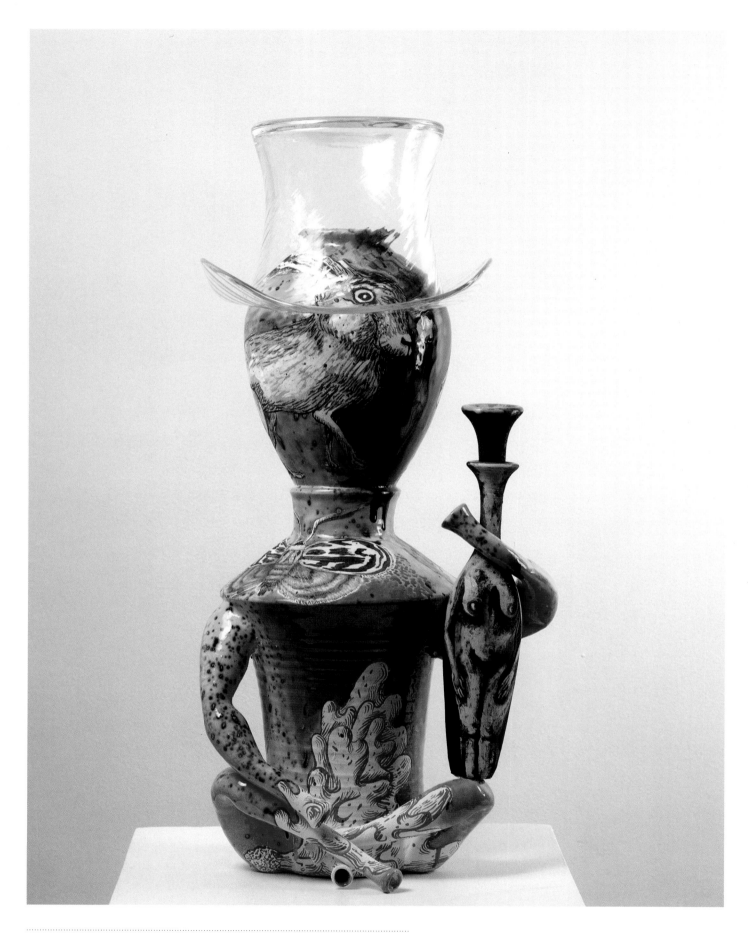

59. MAN WITH GLASS HAT (NEW WORLD SERIES), 1993 (RECTO)

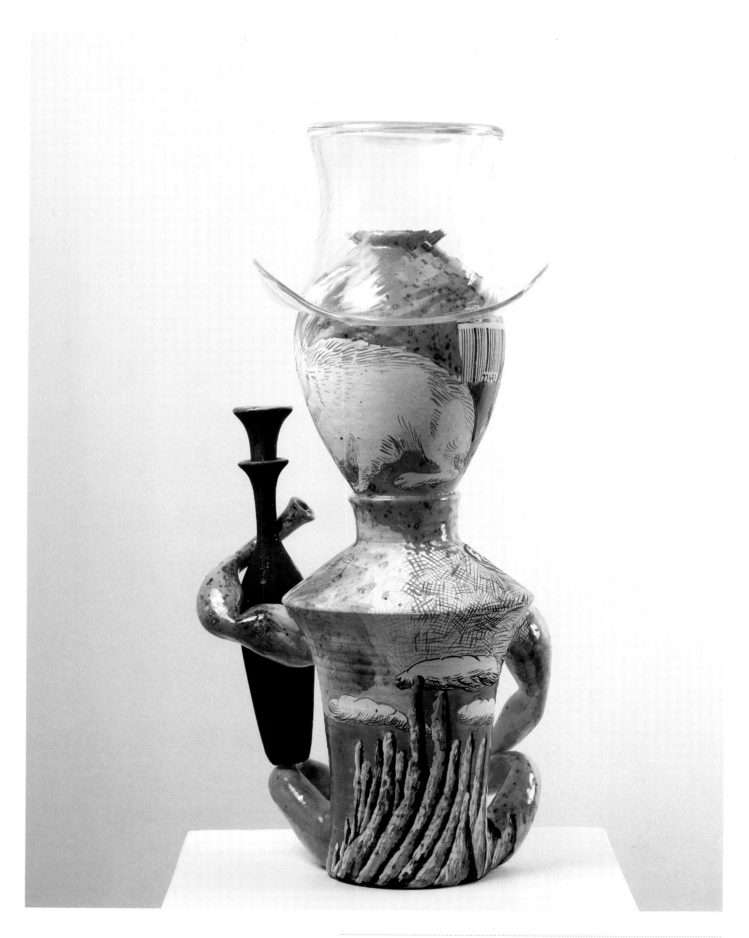

60. MAN WITH GLASS HAT (NEW WORLD SERIES), 1993 (VERSO)

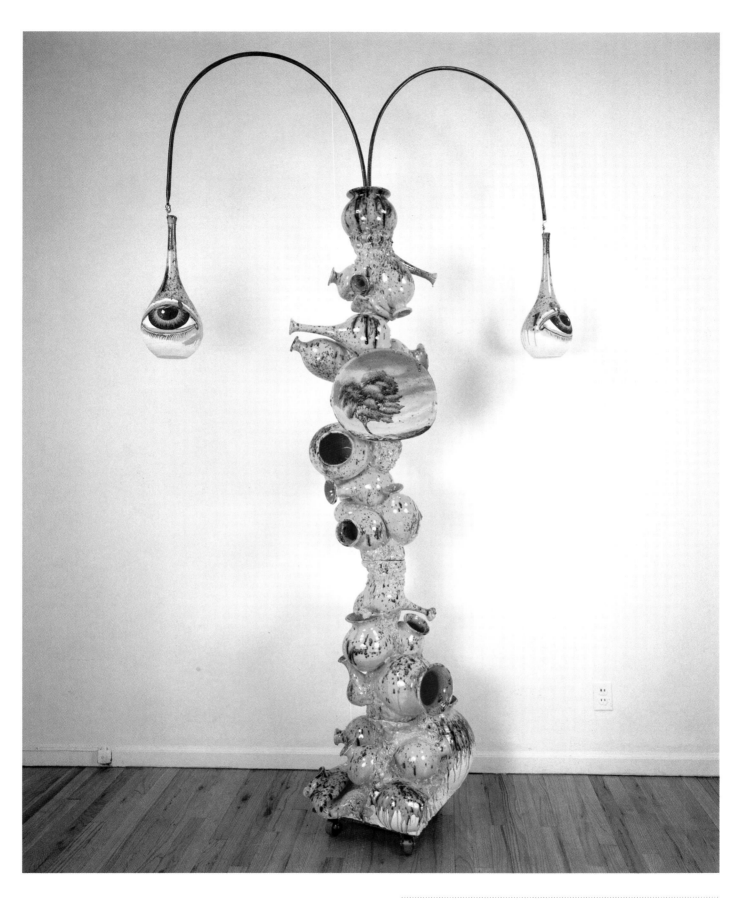

61. YELLOW SKY TOTEM (NEW WORLD SERIES), 1993

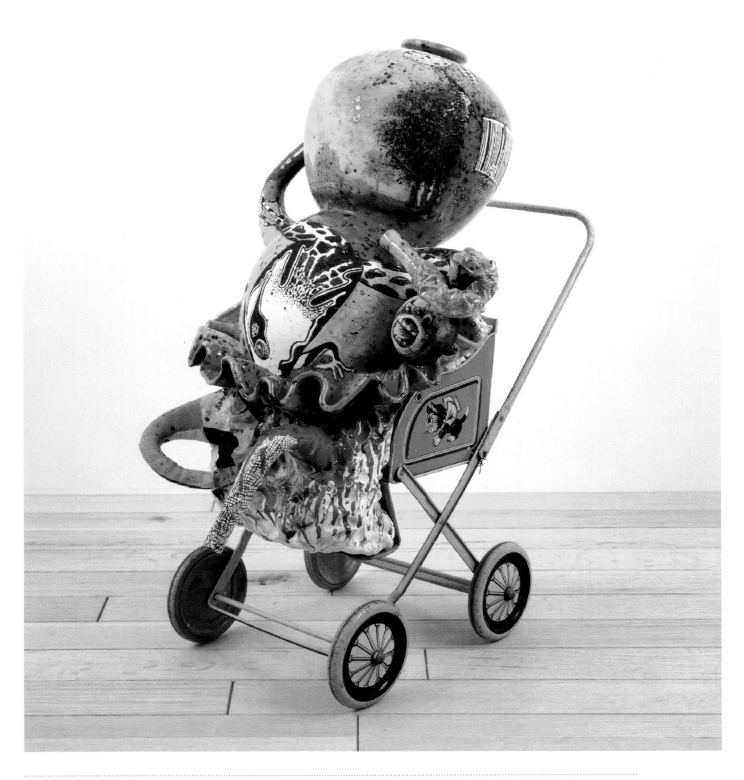

62. ANTHROPOMORPHIC INFANT FORM WITH TUTU IN STROLLER (NEW WORLD SERIES), 1993 (RECTO)

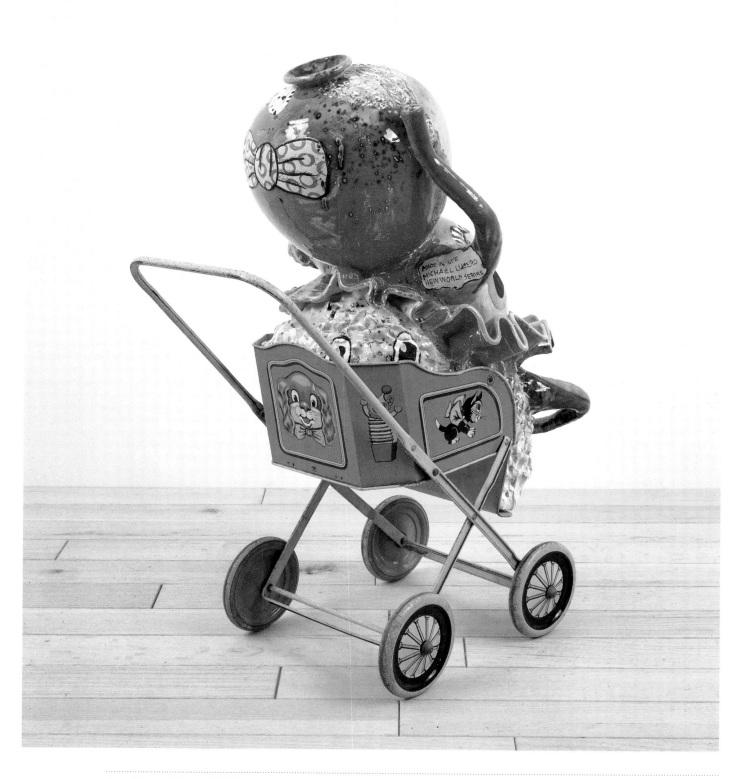

63. **ANTHROPOMORPHIC INFANT FORM WITH TUTU IN STROLLER (NEW WORLD SERIES), 1993** (VERSO)

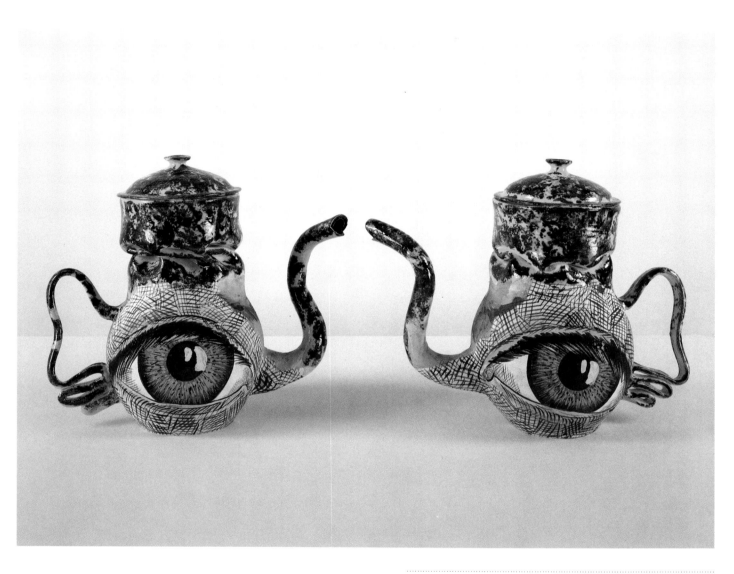

64. EYE OHR TEAPOTS (NEW WORLD SERIES), 1993

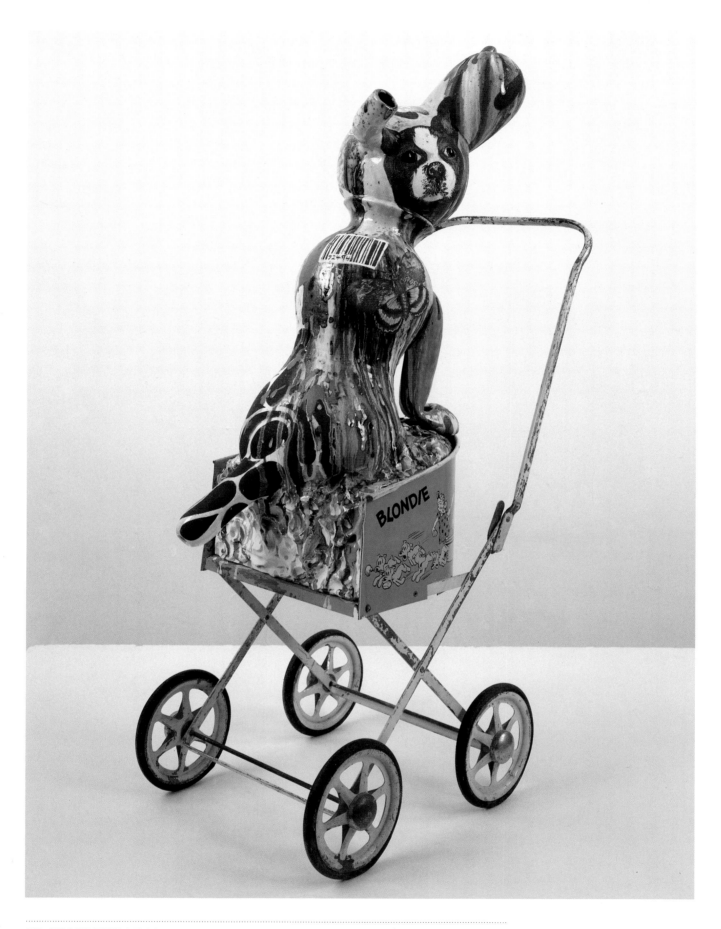

65. ZOOMORPHIC DOG FORM IN STROLLER (NEW WORLD SERIES), 1994 (RECTO)

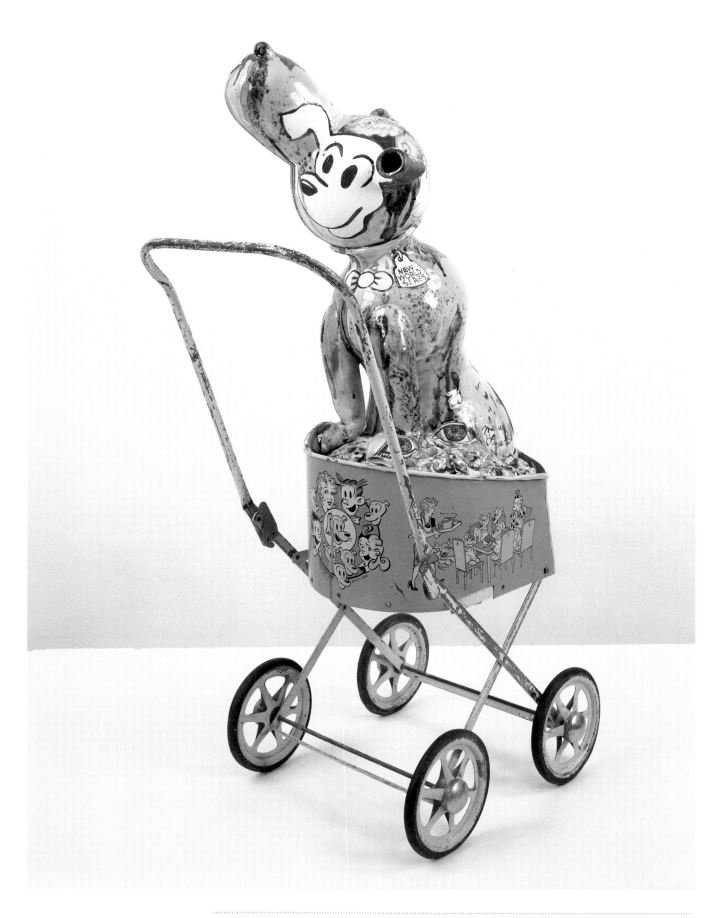

66. ZOOMORPHIC DOG FORM IN STROLLER (NEW WORLD SERIES), 1994 (VERSO)

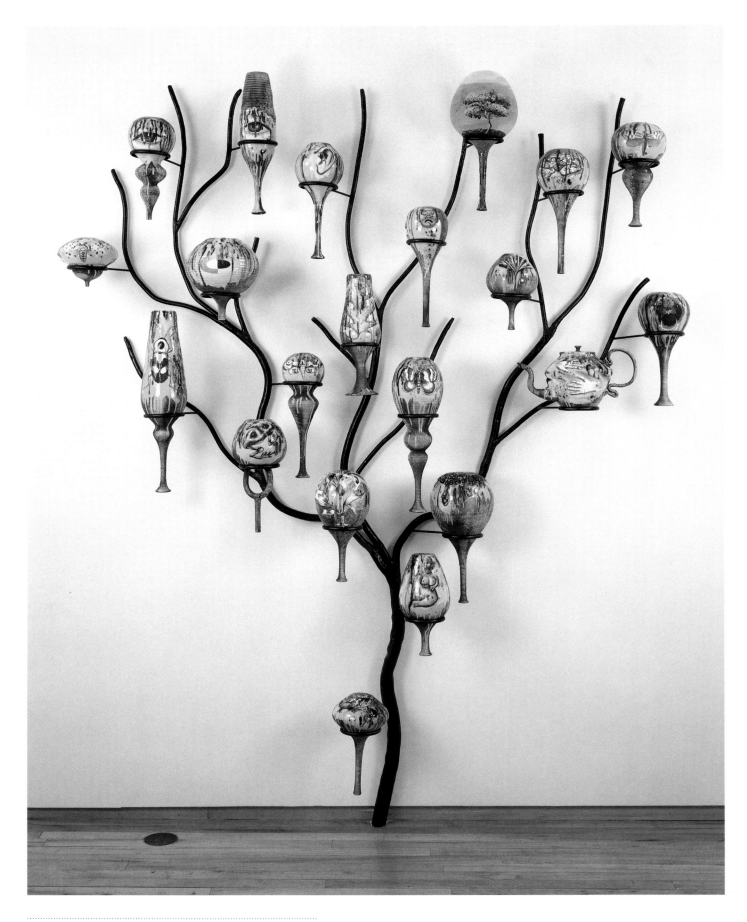

67. SOUL CATCHER (NEW WORLD SERIES), 1994

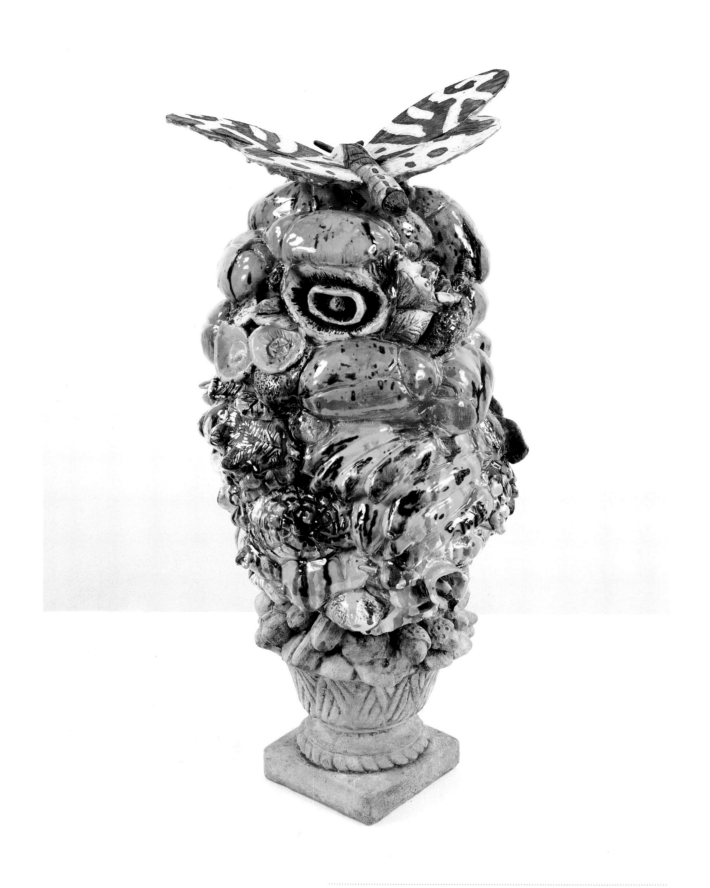

68. BOUQUET WITH MOTH (RECLAMATION SERIES), 1994

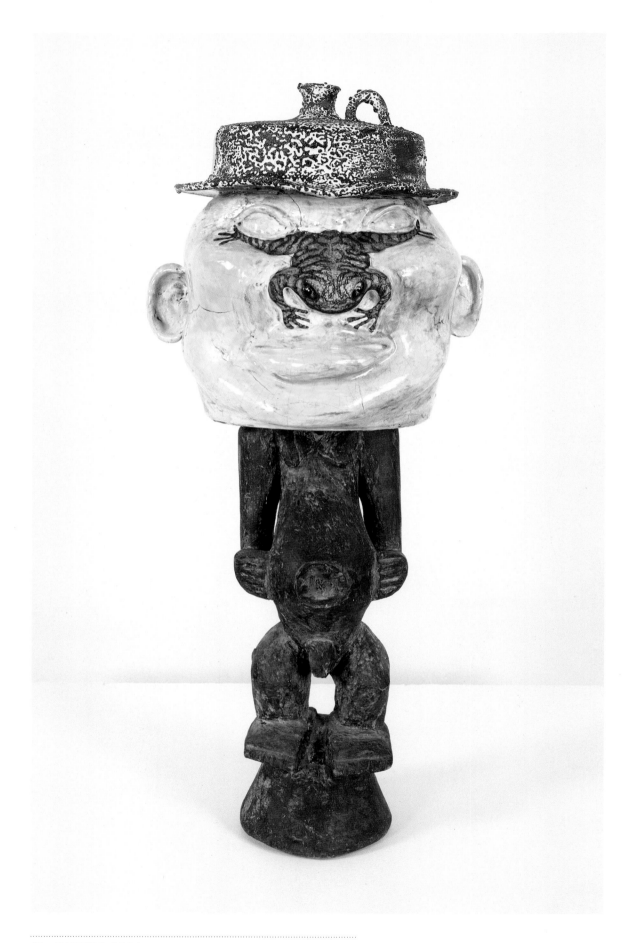

69. YORUBA CAROLINA (RECLAMATION SERIES), 1994

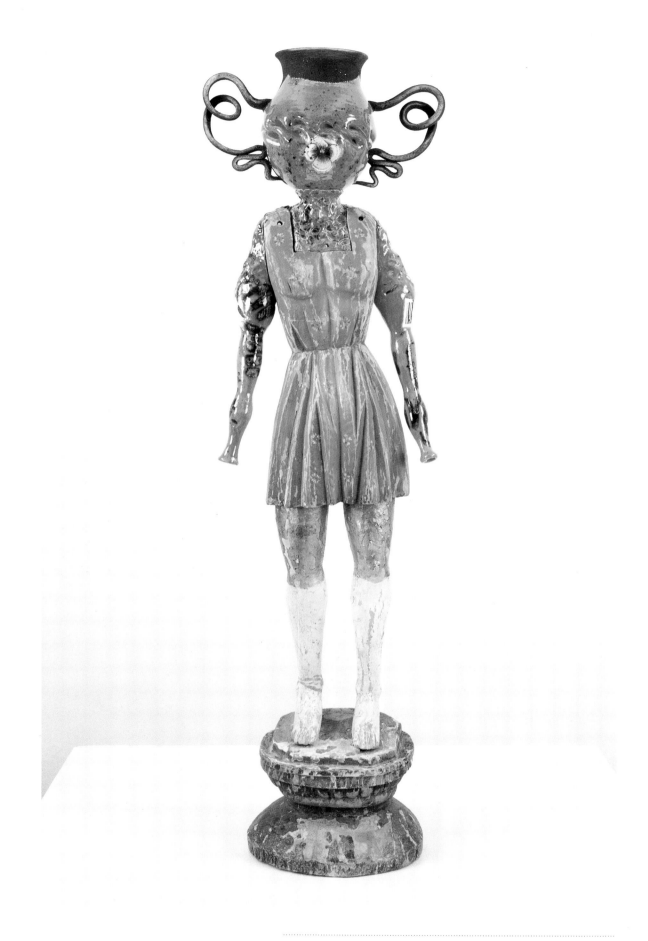

70. FEMALE OHR SANTO (RECLAMATION SERIES), 1994

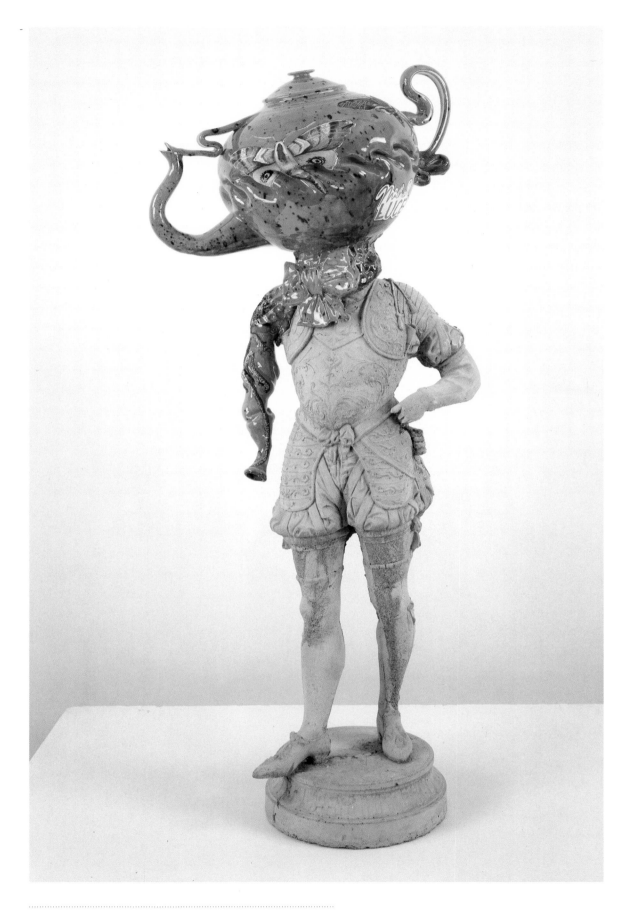

71. CONQUISTADOR (RECLAMATION SERIES), 1995

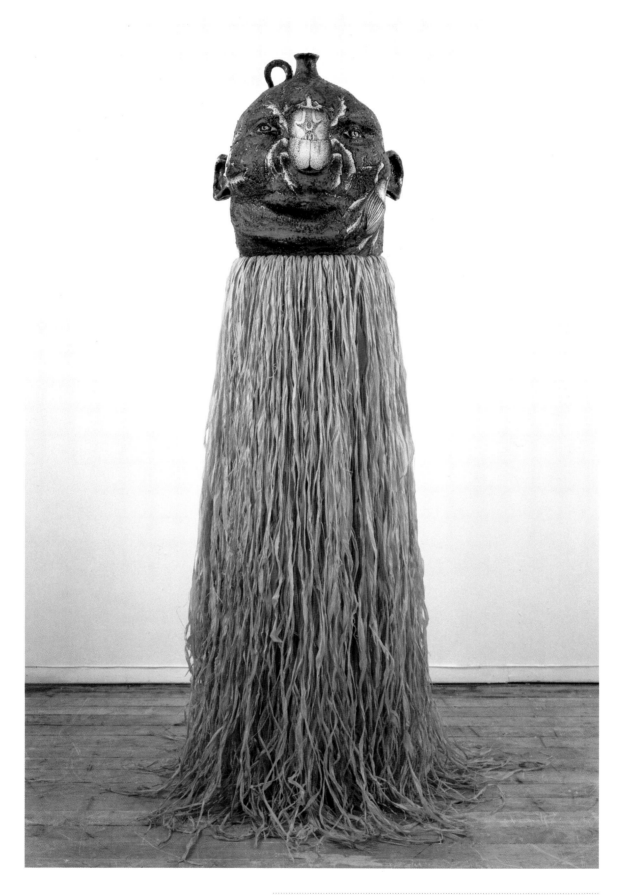

72. ANGOLA CAROLINA (RECLAMATION SERIES), 1995

CATALOGUE OF THE EXHIBITION

UNTITLED (HANGING RAM), 1976
hand-built white earthenware, glaze, enamel,
wire, moss, steel chain, and fur
29 × 26 × 18 inches
(73.6 × 66 × 45.7 cm)
Collection of Caren and Walter Forbes

UNTITLED (DEVIL), 1977
hand-built white earthenware with glazes and
wire armature
70 × 24 × 20 inches
(177.8 × 60.9 × 50.8 cm)
Collection of Stephen and Pamela Hootkin

UNTITLED (IN HONOR OF THE S.W.),
1980
hand-built porcelain, wood, and wire
100 × 35 × 16 inches
(254 × 88.9 × 40.6 cm)
Collection of Stephen and Pamela Hootkin

UNTITLED (LIZARD SLAYER), 1980
hand-built porcelain, wire, and birch wood
100 × 52 × 24 inches
(254 × 132 × 60.9 cm)
Collection of Stephen and Pamela Hootkin

UNTITLED (SNOW-CAPPED
MOUNTAINS), 1982
hand-built white earthenware with glazes, metal
rod, and wire
95 × 42 × 35 inches
(241.3 × 106.7 × 88.9 cm)
Collection of Alan Dinsfriend

UNTITLED (STACKED HEADS), 1983
hand-built white earthenware with glazes, metal
armature, and wood
96 × 9 × 9 inches
(243.8 × 22.8 × 22.8 cm)
Collection of Elaine and Werner Danheisser

PINK NUDE DREAMER, 1984
hand-built white earthenware with glazes
19 × 25 × 21 inches
(48.3 × 63.5 × 53.3 cm)
Collection of Daniel Jacobs and Derek Mason

DREAM DEVELOPER, 1985
hand-built white earthenware with glazes
18 × 23 × 21 inches
(45.7 × 58.4 × 53.3 cm)
Collection of the artist

LUNAR LIFE DREAMER, 1985
hand-built white earthenware with glazes
19 × 24 × 20 inches
(48.3 × 61 × 50.8 cm)
Collection of Hope and Jay Yampol

DAYDREAMER WITH ROCK, 1985
hand-built white earthenware with glazes
34 × 21 × 26 inches
(86.4 × 53.3 × 66 cm)
First Bank System, Inc., Minneapolis,
Minnesota

BIG FROG, 1986
hand-built white earthenware with glazes, steel
stand, and glass
23 × 24 × 46 inches
(58.4 × 61 × 116.8 cm)
Mint Museum of Art, Charlotte, North
Carolina, The Allan Chasanoff Ceramics
Collection

PIKE PERCH, 1986
hand-built white earthenware with glazes, steel
stand, and glass
25 × 30 × 9 inches
(63.5 × 76.2 × 22.9 cm)
Collection of Richard Ekstract

CAMELEON, 1986
hand-built white earthenware with glazes, steel
stand, and glass
26 × 30 × 7 inches
(66 × 76.2 × 17.8 cm)
Collection of the artist

HERCULES BEETLE, 1986
hand-built white earthenware with glazes, steel
stand, and glass
46 × 26 × 12 inches
(116.8 × 66 × 30.5 cm)
Collection of Caren and Walter Forbes

UNIDENTIFIED MOTH, 1986
hand-built white earthenware with glazes,
wood, steel stand, and glass
59 × 104 × 11 inches
(149.9 × 264.2 × 27.9 cm)
Collection of the artist

POND TOTEM, 1987
hand-built white earthenware with glazes, steel
rod, and aluminum base
96 × 26 × 20 inches
(243.8 × 66 × 50.8 cm)
Collection of Dorothy and Fred Weiss

GREENHOUSE, 1988
iron and patinated bronze
84½ × 11½ × 14 inches
(214.6 × 29.2 × 35.6 cm)
Hirshhorn Museum and Sculpture Garden,
Smithsonian Institution. Gift of the Marion L.
Ring Estate, by Exchange, 1989*

SPIRIT, 1988
bronze and steel with patina and enamel
100 × 23½ × 34½ inches
(254 × 59.7 × 87.6 cm)
Collection of the artist

FOSSIL FUEL, 1988
bronze with patina
105 × 11 × 20 inches
(266.7 × 27.9 × 50.8 cm)
Collection of the artist, courtesy Allene LaPides
Gallery

SELF-PORTRAIT AS PRE-COLUMBIAN,
1989
hand-built white earthenware with glazes
96 × 15 × 22 inches
(243.8 × 38.1 × 55.9 cm)
Collection of Janet and Robert Kardon

DRY LAND TOTEM, 1989
hand-built white earthenware with glazes and
steel base with rod
110 × 10 × 10 inches
(279.4 × 25.4 × 25.4 cm)
Collection of the artist

BIG HEART (PLAZA), 1989
hand-built white earthenware with glazes
28 × 32 × 15¼ inches
(71.1 × 81.3 × 39.4 cm)
Collection of the artist

BIG HEART (DEER), 1989
hand-built white earthenware with glazes
27 × 30 × 13½ inches
(68.6 × 76.2 × 34.3 cm)
Collection of Stephen and Pamela Hootkin

COHASSET, 1990
hand-built white earthenware with glazes and
steel base with rod
117 × 17 × 15 inches
(297.2 × 43.2 × 38.1 cm)
Mint Museum of Art, Charlotte, North
Carolina. Gift of the artist in honor of Mark
Richard Leach

SEATED LADY (PRE-COLUMBUS), 1991
hand-built white earthenware with glazes
19 × 15 × 10 inches
(48.3 × 38.1 × 25.4 cm)
Collection of Shonny and Hal Joseph

**MAN WITH VIOLIN (PRE-COLUMBUS),
1991**
hand-built white earthenware with glazes
19 × 13½ × 12 inches
(48.3 × 34.3 × 30.5 cm)
Collection of Donna Schneier

**LADY WITH TWO CURLS
(PRE-COLUMBUS), 1991**
hand-built white earthenware with glazes
18 × 16 × 8 inches
(45.7 × 40.6 × 20.3 cm)
Collection of Alvin H. Baum, Jr.

**MAN BALANCING VESSEL
(PRE-COLUMBUS), 1991**
hand-built white earthenware with glazes
22 × 15 × 9 inches
(55.9 × 38.1 × 22.9 cm)
Collection of Arthur J. Williams

**LADY WITH BEE HIVE
(PRE-COLUMBUS), 1991**
hand-built white earthenware with glazes
18 × 13 × 10 inches
(45.7 × 33 × 25.4 cm)
Collection of Becky and Jack Benaroya

**YOUNG LADY WITH OHR HAIR
(PRE-COLUMBUS), 1991**
hand-built white earthenware with glazes
19 × 13 × 11 inches
(48.3 × 33 × 27.9 cm)
Collection of Patricia Shaw

MIRÓ MOTHER (PRE-COLUMBUS), 1992
hand-built white earthenware with glazes
19 × 15 × 18 inches
(48.3 × 38.1 × 45.7 cm)
Collection of Arlene B. Richman

**LADY WITH OHR HAIR
(PRE-COLUMBUS), 1992**
hand-built white earthenware with glazes
19 × 15 × 10 inches
(48.3 × 38.1 × 25.4 cm)
Collection of Stanley Baumblatt

**ANTHROPOMORPHIC JUG HEAD WITH
MOTH ON HAT (NEW WORLD SERIES),
1992**
wheel-thrown and altered white earthenware
with glazes
18 × 14 × 17 inches
(45.7 × 35.6 × 43.2 cm)
Collection of Gae and Mel Shulman, courtesy
Gallery Gae Shulman

**ANTHROPOMORPHIC JUG HEAD WITH
OHR HAIR (NEW WORLD SERIES), 1992**
wheel-thrown and altered white earthenware
with glazes
17 × 14 × 17 inches
(43.2 × 35.6 × 43.2 cm)
Collection of Linda Leonard Schlenger and
Donald Schlenger

**ANTHROPOMORPHIC FEMALE FORM
WITH WIG (NEW WORLD SERIES), 1992**
wheel-thrown and assembled white earthenware
with glazes and synthetic wig
23½ × 16½ × 10 inches
(59.7 × 41.9 × 25.4 cm)
Collection of Hadley Wine

**LADY WITH ROOTS (NEW WORLD
SERIES), 1993**
wheel-thrown and assembled white earthenware
with glazes
24 × 18 × 12 inches
(61 × 45.7 × 30.5 cm)
Collection of Betsy and Andrew Rosenfield

**MAN WITH GLASS HAT (NEW WORLD
SERIES), 1993**
wheel-thrown, altered, and assembled white
earthenware with glazes and found glass hat
22 × 11 × 11 inches
(55.9 × 27.9 × 27.9 cm)
Collection of Stephen and Pamela Hootkin

**YELLOW SKY TOTEM (NEW WORLD
SERIES), 1993**
wheel-thrown and hand-built white earthenware
with glazes and steel rod
107 × 60 × 27 inches
(271.8 × 152.4 × 68.6 cm)
Collection of Stephen and Pamela Hootkin

**ANTHROPOMORPHIC INFANT FORM
WITH TUTU IN STROLLER (NEW WORLD
SERIES), 1993**
wheel-thrown, altered, and assembled white
earthenware with glazes and found baby stroller
27 × 25 × 14 inches
(68.6 × 63.5 × 35.6 cm)
Collection of Donna Schneier

**EYE OHR TEAPOTS (NEW WORLD
SERIES), 1993**
wheel-thrown and altered white earthenware
with glazes
12 × 17 × 8 inches each
(30.5 × 43.2 × 20.3 cm each)
Collection of Dawn F. Bennett and Martin J.
Davidson

**ZOOMORPHIC DOG FORM IN STROLLER
(NEW WORLD SERIES), 1994**
wheel-thrown, altered, and assembled white
earthenware with glazes and found baby stroller
34½ × 19½ × 12 inches
(87.6 × 49.5 × 30.5 cm)
Collection of Sandra and Gilbert Oken*

**SOUL CATCHER (NEW WORLD SERIES),
1994**
wheel-thrown white earthenware with glazes
and welded steel
100 × 79 × 12 inches
(254 × 200.7 × 30.5 cm)
Collection of Stephen and Pamela Hootkin

..

*Exhibited only at the Renwick Gallery
of the National Museum of American Art,
Smithsonian Institution.

BOUQUET WITH MOTH (RECLAMATION SERIES), 1994
hand-built white earthenware with glazes and cement
33 × 13 × 13 inches
(83.8 × 33 × 33 cm)
Collection of the artist, courtesy David Beitzel Gallery

YORUBA CAROLINA (RECLAMATION SERIES), 1994
wheel-thrown and altered white earthenware with glazes, wood, and steel
72 × 19 × 15 inches
(182.9 × 48.3 × 38.1 cm)
Collection of Mimi and Vinton Sommerville

FEMALE OHR SANTO (RECLAMATION SERIES), 1994
wheel-thrown and altered white earthenware with glazes, polychromed wood, and cement
48 × 9½ × 16 inches
(121.9 × 24.1 × 40.6 cm)
Collection of Francine and Benson Pilloff

CONQUISTADOR (RECLAMATION SERIES), 1995
wheel-thrown and altered white earthenware with glazes and cement
42 × 20 × 10 inches
(106.7 × 50.8 × 25.4 cm)
Collection of Stephen and Pamela Hootkin

ANGOLA CAROLINA (RECLAMATION SERIES), 1995
wheel-thrown and altered white earthenware with glazes, stitched raffia, and steel
68 × 16 × 14 inches
(172.7 × 40.6 × 35.6 cm)
Collection of Stephen and Pamela Hootkin

MICHAEL LUCERO

BORN

Tracy, California, 1953

EDUCATION

1978 M.F.A., University of Washington, Seattle

1975 B.A., Humboldt State University, Arcata, California

SOLO EXHIBITIONS

1995
Allene LaPides Gallery, Sante Fe, New Mexico

David Beitzel Gallery, New York

Garth Clark Gallery, Los Angeles, California

Habatat/Shaw Gallery, Pontiac, Michigan

Linda Farris Gallery, Seattle, Washington

1994
Joseloff Gallery, Hartford Art School, Hartford, Connecticut

David Beitzel Gallery, New York

Dorothy Weiss Gallery, San Francisco, California

1993
Habatat/Shaw Gallery, Farmington Hills, Michigan

1992
Allene LaPides Gallery, Santa Fe, New Mexico

Fay Gold Gallery, Atlanta, Georgia

1991
Fay Gold Gallery, Atlanta, Georgia

Dorothy Weiss Gallery, San Francisco, California

1990
Anderson Gallery, Virginia Commonwealth University, School of Arts, Richmond, Virginia

Fay Gold Gallery, Atlanta, Georgia

Contemporary Arts Center, Cincinnati, Ohio

1988
ACA Contemporary, New York

1987
Linda Farris Gallery, Seattle, Washington

1986
Charles Cowles Gallery, New York

Hokin Kaufman Gallery, Chicago, Illinois

1985
Fuller Goldeen Gallery, San Francisco, California

1984
Charles Cowles Gallery, New York

1983
Charles Cowles Gallery, New York

Hokin Kaufman Gallery, Chicago, Illinois

1982
Linda Farris Gallery, Seattle, Washington

1981
Charles Cowles Gallery, New York

1980
Wake Forest University Art Gallery, Winston-Salem, North Carolina

GROUP EXHIBITIONS

1995
Breaking Barriers: Recent American Craft, American Craft Museum, New York. Exhibition traveled: Portland Art Museum, Oregon; Madison Art Center, Wisconsin; Albany Museum of Art, Georgia

Insight, David Beitzel Gallery, New York

Horse Show, Dorothy Weiss Gallery, San Francisco, California

1993
Contemporary Crafts and the Saxe Collection. Exhibition traveled: Toledo Museum of Art, Ohio; St. Louis Art Museum, Missouri; Newport Harbor Art Museum, Newport Beach, California

Tales and Traditions, Bellingham Museum of Art, Washington

1992
Ceramic Sculpture: Form and Figure, Society for Contemporary Crafts, Pittsburgh, Pennsylvania

Chthonic Realms: Philadelphia Collects Clay, Helen Drutt Gallery, Philadelphia, Pennsylvania

1991
Tea Pot Invitational, Dorothy Weiss Gallery, San Francisco, California

Cup: As a Metaphor, Sybaris Gallery, Royal Oak, Michigan

Contemporary Ceramics, Inaugural Exhibition, Habatat/Shaw Gallery, Farmington Hills, Michigan

Cooper Carry Studios, Atlanta, Georgia

1990

Made in Chico (Michael Lucero and Cheryl Laemmle), California State University Art Gallery, Taylor Hall, Chico

Natural Image, Stamford Museum and Nature Center, Stamford, Connecticut

Explorations—The Aesthetics of Excess, American Craft Museum, New York

1989

Recent Ceramic Works by Michael Lucero and John Roloff, Reese Bullen Gallery, Humboldt State University, Arcata, California

Ceramic Tradition: Figuration, Palo Alto Cultural Arts Center, California

In Clay: Life and Times, School of Art Gallery, Bowling Green State University, Ohio. Exhibition traveled: Emily Davis Gallery, University of Akron, Ohio

1988

Contemporary Ceramics from the First Bank Collection, First Bank, Minneapolis, Minnesota

Works from the Dorothy and Herbert Vogel Collection, Arnot Art Museum, Elmira, New York. Exhibition traveled: Oakland Museum, California; Museum of Fine Arts, Boston, Massachusetts; Chicago Public Library, Cultural Center, Illinois; Orlando Museum of Art, Florida; Virginia Museum of Fine Arts, Richmond

The Eloquent Object: The Evolution of American Art in Craft Media since 1945, Philbrook Museum of Art, Tulsa, Oklahoma. Exhibition traveled: Museum of Fine Arts, Boston, Massachusetts

Drawn to the Surface, Pittsburgh Center for the Arts, Pennsylvania

Expression in Color, New Jersey Center for the Visual Arts, Summit

Unnatural Landscape, Fay Gold Gallery, Atlanta, Georgia

Contemporary Cutouts (collaboration with Cheryl Laemmle), Whitney Museum of American Art, Stamford, Connecticut

Clay Revisions: Plate, Cup, and Vase, Seattle Art Museum, Washington. Exhibition traveled: Portland Art Museum, Oregon; Renwick Gallery of the National Museum of American Art, Smithsonian Institution, Washington, D.C.; Gibson Gallery, State University of New York, Potsdam; Santa Barbara Museum of Art, California

School of Art 1975–1988, Safeco Insurance Corporation, Seattle, Washington

1987

Distinguished Artists Exhibition: Michael Lucero and Cheryl Laemmle, Haggin Museum, Stockton, California

Clay Feats, Snug Harbor Cultural Center, Staten Island, New York

Drawings, Linda Farris Gallery, Seattle, Washington

National/International, Ruth Siegel Gallery, New York

Painters Who Sculpt—Sculptors Who Paint, Althea Viafora Gallery, New York

Contemporary Diptychs: Divided Visions, Whitney Museum of American Art, Stamford, Connecticut. Exhibition traveled: Whitney Museum of American Art at the Equitable Center, New York; Paine Webber, New York

Metafur, Sharpe Gallery, New York

Contemporary American Ceramics, National Museum of Contemporary Art, Seoul, Korea

Specimens (collaboration with Cheryl Laemmle), Forum International Exhibition, Zurich, Switzerland. Exhibition traveled: Kresge Art Museum, Michigan State University, East Lansing; Pittsburgh Center for the Arts, Pennsylvania

Seattle Sculpture 1927–1987, Seattle Center: Bumpershoot Festival, Seattle, Washington

1986

Three Decades of American Sculpture, Seattle Art Museum, Washington

Natural Settings, Corcoran Gallery of Art, Washington, D.C.

The Figure in the Landscape, Florida International University, Miami, Florida

Spectrum: Natural Settings, Corcoran Gallery of Art, Washington, D.C.

New Approaches to Figurative Art, State University of New York, Brockport

Material as Metaphor: Contemporary American Ceramic Sculpture, Chicago Public Library Cultural Center, Illinois

Intimate/INTIMATE, Turman Gallery, Indiana State University, Terre Haute

Architectural Images in Art, Fay Gold Gallery, Atlanta, Georgia

Surrealismo, Barbara Braathen Gallery, New York

Voyages, John Michael Kohler Arts Center, Sheboygan, Wisconsin

Works on Paper, Althea Viafora Gallery, New York

Major Concepts—Clay, Robert Kidd Gallery, Birmingham, Michigan

Boston Collects, Museum of Fine Arts, Boston, Massachusetts

24 by 24, Ruth Siegel Gallery, New York

Craft Today: Poetry of the Physical, American Craft Museum, New York. Exhibition traveled: Denver Art Museum, Colorado; Laguna Beach Art Museum, California; Milwaukee Art Museum, Wisconsin; J. B. Speed Art Museum, Louisville, Kentucky; Virginia Museum of Fine Arts, Richmond

Landscape in the Age of Anxiety, Lehman College Art Gallery, Bronx, New York. Exhibition traveled: Cleveland Center for Contemporary Art, Ohio

Drawings from the Collection of Dorothy and Herbert Vogel, University of Alabama, Tuscaloosa

Contemporary Arts: An Expanding View, The Monmouth Museum, Lincroft, New Jersey. Exhibition traveled: The Squibb Gallery, Princeton, New Jersey

1985

Landscape Show, San Diego University Art Gallery, California

Correspondences: New York Art Now, Laforet Museum, Harajuku, Tokyo. Exhibition traveled: Tochigi Prefectural Museum of Fine Arts, Tazaki Hall Espace, Media Kobe, Japan

Recent Ceramic Sculpture, University Art Museum, University of New Mexico, Albuquerque

Sculpture, Nina Freudenheim Gallery, Buffalo, New York

R.E.M., Carl Lamagna Gallery, New York

New Sculpture, Hal Bromm Gallery, New York

The Figure Renewed, Freedman Gallery, Albright College, Reading, Pennsylvania

Clay, Dayton Art Institute, Dayton, Ohio

Fired Forms: Sculpture in Clay, First Street Forum, St. Louis, Missouri

Is Anybody Home? Esther Saks Gallery, Chicago, Illinois

Contemporary American Ceramics: Twenty Artists, Newport Harbor Art Museum, Newport Beach, California

El Arte Narrativo, Museo Rufino Tamayo, Mexico City, Mexico. Exhibition traveled: P. S. 1, Institute for Art and Urban Resources, Long Island City, New York

An Inside Place, Noyes Museum, Oceanville, New Jersey

Body and Soul: Recent Figurative Sculpture, Contemporary Arts Center, Cincinnati, Ohio

American Clay Artists: Philadelphia '85, The Port of History, Philadelphia, Pennsylvania

Cityscapes/Countryscapes: Redefined, Monique Knowlton Gallery, New York

The Doll Show: Artists' Dolls and Figurines, Hillwood Art Gallery, C. W. Post Center, Long Island University, Brookville, New York

1984
Robert Brady/Michael Lucero, Huntsville Museum of Art, Alabama

Imagined Icons, Clark Gallery, Lincoln, Massachusetts

A Passionate Vision: Contemporary Ceramics from the Daniel Jacobs Collection, DeCordova Museum, Lincoln, Massachusetts

Multiplicity in Clay, Metal, and Fiber, Skidmore College, Saratoga Springs, New York

American Sculpture: Three Decades, Seattle Art Museum, Washington

The Twentieth Century: The San Francisco Museum of Modern Art Collection, San Francisco Museum of Modern Art, California

New Narrative Painting: Selections from the Metropolitan Museum of Art, Museo Rufino Tamayo, Mexico City, Mexico

1983
Self-Portraits, Linda Farris Gallery, Seattle, Washington

Self-Image, Sharpe Gallery, New York

Sculpture Now: Recent Figurative Works, Institute of Contemporary Art of the Virginia Museum, Richmond

The Raw Edge: Ceramics of the 80s, Hillwood Art Gallery, C. W. Post Center, Long Island University, Brookville, New York

Contemporary Clay Sculpture: Selections from the Daniel Jacobs Collection, Heckscher Museum, Huntington, New York

Eight Visions (curated by Carter Ratcliff), One Penn Plaza, New York

Fellows Exhibition, Center for Music, Drama and Art, Fine Arts Gallery, Lake Placid, New York

Bay Area Collects: A Diverse Sampling, San Francisco Museum of Modern Art, California

Ceramic Directions: A Contemporary Overview, State University of New York, Stony Brook

1982
Young American Award Winners, American Craft Museum, New York

New–New York, University Fine Art Gallery, Florida State University, Tallahassee

Surls, Scanga, Lucero, Delahunty Gallery, Dallas, and Texas Gallery, Houston

Still Modern after All These Years, Chrysler Museum, Norfolk, Virginia

20th Anniversary Exhibition of the Vogel Collection, Brainerd Art Gallery, College of Art and Science, State University of

New York, Potsdam. Exhibition traveled: Gallery of Art, University of Northern Iowa, Cedar Falls

1981
The Clay Figure, American Craft Museum, New York

Clay, Museum of Art, Rhode Island School of Design, Providence

30 Americans, John Michael Kohler Arts Center, Sheboygan, Wisconsin

The Figure: A Celebration, Museum of South Texas, Corpus Christi

Drawings by Sculptors, Quay Gallery, San Francisco, California

Graphics Plus, Herbert F. Johnson Museum of Art, Cornell University, Ithaca, New York

1980
Homage to Josiah Wedgewood, Museum of the Philadelphia Civic Center, Pennsylvania

Helen Drutt Gallery, Philadelphia, Pennsylvania

1979
Unpainted Portrait, John Michael Kohler Arts Center, Sheboygan, Wisconsin

Fine Art, Seattle Art Museum, Washington

1978
Eastern Washington University Art Gallery, Cheney

Greenwood Gallery, Seattle, Washington

Young Americans, American Craft Museum, New York

1977
Science Fiction X-Po Show, Seattle, Washington

University of Oregon Art Gallery, Portland

Beauty and the Beast, John Michael Kohler Arts Center, Sheboygan, Wisconsin

1993
Richard Koopman Distinguished
Chair in the Visual Arts, University
of Hartford, Connecticut

1984
National Endowment for the Arts Artist
Fellowship

1983
Nettie Marie Jones Fellowship, Center
for Music, Drama and Art, Lake Placid,
New York

1981
National Endowment for the Arts Artist
Fellowship

1980
Creative Artists Public Service Program
Fellowship

1979
National Endowment for the Arts Artist
Fellowship

1978
Young American Award, Museum
of Contemporary Craft Council,
New York

1977–78
Ford Foundation Scholarship

SELECTED PUBLIC COLLECTIONS
American Craft Museum, New York

Arkansas Art Center, Little Rock

Everson Museum of Art, Syracuse,
New York

First Bank, Minneapolis, Minnesota

High Museum of Art, Atlanta, Georgia

The Hirshhorn Museum and Sculpture
Garden, Washington, D.C.

The Metropolitan Museum of Art,
New York

Mint Museum of Art, Charlotte,
North Carolina

Museo Rufino Tamayo, Mexico City,
Mexico

National Museum of Contemporary
Art, Seoul, Korea

The New Museum of Contemporary
Art, New York

San Francisco Museum of Modern Art,
California

Seattle Art Museum, Washington

Toledo Museum of Art, Ohio

SELECTED BIBLIOGRAPHY

GENERAL

Bataille, Georges. *Lascaux or The Birth of Art.* Trans. Austyrn Wainhouse. Lausanne: Skira, 1955.

Berlant, Tony, et al. *Mimbres Pottery.* New York: Hudson Hills Press, 1983.

Breton, André. *Manifestoes of Surrealism.* Ann Arbor: The University of Michigan Press, 1972.

Browder, Clifford H. *André Breton: Arbiter of Surrealism.* Geneva: Droz, 1967.

Carrasco, David, and Eduardo Matos Moctezuma. *Moctezuma's Mexico.* Niwot: University Press of Colorado, 1992.

Clifford, James. *The Predicament of Culture: Twentieth Century Ethnography, Literature and Art.* Cambridge: Harvard University Press, 1988.

Debroise, Olivier. "Heart Attacks: On a Culture of Missed Encounters and Misunderstandings." In *El Corazón Sangrante/The Bleeding Heart.* Boston: Institute of Contemporary Art, 1992, pp. 13–61.

Ernst, Max. *Beyond Painting and Other Writings by the Artist and His Friends.* New York: Wittenborn, Schultz, 1948.

Fer, Briony. "Surrealism, Myth and Psychoanalysis." In *Realism, Rationalism, Surrealism: Art Between the Wars.* New Haven: Yale University Press, 1993.

Ferguson, Russell, et al. *Out There: Marginalization and Contemporary Cultures.* Cambridge: M.I.T. Press, 1990.

Halper, Vicki. *Clay Revisions: Plate, Cup, Vase.* Seattle: Seattle Art Museum, 1987.

Hecht, Eugene. *After the Fire: George Ohr, an American Genius.* Lambertville, N.J.: Arts and Crafts Quarterly Press, 1994.

Karp, Ivan, and Steven D. Levine, eds. *Exhibiting Cultures: The Poetics and Politics of Museum Display.* Washington, D.C.: Smithsonian Institution Press, 1990.

_____. *Museums and Communities: The Politics of Public Culture.* Washington, D.C.: Smithsonian Institution Press, 1992.

Leiris, Michel. "Civilization." *Documents* 1, no. 4 (1929): 221.

_____. "L'Homme et son intérieur." *Documents* 2, no. 5 (1930): 261, 266.

Lévy-Bruhl, Lucien. *Primitive Mentality.* Trans. Lilian Clare. Boston: Beacon Press, 1966.

Lippard, Lucy R. *Mixed Blessings: New Art in a Multicultural America.* New York: Pantheon, 1990.

_____, ed. *Partial Recall.* New York: The New Press, 1992.

Manhart, Marcia, and Tom Manhart, eds. *The Eloquent Object: The Evolution of American Art in Craft Media since 1945.* Tulsa: The Philbrook Museum of Art, 1987.

McEvilley, Thomas. *Art and Otherness: Crisis in Cultural Identity.* New York: McPherson and Company, 1992.

Morrison, Toni. *Playing in the Dark: Whiteness and the Literary Imagination.* New York: Vintage Books, 1992.

Peraza, Nilda, et al. *The Decade Show: Frameworks of Identity in the 1980s.* New York: Museum of Contemporary Hispanic Art, 1990.

Richter, Hans. *Dada Art and Anti-Art.* New York: McGraw-Hill, 1965.

Sitch, Sidra, ed. *Anxious Visions: Surrealist Art.* Berkeley: University of California Press, 1990.

Thompson, Robert Farris. *Flash of the Spirit: African and Afro-American Art and Philosophy.* New York: Vintage Books, 1984.

Tobias, Henry J. *A History of the Jews in New Mexico.* Albuquerque: University of New Mexico Press, 1990.

Townsend, Richard F., ed. *The Ancient Americas: Art from Sacred Landscapes.* Chicago: Art Institute of Chicago, 1992.

Vlach, John Michael. *By the Work of Their Hands: Studies in Afro-American Folklife.* Charlottesville: University of Virginia Press, 1991.

_____. *The Afro-American Tradition in Decorative Arts.* Athens: The University of Georgia Press, 1990.

Vogel, Susan, et al. *Africa Explores: Twentieth Century African Art.* Munich: Prestel Verlag, 1991.

_____. *ART/Artifact: African Art in Anthropology Collections.* Munich: Prestel Verlag, 1988.

Articles and Reviews

Adams, Brooks. "Michael Lucero at Sharpe and Charles Cowles." *Art in America,* March 1985, pp. 157–58.

Allen, Jane Addams. "A Distant Viewing of 'Natural Settings.'" *Washington Times,* January 13, 1986.

____. "Spectrum: Natural Settings." *Washington Times Magazine, Contents,* January 17, 1986.

Ashton, Dore. "Perceiving the Clay Figure," *American Craft,* April/May 1981, pp. 24–31.

Basa, Lynn. "Artist Finds Use of Clay, Bronze Fires His Imagination." *Journal-American* (Alabama), July 7, 1987, p. 4.

Berger, David. "Sculpture Exhibit Features American Works." *Seattle Times,* November 23, 1984, p. 4.

Bonetti, David. "Ceramicists Give New Twist to the Cosmic Vision." *San Francisco Examiner,* May 9, 1991, p. 3.

Bourdon, David. "The Clay Figure." *Vogue,* May 1981, pp. 40, 42.

"Ceramic Study Center Opens." *Ceramics Monthly,* February 1987, pp. 69–70.

Cohen, Ronny. "Michael Lucero." *Art News,* October 1982, pp. 163, 166.

Colby, Joy Hakanson. "Pot Luck." *Detroit News,* September 12, 1991, p. 3.

____. "Reflections on a Hot Glass Month." *Detroit News,* April 16, 1993, p. 6.

Collins, Tom. "Dust in the Alcove: The Museum's Clay Feet." *Sante Fe Reporter,* January 12–18, 1994, pp. 23–24.

de Vuono, Frances. "Michael Lucero." *ArtNews,* May 1995, p. 156.

Failing, Patricia. "Michael Lucero: Homage to Ancient Arts." *American Craft,* February/March 1995, pp. 32–37.

Fauntleroy, Gussie. "Reclaiming Art, Putting It Back on a Pedestal." *The New Mexican,* July 14, 1995.

Fernandes, Joyce. "Michael Lucero." *Arts,* September 1983, p. 20.

Fox, Catherine. "Heart Is Vessel for Lucero's Messages." *Atlanta Constitution,* June 8, 1990, p. 9.

Glueck, Grace. "Art: The Clay Figure at the Craft Museum." *New York Times,* May 1981.

____. "Design Notebook." *New York Times,* January 28, 1982, p. 10.

____. Review of Michael Lucero's sculpture at Charles Cowles Gallery. *New York Times,* October 12, 1984, p. 24.

Hackett, Regina. "Disgraced Objets d'Art Are Taken to Higher Glory." *Seattle Post-Intelligencer,* January 6, 1995.

Harris, Susan B. "Totem." *Arts Magazine,* April 1984, p. 45.

Harrison, Helen. "A Celebration of Ceramics." *New York Times,* August 14, 1983, p. 21.

____. "L.I. Offers Sculpture in Wooded Sites." *New York Times,* August 5, 1983.

____. "Unorthodox Ceramics." *New York Times,* April 17, 1983.

Higby, Wayne. "'Young Americans' in Perspective." *American Craft,* April/May 1982, pp. 20–25.

"His Heart Is in His Work." *Chicago Sun-Times,* July 1, 1990, Vista, p. 3.

James, Claudia. "Drawn to the Surface: Artists in Clay and Glass." *Dialogue,* October 1988, p. 42.

Jinkner-Lloyd, Amy. "Shape and Form." *Creative Loafing/Atlanta,* 1992, pp. 25–26.

Kalil, Susie. "Texas Ranges: Houston, from Boogeymen to 'The End Result of Constructivist Theory.'" *Art News,* December 1982, pp. 82–85.

Kangas, Matthew. "The Bronze Menagerie." *Seattle Weekly,* July 8–14, 1987, p. 40.

____. "Michael Lucero at the Contemporary Arts Center." *Art in America,* September 1990, pp. 202–3.

____. "Michael Lucero Discovers America." *Sculpture,* July/August 1992, pp. 36–43.

____. "Self Portraits: The Soul Observed." *Arts Line,* August 1983.

____. "Wearing Clement's Tie." *Reflex,* August/September 1994, p. 21.

Klevan, Stanley P. "N.Y. Artists Recall Roots in Stockton." *Stockton* (California) *Record,* January 15, 1987, p. 1.

Kutner, Janet. "Three Spirits—Scanga, Lucero, and Surls: Sculpture Opens New Delahunty Gallery." *Dallas Morning News,* September 17, 1982, pp. 1–2.

Larson, Kay. "Peaceable Kingdom." *New York Magazine,* April 28, 1986, pp. 96–97.

Leonard, Pamela Blume. "'New World' Has Fun Disrupting the Familiar." *Atlanta Journal Constitution,* December 25, 1992, p. 8.

Levy, Estelle. "Michael Lucero: Hearts of Clay." *Ceramics Monthly,* March 1990, pp. 35–36.

Linberg, Ted. "Reclaiming Disasters." *Reflex,* March 1995.

Lipofsky, Marvin. "Young Americans: Clay/Glass." *Craft Horizons,* June 1978, pp. 50–55.

Malarcher, Patricia. "Ceramics: Expression through Color." *New York Times,* March 20, 1988.

____. "Exploring the Art-Crafts Connection." *New York Times,* February 22, 1987.

Marks, Ben. "Michael Lucero," *Art in America,* June 1995, pp. 111–12.

McTwigan, M. "Paradise Regained." *American Ceramics,* 1990, pp. 26–31.

Melrod, George. "Brave New Art World." *Art and Antiques,* January 1995, p. 30.

Miro, Marsha. "Intuition and Pop Culture Mix into Superb Ceramics." *Detroit Free Press,* April 9, 1993.

____. "A Teacher Inspires Masterful Feats of Clay." *Detroit Free Press,* April 24, 1995.

Montagu, Kyra. "Daniel Jacob's Collection Exhibition." *Art New England 5,* no. 7 (June 1984).

Morgan, Robert C. "Reconstruction with Shards." *American Ceramics,* February 1, 1982, pp. 36–42.

Newhall, Edith. "Talent: Michael Lucero." *New York Magazine,* May 22, 1995, p. 101.

Paine, Janice. "Surreal Ceramics." *Ceramics Monthly,* November 1989, pp. 28–30.

Porges, Maria. "Michael Lucero." *Sculpture,* September/October 1991, p. 82.

Riley, Jan. "An Interview with Michael Lucero." *National Council on Education in the Ceramic Arts Journal,* 1990–91, pp. 17–21.

"Sculpture Show." *Seattle Post-Intelligencer*, May 28, 1982.

Shannon, Mark. "Michael Lucero: The Unnatural Science of Dreams." *American Ceramics*, 1986, pp. 28–33.

Shapiro, Howard-Yana, and James Yood. "Ceramic Art: Wading into the Mainstream?" *New Art Examiner*, April 1986, pp. 22–24.

Sozanski, Edward J. "It's the Essence of Utility and Fantasy." *Providence Journal–Weekend*, April 17, 1981.

Tarzan, Deloria. "Lucero's Show Has Freeze-Frame Feeling." *Seattle Times*, July 17, 1987.

_____. "Towering Clay Figures Haunting Creativity." *Seattle Times*, June 2, 1982, p. 7.

Taylor, Robert. "Play, Passion Revealed in Ceramics." *Boston Sunday Globe*, April 15, 1984.

Taylor, Sue. "Michael Lucero." *New Art Examiner*, October 1983.

Updike, Robin. "Art in the Craft: Galleries Open '95 on a Strong Note." *Seattle Times*, January 17, 1995.

_____. "Who Cares What It's Called? 'Breaking Barriers–Recent American Craft.'" *Seattle Times*, February, 27, 1995.

Van Proyen, Mark. "Strange Deities: Michael Lucero at Dorothy Weiss Gallery." *Artweek*, May 23, 1991, p. 11.

Vidali, Roberto. "Laemmle and Lucero." *Juliet Art Magazine*, April/May 1987, pp. 11, 35.

_____. "Michael Lucero." *Juliet Art Magazine*, April/May 1985, p. 16.

Wechsler, Susan. "Views on the Figure." *American Ceramics*, March 1, 1984, pp. 16–25.

Zimmer, Kathy. "Michael Lucero." *Art Scene*, April 1995, p. 15.

Zimmer, William. "Biding Time." *New York Magazine*, November 18, 1985, p. 29.

_____. "Contemporary Cutouts on View in Stamford." *New York Times*, January 3, 1988, p. 20.

_____. "Contemporary Diptychs at the Whitney." *New York Times*, April 26, 1987, p. 37.

_____. "Enigmatic Interiors at Noyes." *New York Times*, New Jersey ed., August 25, 1985, p. 20.

_____. "German Easels." *Soho News*, May 1981.

_____. "A New Figure on the Horizon." *Arts*, August 1983, pp. 26–29.

Exhibition Catalogues and Books

Aguirre, George L., et al. *The Eloquent Object: The Evolution of American Art in Craft Media Since 1945*. Seattle: University of Washington Press, 1988.

Clark, Garth. *American Ceramics–1876 to the Present*. New York: Abbeville Press, 1987.

Davis, Zina. *Investigations: Tony Hepburn, Michael Lucero*. West Hartford: Hartford Art School, University of Hartford, 1994.

English, Helen W. Drutt. *Contemporary Arts: An Expanding View*. Lincroft, N.J.: Monmouth Museum, 1986.

Feinstein, Roni. *Contemporary Diptychs: Divided Visions*. New York: Whitney Museum of American Art at the Equitable Center, 1987.

Frank, Peter. *Linda Farris Gallery: Self-Portraits*. Seattle, Washington: Linda Farris Gallery, 1983.

Friedrich, Maria. *A Passionate Vision*. Lincoln, Mass.: DeCordova Museum, 1984.

Halper, Susan. *Contemporary Pedestal Sculpture*. 1984.

_____. *Natural Settings*. Washington, D.C.: Corcoran Gallery of Art, 1986.

Hammel, Lisa. *Drawn to the Surface: Artists in Clay and Glass*. Pittsburgh: Pittsburgh Center for the Arts, 1988.

Harrington, LeMar. *Ceramics in the Pacific Northwest: A History*. Seattle: University of Washington Press, 1979.

Ilse-Neuman, Ursula. "Michael Lucero," in *Explorations: The Aesthetic of Excess*. New York: The American Craft Museum, 1990, pp. 32–35.

Johnson, Brooks, and Thomas W. Styron. *Still Modern after All These Years*. Norfolk: Chrysler Museum, 1982.

Kangas, Matthew. *Breaking Barriers: Recent American Craft*. New York: American Craft Museum, 1995.

Littman, Robert R. *El Arte Narrativo: Pintura Narrativo Mexicana*. Mexico City: Museo Rufino Tamayo, 1984.

Lucie-Smith, Edward, and Paul J. Smith. *Craft Today: Poetry of the Physical*. New York: American Craft Museum, 1986.

Manhart, Marcia. *Objects and Drawings from the Sanford M. and Diane Besser Collection*. Tulsa: Philbrook Museum of Art and Arkansas Art Center, 1992.

Mayer, Charles S. *intimate/INTIMATE*. Terre Haute: Turman Gallery, Indiana State University, 1986.

Moufarrege, Nicholas A. *Correspondences– New York Art Now*. Harajuka, Tokyo: Laforet Museum, 1985.

Ratcliff, Carter. *Michael Lucero*. New York: ACA Galleries, 1988.

Rifkin, Ned. *Natural Settings*. Washington, D.C.: Corcoran Gallery of Art, 1986.

Rogers-Lafferty, Sarah. *Body and Soul/ Aspects of Recent Figurative Sculpture*. Cincinnati: Contemporary Arts Center, 1985.

Sachs, Sid. *An Inside Place*. Oceanville, N.J.

Schimmel, Paul. *Contemporary American Ceramics: Twenty Artists*. Newport Beach, Cal.: Newport Harbor Art Museum, 1985.

Sculpture Now: Recent Figurative Works. Exhibition brochure. Richmond: Institute of Contemporary Art of the Virginia Museum, 1983.

Taragin, Davira S. *Contemporary Crafts and the Saxe Collection*. New York: Hudson Hills Press, 1993.

Wechsler, Susan. *Low-Fire Ceramics, A New Direction in American Clay*. New York: Watson Guptill Publishers, 1981.

_____. *The Raw Edge: Ceramics of the 80s*. Brookville: C. W. Post College, 1983.

Zimmer, William. *Lucero, Scanga, Surls: The Premier Company*. Dallas: Delahunty Gallery with Texas Gallery, Houston, 1982.

MINT MUSEUM OF ART

Frances Geter
Security Captain

Diane Turner
Security Officer

Paula Wise
Security Officer

Willie Anderson
Maintenance Supervisor

John Gill
Maintenance

Samantha Montgomery
Maintenance

Eric Perry
Maintenance

Jarvis Sullivan
Maintenance

COMMUNITY RELATIONS

Carolyn Mints
Director of Community Relations

Nikki Bennett
Front Desk Receptionist

Jean Brown
Front Desk Receptionist

Loretta Johnson
Front Desk Receptionist

Elaine Pearce
Front Desk Receptionist

EDUCATION

Cheryl A. Palmer
Director of Education

Janet Austin
Education Assistant

Debbie "Qstarl" Coleman
Outreach Coordinator

Susan S. Perry
Docent and Tour Coordinator

Jill Shuford
School Programs Coordinator

Robert West
Curator of Film and Video

Sara H. Wolf
Librarian

Sally Twichell
Library Assistant

COLLECTIONS AND EXHIBITIONS

Charles L. Mo
Director of Collections and Exhibitions

Gary L. Brown
Collections and Exhibitions Assistant

M. Mellanay Delhom
Historical Pottery and Porcelain Consultant

Anne E. Forcinito
Assistant Curator of Collections

James Jordan
Curator of Decorative Arts

Kathy L. Kay
Assistant Curator of Collections

Mark Richard Leach
Curator of 20th-Century Art

Jane Ellen Starnes
Curator of Costume and Textiles

Martha Tonissen Mayberry
Registrar

E. Michael Whittington
Curator of Non-Western Art

DESIGN AND INSTALLATION

Kurt Warnke
Head of Design and Installation

Emily Blanchard
Graphic Designer

Mitchell Francis
Cabinetmaker/Preparator

William Lipscomb
Preparator

DEVELOPMENT

James R. Hackney, Jr.
Director of Development and Marketing

Phil Busher
Public Relations Coordinator

John B. West
Marketing Assistant

Mary Irving Campbell
Mint Auxiliary Secretary

Betsy Durland
Membership Coordinator

Nikki Boyce
Part-time Membership Assistant

Heather Brody
Membership Assistant

Sandra S. Fisher
Manager Museum Shop

Jean Long
Director of Gift Planning

Sarah Smythe
Development Office Manager

Polly B. McKeithen
Development Officer

Andrew King
Development Assistant

Nettie Reeves
Marketing Coordinator

INDEX

PHOTOGRAPH CREDITS